Augustus Saint-Gaudens: Master Sculptor

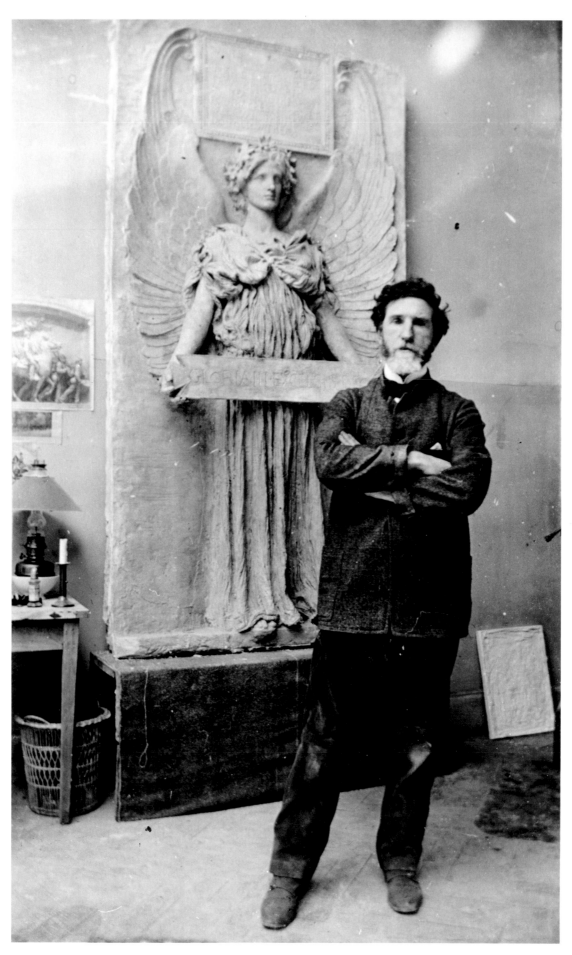

Augustus Saint-Gaudens in his Paris studio, 1898, photograph (private collection).

Augustus Saint-Gaudens

Master Sculptor

Kathryn Greenthal

The Metropolitan Museum of Art, New York

Distributed by G. K. Hall & Co., Boston

For Ted

Copyright © 1985 by The Metropolitan Museum of Art
Published by The Metropolitan Museum of Art, New York

Bradford D. Kelleher, Publisher
John P. O'Neill, Editor in Chief
Polly Cone, Project Coordinator
Mary-Alice Rogers, Editor
Abby Goldstein, Designer
Henry von Brachel, Production Manager
Photography by Jerry L. Thompson commissioned for this publication.
Type set by Columbia Publishing Company, Inc., Frenchtown, New Jersey
Printed by the Meriden Gravure Company, Meriden, Connecticut
Bound by Publishers Book Bindery, Long Island City, New York

Distributed by G. K. Hall & Co., 70 Lincoln Street, Boston, Massachusetts 02111

Library of Congress Cataloging-in-Publication Data

Greenthal, Kathryn.
 Augustus Saint-Gaudens, master sculptor.

 Bibliography: p.
 1. Saint-Gaudens, Augustus, 1848–1907—Criticism and
interpretation. I. Saint-Gaudens, Augustus, 1848–1907.
II. Metropolitan Museum of Art (New York, N.Y.) III. Title.

NB237.S2G74 1985 730'.92'4 85-15313
ISBN 0-87099-437-8
ISBN 0-8161-8789-4 (G. K. Hall)

This project is supported by generous grants from the William Cullen Bryant
Fellows of The American Wing at The Metropolitan Museum of Art and from
Clevepak Corporation, The Henry Luce Foundation, and the Wyeth Endow-
ment for American Art.

Contents

Notes for the Reader

All references to "sketches" are to be understood as three-dimensional studies; sketches in pencil or in pen-and-ink are herein referred to as "drawings."

Dates of the works of art are assigned according to those recorded on the objects or, where none is recorded, according to available information as to when a work was actually completed or, in some cases, installed.

FOREWORD

Augustus Saint-Gaudens stands in the forefront of American nineteenth-century sculptors. The breadth of his work is exceptional and ranges from delicate cameos and portrait reliefs to public monuments that are among the finest of their kind. All are imbued with a characteristic skill and unmistakable sensitivity. Although Saint-Gaudens studied and worked in Paris as a young man and was steeped in the neoclassical and Beaux-Arts styles that characterized the sculpture of the day, he nonetheless produced works which are distinctly American in respect to subject and treatment. Among these belong the commissions for which he is still so esteemed: the Farragut Monument, the Adams Memorial, the Shaw Memorial, and the Sherman Monument. The passage of time has in no way diminished the grandeur of these public tributes, and they move us as eloquently and powerfully today as they did when they were unveiled.

In writing this volume, Kathryn Greenthal has provided a most useful study that examines the sculptor's work against the background of his time. The concurrent exhibition of Saint-Gaudens's sculpture, which opens at The Metropolitan Museum of Art, was also organized by Miss Greenthal, and will travel to the Museum of Fine Arts, Boston.

PHILIPPE DE MONTEBELLO
Director
The Metropolitan Museum of Art

Preface

Three-quarters of a century after his death, in 1907, Augustus Saint-Gaudens stands at the very head of the list of great American artists; indeed, it would not be unfair or unkind to the many great American sculptors, past and present, to claim him as the greatest of them all. Saint-Gaudens's mature works—large or small, in full-round or bas-relief, made of plaster, terra-cotta, stone, or bronze—all possess such superb qualities of line, form, color, and surface, and speak so well of blending the ideal and the real, that they capture equally our mind and our eye with the illusive impact of great beauty found only in the finest art objects. Never crude or saccharine, wonderfully drawn and modeled, his sculpture will always invite the thoughtful caress of hand and eye as well as an appreciation of the fine cast of mind that lay behind its creation. Saint-Gaudens's work now occupies an important, recognized, and merited place among the best art productions of the recent past.

Beyond possessing a rare artistic nature, Augustus Saint-Gaudens was an extremely fortunate man in that his career as an American sculptor flourished during the last quarter of the nineteenth century and the opening years of the twentieth. In those yeasty years the United States was transformed from a war-shattered nation of moderate population and economic capabilities—a country that lacked the strength and cultivation of the great European powers—into a modern industrial nation brimming with the confidence and creativeness necessary to give it a place of honor among the most important nations of the world. The economic, industrial, and cultural changes that then took place, allowing such a new world rank, had enormously meaningful parallels in the arts of America. Artistic training, to a great degree the product of environment and instruction, became far more sophisticated in this country as students benefited from an assumption that became general among them: that study in Europe was essential to success as an American artist. Saint-Gaudens, like countless of his contemporaries, went to France and Italy, where—particularly in France—he received the best and most up-to-date sculpture training available in the world. Students of the arts also learned that while the United States of America was a wonderful country, it was not the only wonderful one: when they returned from their studies abroad, the new cosmopolitan attitudes they brought with them came to occupy center stage of the domestic art world, as they have continued to ever since. It is appropriate that Kathryn Greenthal, with her work here printed, has undertaken the task of presenting Saint-Gaudens in an entirely different perspective, one that for the first time reveals him on an international plane.

This book, and the exhibition mounted concurrently with it, belong to a series of publications and exhibitions that the Metropolitan Museum has sponsored, under the supervision of Lewis I. Sharp, curator of American sculpture, to present for public enjoyment and study American sculpture of the nineteenth and early twentieth centuries. The series has been dedicated to comprehensive views of the work of Erastus Dow Palmer, John Quincy Adams Ward, and, now, Augustus Saint-Gaudens. This project, among others within the Museum, has benefited since 1980 from the enlightened support and encouragement of the Clevepak Corporation, which has manifested its interest with a generous grant. The Clevepak grant together with

one from the Henry Luce Foundation have made it possible for Jerry L. Thompson to produce with splendor and fidelity his photographs of Saint-Gaudens's sculpture that appear in the text. The William Cullen Bryant Fellows of the American Wing have also provided substantial funds, theirs used to help to defray the cost of editing and producing this book. The Metropolitan Museum of Art and the American Wing are truly fortunate to have such loyal friends and supporters.

JOHN K. HOWAT
The Lawrence A. Fleischman Chairman of
 the Departments of American Art
The Metropolitan Museum of Art

ACKNOWLEDGMENTS

My interest in Augustus Saint-Gaudens grew out of discussions with Lewis I. Sharp and the late H. W. Janson. Both men were instrumental in my choosing the sculptor as the subject of a doctoral dissertation, now in preparation, that I will submit to the Institute of Fine Arts, New York University. Professor Janson introduced me to the study of nineteenth-century sculpture, and I shall always be grateful for his guidance, enthusiasm, and friendship. Lewis Sharp, who, together with John K. Howat at the Metropolitan Museum, provided me with the opportunity to write this book as well as to organize the Museum's 1985–86 exhibition of Saint-Gaudens's sculpture, is most responsible for having helped bring forth this volume. His support at every turn has meant a great deal to me.

I wish to thank my other colleagues in the Departments of American Art, especially Natalie Spassky, Doreen B. Burke, Kathleen Luhrs, and Donna J. Hassler, who willingly brought information to my attention. In addition, Emely Bramson, Pamela Hubbard, Nancy Gillette, Linda Yeager, Susan Ebner, and Caroline V. Green have graciously helped with many time-consuming details.

Also at the Museum, James Draper of the Department of European Sculpture and Decorative Arts and Maxwell L. Anderson of the Department of Greek and Roman Art answered queries with their customary kindness and erudition. Polly Cone of the Editorial Department has been a most effective guide in putting this book into production, and I thank her and the book's designer, Abby Goldstein, for the form the book has taken. Jeanie M. James offered valuable assistance with material pertaining to Saint-Gaudens in the Museum's Archives, and William H. Walker and his staff in the Thomas J. Watson Library facilitated the use of the library's considerable resources. Members of the Department of Objects Conservation, especially John Canonico and Shinichi Doi, have admirably conserved a number of works in the exhibition. Linda M. Sylling, of Operations, and Linden Havemeyer Wise, of the Vice President, Secretary and Counsel's Office, efficiently took care of the business and legal arrangements for the show as Registrars John Buchanan, Herbert Moskowitz, and Laura Rutledge Grimes did of the arrangements for its packing and shipping.

It is an honor to have the exhibition travel to the Museum of Fine Arts, Boston, and I am particularly indebted to Jan Fontein, Ross W. Farrar, Peabody Gardner, Katherine B. Duane, Jonathan Fairbanks, Anne L. Poulet, and Cornelius Vermeule for their collaboration. The lenders to the exhibition, both public and private, have been enormously generous. Without their cooperation, I could not have gathered together so many of Saint-Gaudens's finest works.

Chester Dale and Andrew W. Mellon Fellowships permitted me to conduct research, and a grant from the Wyeth Endowment for American Art was much appreciated. Three organizations have made significant contributions to this book. The Henry Luce Foundation, the sponsor for the catalogue in preparation of the Metropolitan Museum's collection of American sculpture, funded Jerry L. Thompson's photographs of Saint-Gaudens's works that are owned by the Museum. Clevepak Corporation, which sponsored the exhibition at the Metropolitan Museum, underwrote the expenses for Mr. Thompson's photographs of works by Saint-Gaudens outside of the Museum's collection. The Metropolitan Museum's Bryant Fellows, as patrons of the American Wing's publication of books on American art, contributed funds to cover certain edi-

torial expenses. A word of thanks is clearly due Jerry L. Thompson for his superb photographs, which have both enriched the book and my perception of Saint-Gaudens's power.

John H. Dryfhout, Curator and Superintendent of the Saint-Gaudens National Historic Site in Cornish, New Hampshire always accorded me a warm welcome at the Site and shared with me his wealth of knowledge about Saint-Gaudens. It also gives me pleasure to thank the Trustees of the Saint-Gaudens Memorial, Inc., for their interest in the book and the exhibition. Philip N. Cronenwett and Kenneth C. Cramer of the Special Collections Division of the Dartmouth College Library, where the Saint-Gaudens Papers are preserved, made every possible effort to facilitate my research, and special thanks are due them.

I am especially grateful to Ruth Butler and Nancy Scott for having read the manuscript. Professors Butler and Scott as well as Deborah Menaker and Alison West have been unwavering in their support and counsel and more than generous with their suggestions and insights. I should also like to thank Anne Pingeot of the Musée d'Orsay at this juncture, as her assistance has been unfailing and her knowledge has so thoroughly benefited me.

I am pleased to acknowledge the institutions, libraries, and archives, and the members of their staffs who have helped with my research: Archives of American Art, Smithsonian Institution, Boston, Robert F. Brown and Joyce Tyler; Boston Art Commission, Mary O. Shannon; Boston Athenaeum, Donald Kelley; Boston Public Library, Theresa D. Cederholm and Sinclair Hitchings; Massachusetts Historical Society, Boston, Stephen T. Riley; Massachusetts State House Archives and Library, Boston; Nichols House Museum, Boston, William H. Pear; Trinity Church, Boston, Bettina A. Norton; the Houghton Library, Harvard University, Cambridge, Massachusetts, Nancy Finlay; the Art Institute of Chicago, Milo M. Naeve and John Zukowsky; Chicago Historical Society, Archie Motley; National Gallery of Art, Dublin, Homan Potterton; National Library of Dublin; National Museum of Ireland, Dublin, Oliver Snoddy; National Library of Scotland, Edinburgh, I. G. Brown; Courtauld Institute of Art, London, Philip Ward-Jackson and Benedict Read; Beinecke Rare Book and Manuscript Library, Yale University, New Haven; American Academy and Institute of Arts and Letters, New York City, Margaret M. Mills; the American Numismatic Society, New York City, Alan M. Stahl and Richard Doty; Avery Architectural and Fine Arts Library, Columbia University, New York City, Janet Parks and Herbert Mitchell; Cooper-Hewitt Museum, Smithsonian Institution, New York City, Elaine Evans Dee; National Academy of Design, New York City, Barbara S. Krulik; the New York Public Library; The New-York Historical Society, Wendy J. Shadwell and Thomas Dunnings; New York Life Insurance Company, New York City, Pamela Dunn Lehrer; Archives Nationales, Paris, Martine Constans; Musée de la Monnaie, Paris, Yvonne Goldenberg and Jean-Marie Darnis; Musée d'Orsay, Paris, Antoinette Le Normand-Romain, Marc Bascou, and Jacqueline Henry; Musée du Petit Palais, Paris, Thérèse Burollet; Musée Rodin, Paris, Monique Laurent; Library of Congress, Washington, D.C.; National Gallery of Art, Washington, D.C., John Wilmerding; National Museum of American Art, Smithsonian Institution, Washington, D.C., William H. Truettner; Peter A. Juley and Son Collection, National Museum of American Art, Smithsonian Institution, Washington, D.C.; National Portrait Gal-

lery, Smithsonian Institution, Washington, D.C., Robert G. Stewart, Monroe Fabian, and Beverly Cox.

Many individuals have provided information and assistance: Mr. and Mrs. Oliver F. Ames, Arthur Beale, Avis Berman, Flora Biddle, Mrs. Peter Borie, Laura Camins, June Clark-Moore, John Coolidge, Karen C. Crislip, Hildegard Cummings, Peter H. Davidson, Ann Gibson, Brendan Gill, Victoria Glaser, Lloyd Goodrich, James Graham, George Griswold, Anne Tonetti Gugler, George Gurney, Michael Hall, Wilhelmina S. Harris, Henry-Russell Hitchcock, Edmund Homer, Gail Homer, Lawrence Homolka, Mr. and Mrs. William White Howells, Sarah S. Ingelfinger, Paula Kozol, Francis W. Kowsky, Ann La Farge, the late Henry La Farge, Mrs. Eric Lagercrantz, Henry Lee, Alice E. Levi Duncan, Elizabeth Lowell, Russell Lynes, Kathleen E. Macfie, Mrs. Charles McLane, Susan Menconi, Ginette de B. Merrill, James F. O'Gorman, Nicholas Penny, Farwell W. Perry, Jan Seidler Ramirez, Michael Richman, Michael St. Germain, Isabelle Savell, Robert Severy, Michael Shapiro, Parkman Shaw, Alice Shurcliff, Mrs. Gordon Sweet, John Walsh, Jr., Jeanne Wasserman, Elizabeth Gilman Dodge White, Frederick Lawrence Peter White, the late Mrs. Lawrence Grant White, Mrs. Winthrop Wetherbee, Burke Wilkinson, Richard Guy Wilson.

On a personal note, I wish to thank my mother and my father, who passed on to me a love for art and beauty which helped give life to my appreciation of Saint-Gaudens's genius. In Boston, my husband, Theodore A. Stern, bore neglect with supreme patience and understanding. His assistance and encouragement have been absolute, and I am humbled by the sacrifice he made to have this book brought to fruition.

KATHRYN GREENTHAL
New York, 1985

COLORPLATES

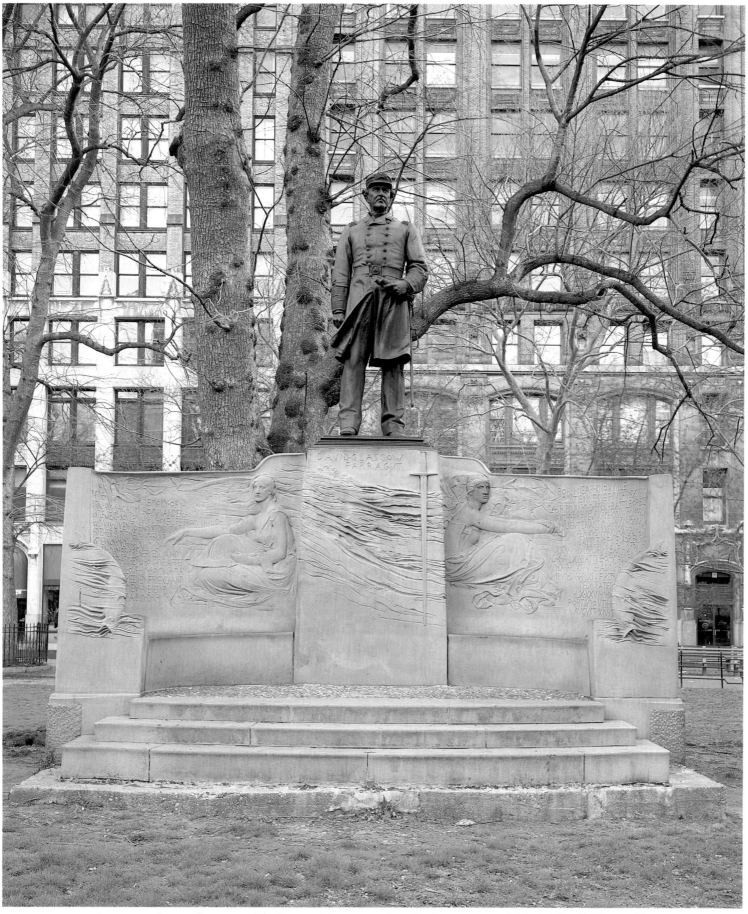

PL. I. AUGUSTUS SAINT-GAUDENS, *The Farragut Monument*, 1879–80, bronze statue of Admiral David Glasgow Farragut, over life-size (New York City, Madison Square Park). The granite exedra is a copy of the original bluestone base designed by Stanford White.

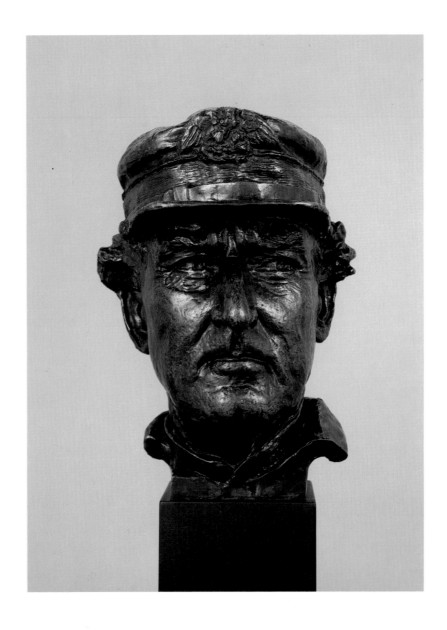

PL. II (above). AUGUSTUS SAINT-GAUDENS, *Head of Farragut*, 1879–80, this cast 1910, bronze, h. 11¼ in. (New York City, The Metropolitan Museum of Art, Gift by subscription through the Saint-Gaudens Memorial Committee, 1912).

PL. III (opposite). AUGUSTUS SAINT-GAUDENS, *Bessie Springs Smith* (Mrs. Stanford White), 1884, marble relief, 24¹⁵⁄₁₆ in. × 11¹⁵⁄₁₆ in.; frame, gilded wood with gesso, designed by Stanford White (New York City, The Metropolitan Museum of Art, Gift of Erving Wolf Foundation, 1976).

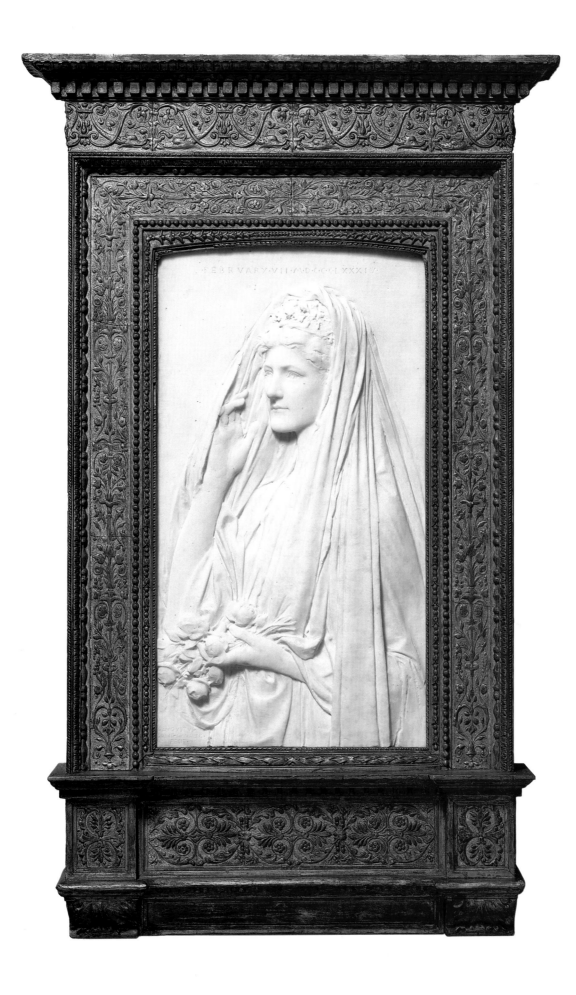

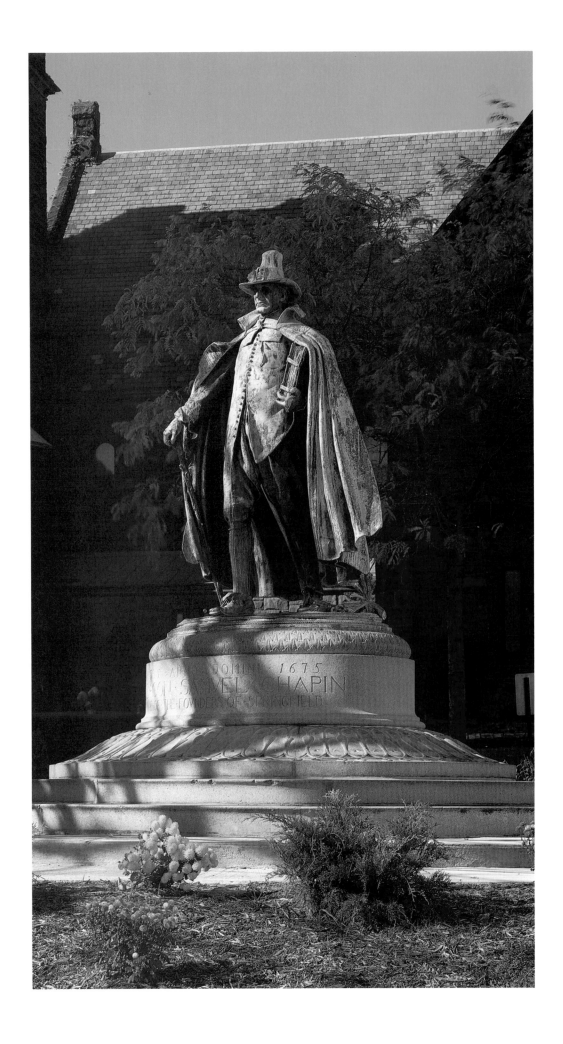

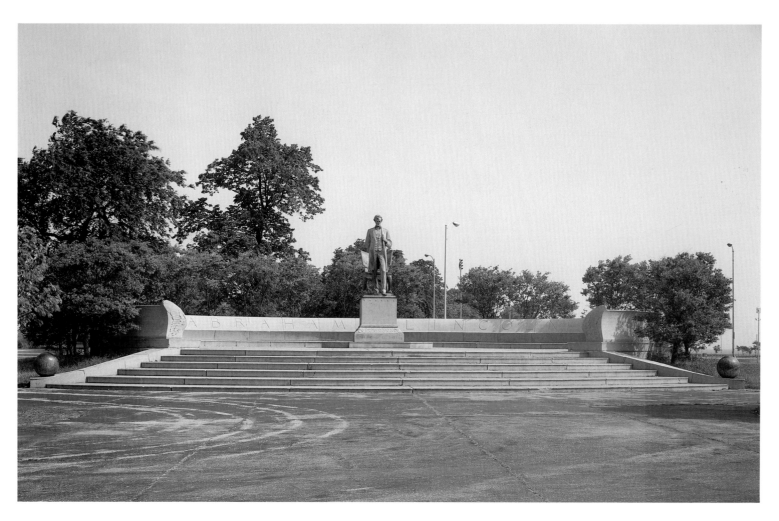

PL. IV (opposite). Augustus Saint-Gaudens, *The Puritan*, 1886, bronze statue, over life-size; granite pedestal designed by Stanford White (Springfield, Massachusetts, Merrick Park).

PL. V (above). Augustus Saint-Gaudens, *Abraham Lincoln* ("The Standing Lincoln"), 1887, bronze statue, over life-size; granite pedestal and exedra designed by Stanford White (Chicago, Lincoln Park).

PL. VI (right). "The Standing Lincoln."

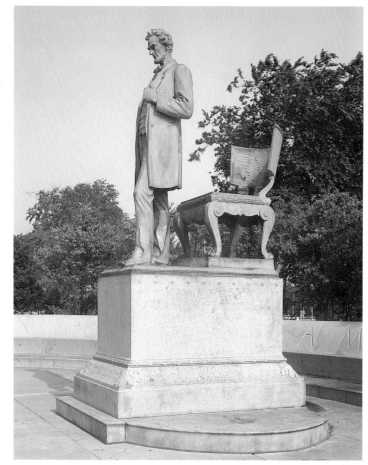

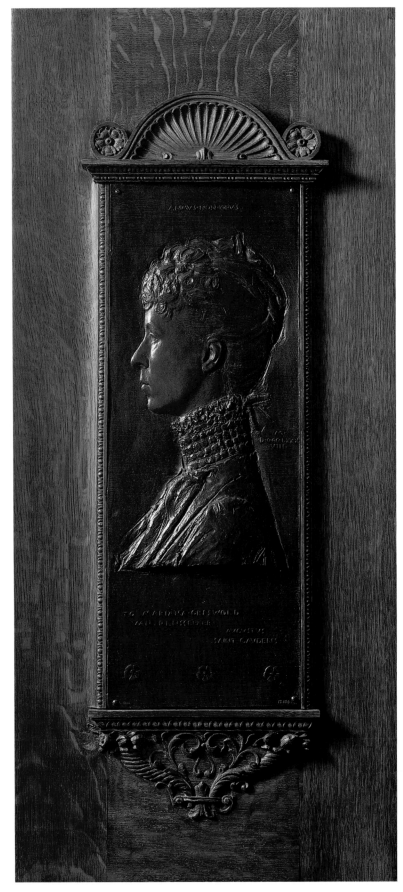

PL. VII. AUGUSTUS SAINT-GAUDENS, *Portrait of Mrs. Schuyler Van Rensselaer*, 1888, this cast 1890,
bronze relief, 20⁷⁄₁₆ in. × 7¾ in.; wood frame probably designed by Stanford White (New York City,
The Metropolitan Museum of Art, Gift of Mrs. Schuyler Van Rensselaer, 1917).

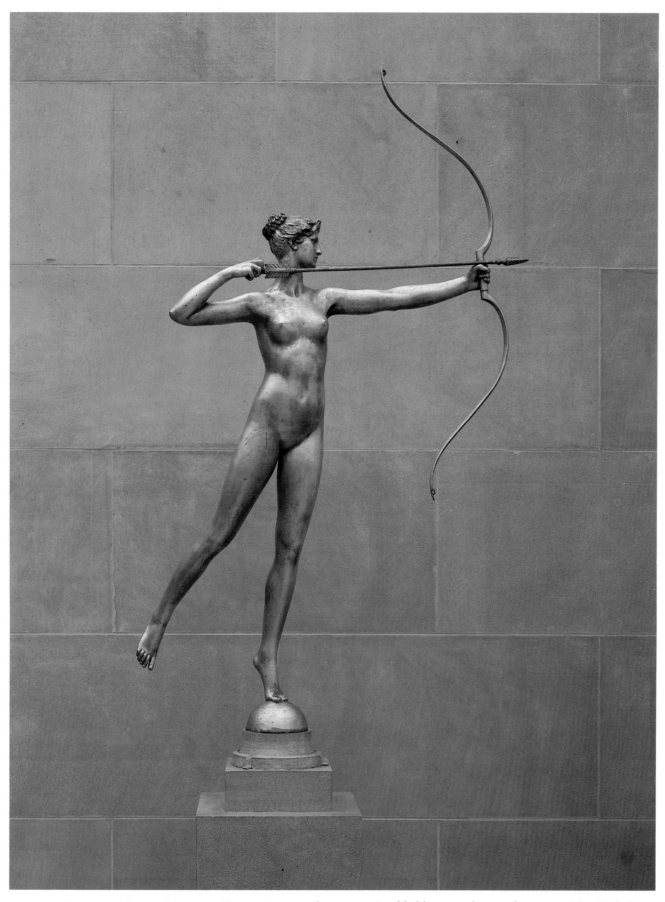

PL. VIII. Augustus Saint-Gaudens, *Diana*, 1893–94, this cast 1928, gilded-bronze reduction, h. 102 in. (New York City, The Metropolitan Museum of Art, Rogers Fund, 1928).

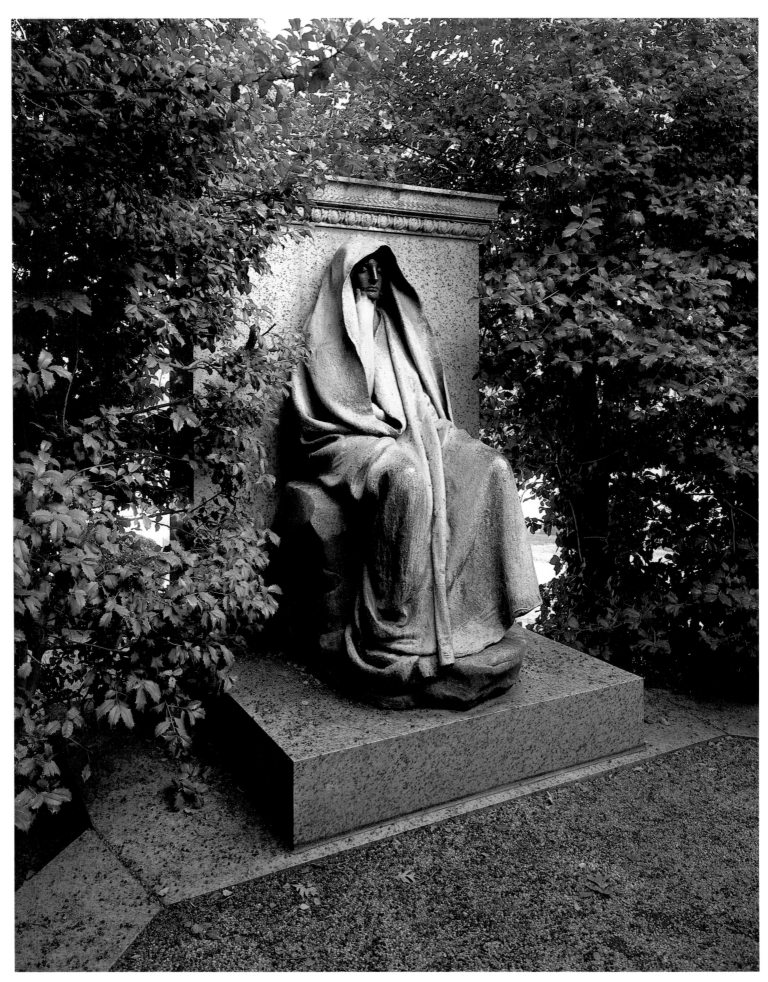

PL. IX. AUGUSTUS SAINT-GAUDENS, *The Adams Memorial*, 1890–91, bronze statue, over life-size, on stone base; granite pedestal and setting designed by Stanford White (Washington, D.C., Rock Creek Cemetery).

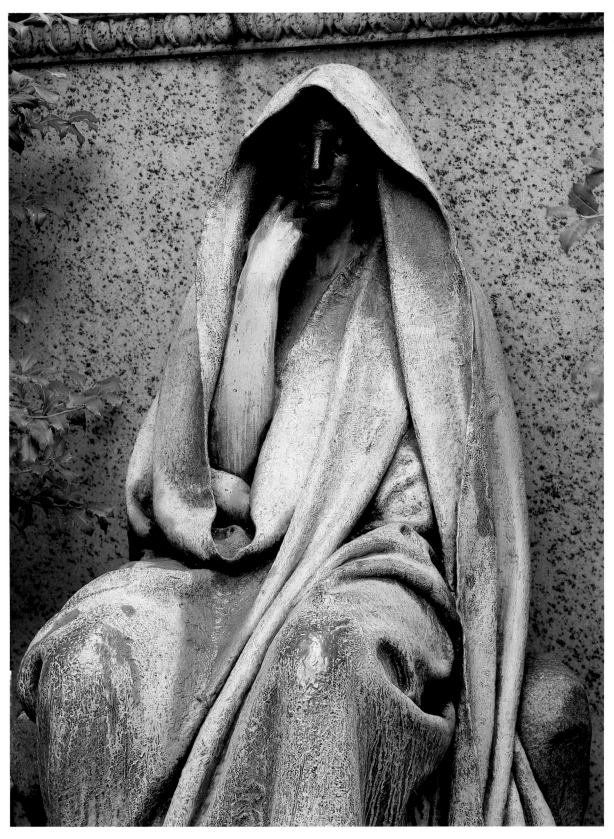

PL. X. *The Adams Memorial*, detail.

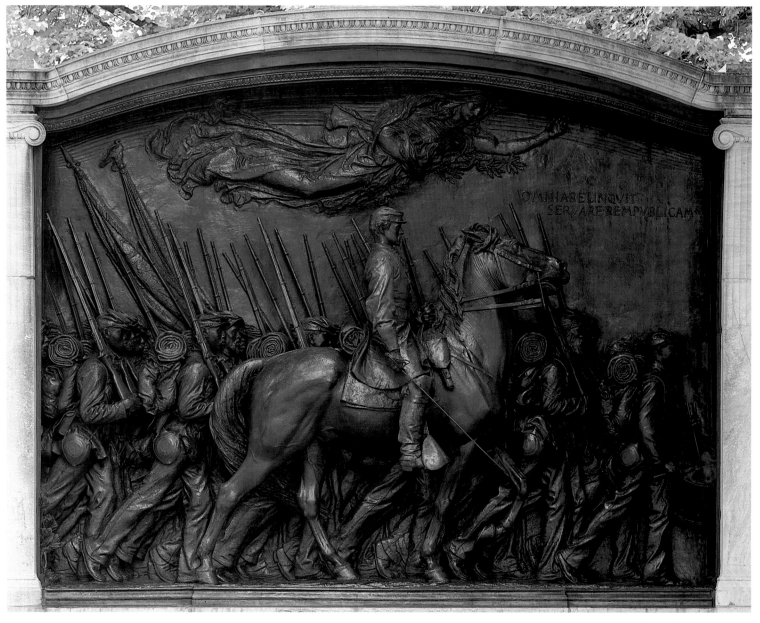

PL. XI. AUGUSTUS SAINT-GAUDENS, *Memorial to Robert Gould Shaw*, 1897, bronze relief, figures life-size; Knoxville marble frame designed by Charles McKim (Boston, Boston Common).

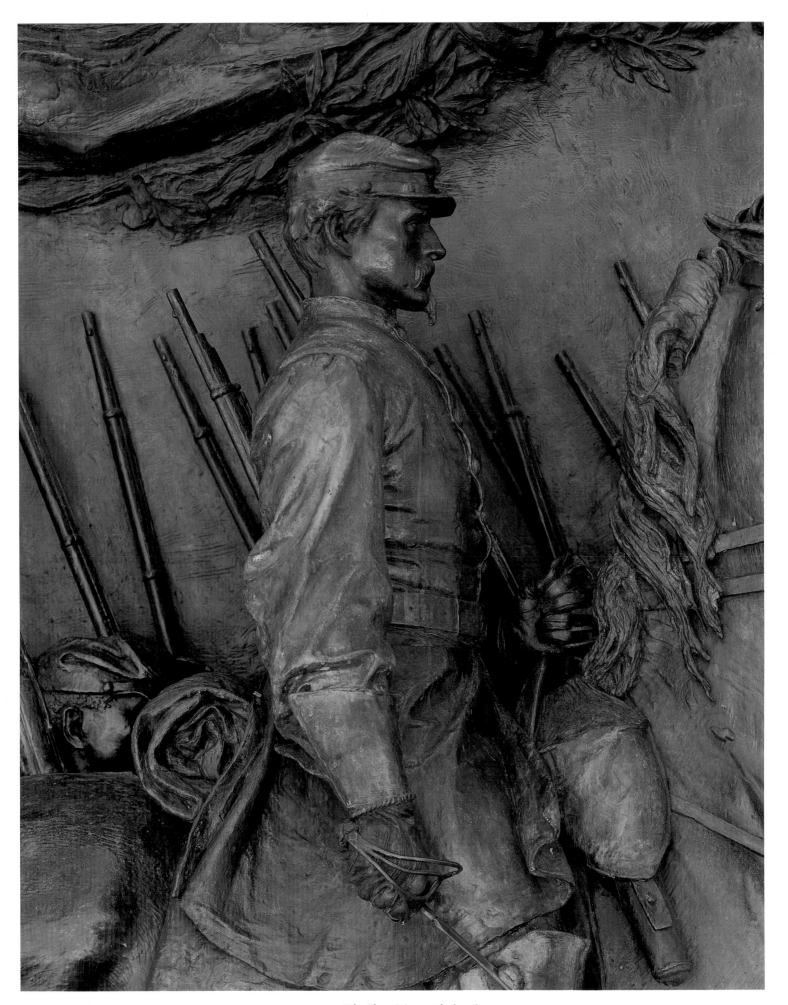

PL. XII. *The Shaw Memorial*, detail.

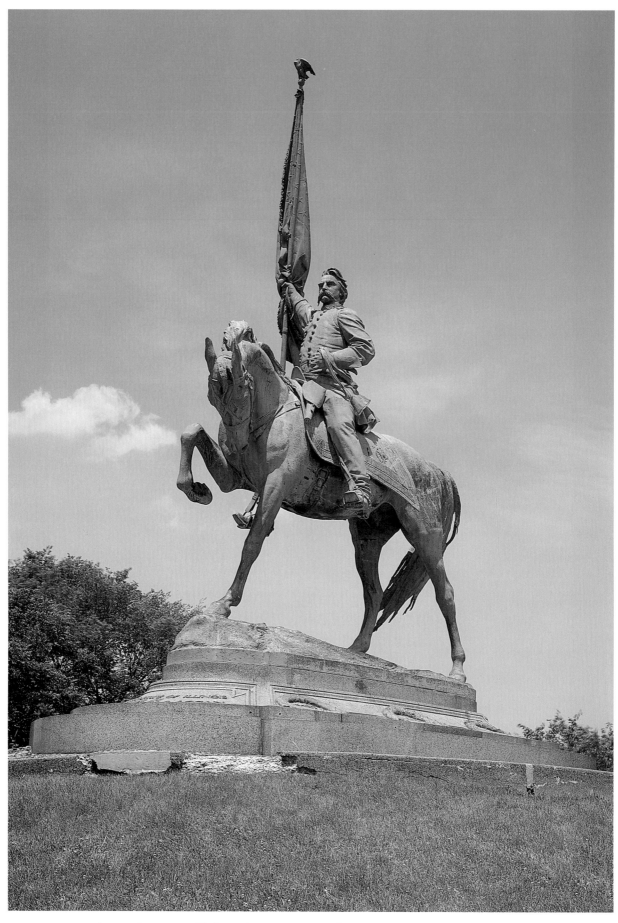

PL. XIII. AUGUSTUS SAINT-GAUDENS, *The Logan Monument*, 1897, bronze equestrian statue of Major General John A. Logan, over life-size; granite pedestal designed by Stanford White (Chicago, Grant Park).

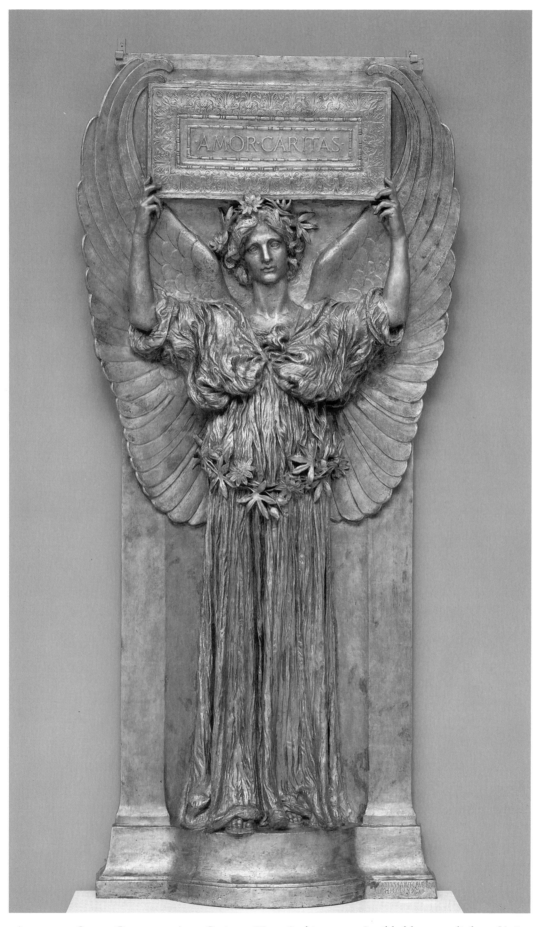

PL. XIV. AUGUSTUS SAINT-GAUDENS, *Amor Caritas*, 1880–98, this cast 1918, gilded-bronze relief, 113⅝₁₆ in. × 50 in. (New York City, The Metropolitan Museum of Art, Rogers Fund, 1918).

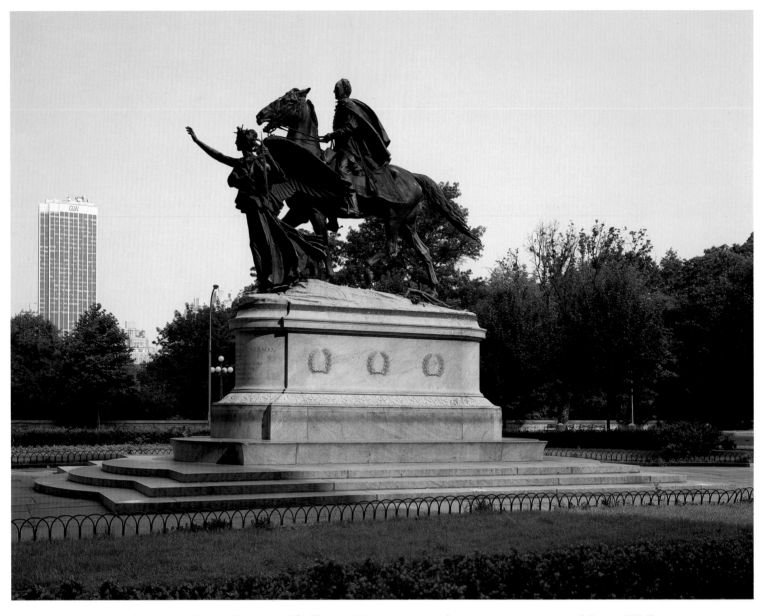

PL. XV. AUGUSTUS SAINT-GAUDENS, *The Sherman Monument*, 1903, bronze equestrian statue of General William Tecumseh Sherman, over life-size; granite pedestal designed by Charles McKim (New York City, Grand Army Plaza).

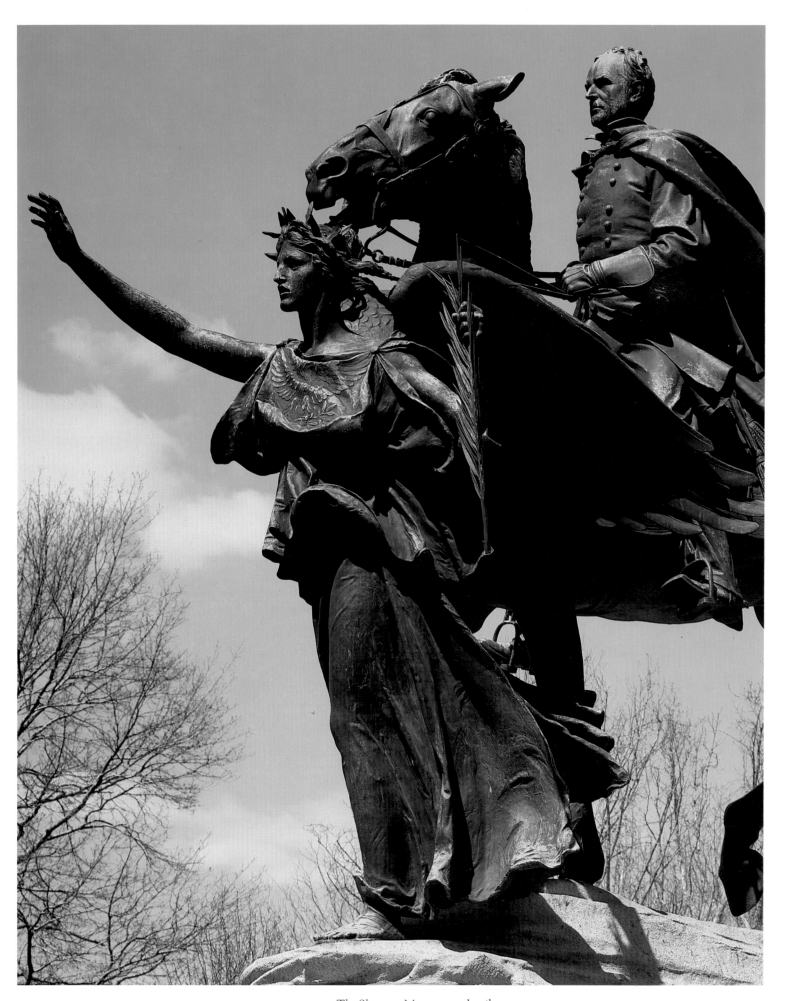

PL. XVI. *The Sherman Monument*, detail.

PL. XVII. Augustus Saint-Gaudens, *Head of Victory*, 1902, gilded bronze, h. 8¼ in.
(Boston, Nichols House Museum).

Augustus Saint-Gaudens: Master Sculptor

Augustus Saint-Gaudens, 1905, photograph (Hanover, New Hampshire, Dartmouth College Library)

SAINT-GAUDENS REASSESSED

At the beginning of the twentieth century, no American sculptor was more celebrated than Augustus Saint-Gaudens.[1] When he died, in 1907, his passing was recorded in the foreign press, and his career was the subject of lengthy commentary in domestic newspapers. The *Boston Globe*, which featured his obituary on its front page, hailed him as the artist who had "raised the standard of sculpture in America to a height little dreamed of 30 years ago [and whose] influence during this period has been felt in nearly every part of the domain of art in the United States."[2] Yet within a few years of his death his reputation had faded, the victim of the totally different form that so-called modern art was taking during the teens and later decades of the century. Saint-Gaudens's talent nevertheless remained unquestioned: a reporter for *Time*, in reviewing an exhibition of his sculpture held in 1948 at The Century Association in New York on the hundredth anniversary of the sculptor's birth, commented that the show "highlighted the delicacy of his bas-reliefs and reached a rare pitch of portraiture in the stubble-bearded head of General Sherman."[3] The reporter went on to speak of such major Saint-Gaudens works as Chicago's "Standing Lincoln" (fig. 120; pls. v, vi), Washington's *Adams Memorial* (fig. 126; pl. ix), Boston's *Shaw Memorial* (fig. 151; pl. xi), and New York's *Sherman Monument* (fig. 163; pl. xv) as "art which exerts a grip on millions of imaginations."[4] In 1969, the National Portrait Gallery devoted a show to Saint-Gaudens's portrait reliefs, which *Time* reported variously as "sensitively modeled" and reflecting "the understanding of a psychologist."[5]

Many contemporary critics nevertheless continued to denigrate the achievements in American sculpture during the last century. After several negative reactions to exhibitions held in New York in the nineteen-sixties and seventies had been published, the noted scholar H. W. Janson, writing in the *American Art Review*, called for a new evaluation, based on historical perspective, of the period. In refuting reviewers' claims that what had been exhibited was unworthy of serious attention, he said, in part: "The trouble with American 19th-century sculpture is the way we habitually think about it rather than any inherent defect in the material itself." He concluded: "We are likely to find that, taken as a whole, American 19th-century sculpture does have a distinctive character in that it is not like French, English, German, or Italian sculpture, although it has links with all of them, and that it differs from any of these in much the same way they differ from each other. That American sculpture, within less than a hundred years, established itself as a full-fledged member of the Western sculptural community seems to me no mean achievement."[6]

Perhaps out of the renewed sense of national pride that resulted from the country's bicentennial celebration, increasing numbers of collectors, scholars, and curators began to look at American sculpture of the 1800s with a less biased eye. In 1984, three exhibitions either were devoted entirely to the works of Augustus Saint-Gaudens or included them: in Boston, the Athenaeum presented "Touched with Nobility: Portrait Sculpture of American Women," devoted to his cameos, busts, reliefs, and other small works; in

New Jersey, at The Newark Museum, an exhibition focusing on the use of bronze as a preferred material by American sculptors from the mid-nineteenth century to the present day included several of his sculptures; and New York City's Cooper Union, in a show presented at its Houghton Gallery, featured bronzes and drawings by Saint-Gaudens, one of its most famous alumni. In 1985, The Metropolitan Museum of Art, organizing an exhibition of his work in association with the Museum of Fine Arts, Boston, again provided the public with the opportunity to judge for itself the merits of one of the most illustrious names in the lexicon of nineteenth-century sculpture. Thus the modern viewer, surveying the products of his extraordinary talent in these exhibitions and others yet to come, is in an unprecedented position to assess with objectivity the belief held by many that Augustus Saint-Gaudens is the greatest sculptor that America has yet produced.

Saint-Gaudens and the Sculpture of His Time

During his lifetime, Saint-Gaudens aspired to an international reputation, an ambition that he splendidly achieved. It was clear to him at an early age that he could best attain worldwide stature by first gaining recognition in Europe, and he went to Paris, which in the second half of the nineteenth century was becoming the art center of the world. The success he achieved there, as attested to by the honors he won at its Salons and Universal Expositions, has never received the emphasis it deserves as one of the foundations for his renown in the United States. In the late years of the last century a few American writers, unabashedly chauvinistic in motivation, chose to represent Saint-Gaudens's work as the harbinger of a new era in American sculpture without giving sufficient credit to the European heritage in which it was rooted. In the case of the Farragut monument figure, for example (fig. 1), the stance of the figure and the positioning of the head have been traced to Donatello's *Saint George* (fig. 82), though the work has been described by Wayne Craven as "an original piece and not an eclectic reinterpretation of a historic style."[7] Nevertheless, a thorough examination of Saint-Gaudens's artistic achievement cannot be made without the inclusion of his European experience. The rich diversity of Saint-Gaudens's oeuvre, typical of the art of the late nineteenth century, includes portraits in relief and in the round, decorative sculpture, funerary memorials, and public mon-

uments. Because no artist's accomplishments can be judged in isolation, Saint-Gaudens's sculpture must be compared with that produced by both American and European artists of his period, not only to define what is unique to him but also to determine his place within a wide sculptural perspective.

In the 1860s, at about the time Saint-Gaudens was executing his earliest works, sculpture being created by Americans both in the United States and in Italy, that traditional source of artistic inspiration, consisted essentially of neoclassical and realistic portraiture, tabletop sculpture, monuments honoring national and local heroes, and depictions of allegorical and mythological subjects. After the deaths of Horatio Greenough, in 1852, and Thomas Crawford, in 1857, the first-generation expatriate neoclassical sculptors producing these works included Hiram Powers (1805–1873), then at the end of his career. Among the second-generation neoclassicists living in Italy, the best known were Randolph Rogers (1825–1892), William Wetmore Story (1819–1895), and Harriet Hosmer (1830–1908), who were at mid-point in their careers. Stay-at-homes, also in mid-career, were Henry Kirke Brown (1814–1886) and Erastus Dow Palmer (1817–1904). Brown and Palmer worked in marble, but also used bronze, as, on occasion, did Rogers and Story, though they all lacked an understanding of the sculptural possibilities inherent in that medium. The unique qualities of bronze were not fully exploited by an American sculptor until John Quincy Adams Ward, who had learned the technique from his teacher and mentor, Henry Kirke Brown, came into his own in the 1860s.

In the last quarter of the century, when Saint-Gaudens's career was flourishing, progressive American sculptors had completed the gradual transition from the neoclassical (by then essentially retardataire) to a realistic or Beaux-Arts mode; those Americans still working in the neoclassical style were at least one generation behind their French and Italian colleagues. The perseverance into the eighteen-seventies and eighties of the neoclassical style in American sculpture resulted in part from the lengthy careers of Story, Richard Saltonstall Greenough (1819–1904), and others who had worked in Italy. Nevertheless, the neoclassicism

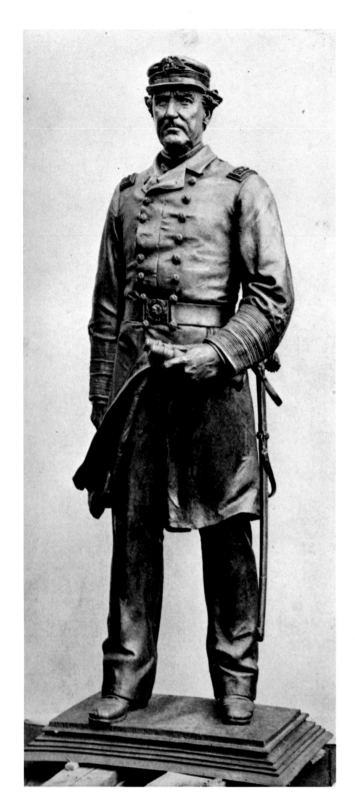

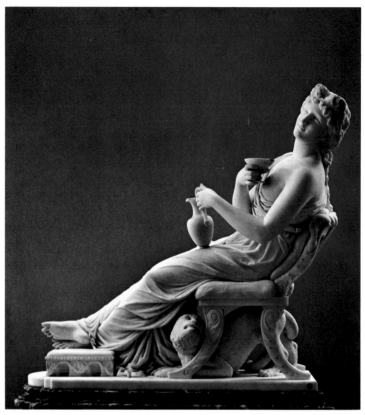

Fig. 1 (left). Augustus Saint-Gaudens, Figure of Admiral David Glasgow Farragut for *The Farragut Monument*, 1879–80; photograph (New York City, Collection of the American Academy and Institute of Arts and Letters).

Fig. 2 (above). Richard Greenough, *Circe*, 1882, marble statue, h. 54½ in. (New York City, The Metropolitan Museum of Art, Gift of Misses Alice and Evelyn Blight and Mrs. W. P. Thompson, 1904).

Fig. 3 (opposite, left). Franklin Simmons, *The Promised Land*, 1874, marble statue, h. 63 in. (New York City, The Metropolitan Museum of Art, Gift of Jonathan Ackerman Coles, 1897).

Fig. 4 (opposite, middle). Augustus Saint-Gaudens, *Silence*, 1874, marble statue, h. 88 in. (Utica, New York, Daniel D. Tompkins Memorial Chapel, Masonic Home).

Fig. 5 (opposite, right). Augustus Saint-Gaudens, *Dr. Walter Cary*, 1878, bronze relief, 9³⁄₁₆ in. × 6⁹⁄₁₆ in. (private collection).

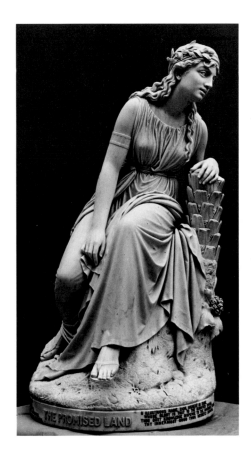
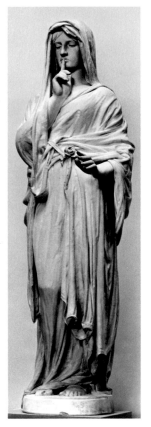
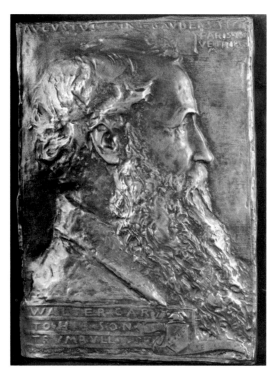

of Story or Richard Greenough should not be confused with that of Horatio Greenough—Richard's elder brother—Thomas Crawford, or Hiram Powers. The younger generation of neoclassicists were also working in marble, but their themes and the manner in which they presented their subjects were generally not so much purely classical and heroic in the traditional sense as they were anecdotal, romantic, and nostalgic in a fashion that catered to the Victorian penchant for sentimentality.

After the 1860s, as American sculptors became more proficient and comfortable in using bronze—especially for portraiture—and were replacing togas with contemporary dress for the attire of their subjects, naturalism became generally acceptable as a style. It was treated with supreme skill by Ward, who was capable of presenting in a most compelling way the very essence of an individual. There is a dignity of spirit and a sureness of hand in his best portraits that elevate his work far above that of the majority of the style's practitioners, which was often unimaginative and literal. An inspired work in the naturalistic vein was not merely one that represented the sitter but, more important, one that infused his image with vitality and a sense of his character. In that respect, Saint-Gaudens's greatest portraits are realized with such a superb technique, especially in his use of bronze, that their intensity and bravura almost dazzle the eye.

While American neoclassicism was slowly dying out as a style, the American interpretation of the Beaux-Arts mode was in its early stages of development, and, for a brief while, the two existed concurrently. For example, at virtually the same time as the young Saint-Gaudens was executing the bronze figure of Farragut (fig. 1), characterized by a bold and vigorous naturalism, Richard Greenough's neoclassic *Circe* (fig. 2), though originally modeled in 1853, was put into marble as late as 1882, a reflection of the continuing and insatiable Victorian taste for banal story-telling. The divergence in the two styles can be illustrated by contrasting the work of Saint-Gaudens with that of Franklin Simmons (1839–1913), a sculptor his elder by only nine years. Simmons settled in Italy (a country whose artistic prestige was by then waning)[8] in 1867, the same year that Saint-Gaudens went off to study in Paris. In 1874, both men executed works that show a classicized spirit: Simmons, *The Promised Land* (fig. 3); Saint-Gaudens, *Silence* (fig. 4). But by the

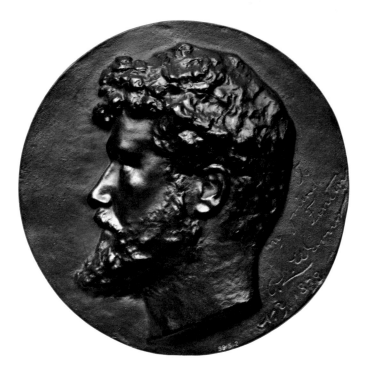

Fig. 6. HENRI CHAPU, *Tony Robert-Fleury*, 1863, bronze medallion, diam. 5¾ in. (Paris, Musée d'Orsay).

Fig. 7. OLIN LEVI WARNER, *Thomas Fenton*, 1878, bronze medallion, diam. 7 in. (New York City, The Metropolitan Museum of Art, Gift of the National Sculpture Society, 1898).

end of only four years Saint-Gaudens had made a great leap forward in style to his richly modeled *Dr. Walter Cary* (fig. 5), leaving forever behind the neoclassical form that no longer served him. Simmons, for his part, carried on it to one degree or another for the rest of his career, creating only traditional and largely uninspired works.

The term "Beaux-Arts style" is a convenient though not altogether satisfactory means of defining the sort of sculpture Americans were producing between 1876 and 1914. Sculpture so characterized reflected the training to be obtained at the École des Beaux-Arts in Paris. The term, which became somewhat loosely applied (Daniel Chester French [1850–1931], one of the best known of the so-called Beaux-Arts sculptors, never even enrolled at the school), generally referred to a sculptor's adherence to an academic emphasis on the human form; his emulation of antique, Renaissance, and baroque precedents; and his having studied in Paris: at the École, the École Gratuite de Dessin (the Petite École), the Académie Julian, the Académie Colarossi or with any of the many French sculptors who taught in their own ateliers. In this broad definition, then, dozens of artists from Saint-Gaudens to Frederick MacMonnies (1863–1937) to Gutzon Borglum (1867–1941) are considered as having practiced in the Beaux-Arts style.

✤

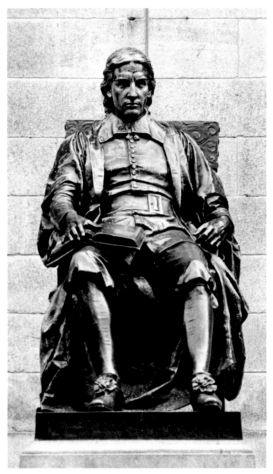

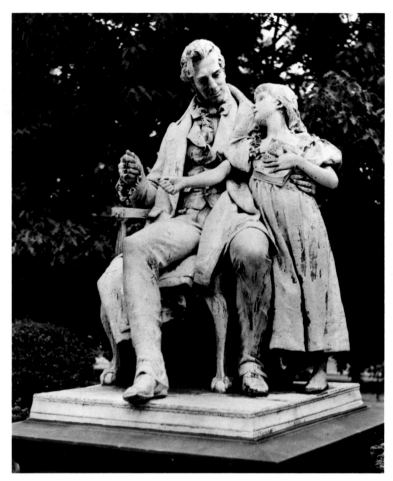

Fig. 8. DANIEL CHESTER FRENCH, *John Harvard*, 1884, bronze statue, over life-size (Cambridge, Massachusetts, Harvard University, Courtesy of the Fogg Art Museum, Gift–Samuel James Bridge, 1883).

Fig. 9. DANIEL CHESTER FRENCH, *Thomas Gallaudet Memorial*, 1888, bronze statue, over life-size (Washington, D.C., Gallaudet College).

At least for the cameos that were his earliest works, Saint-Gaudens was a product of the apprenticeship system, the course of practical study for most sculptors and craftsmen in America. Until the 1870s, when sculptors were first hired to teach at the Pennsylvania Academy of the Fine Arts and at the Boston Museum School, the only real alternative to an apprentice education was to study abroad—primarily in Italy. When Saint-Gaudens went to Paris in 1867, he was one of the first Americans to choose that city over Rome or Florence as the place for learning to sculpt. As Paris became more widely known, not only as the locus of a wide variety of new techniques in painting, sculpture, and architecture but also, because of its artistic diversity and rigorous training, as the most favorable place for acquiring an artistic skill, Americans began to enroll at the École des Beaux-Arts in increasing numbers.

Paris as a place to train had a different meaning for every American sculptor. Olin Levi Warner, for example, who was born in 1844 and had studied at the Petite École in 1869 and at the École des Beaux-Arts in 1870, revealed in a work such as *Thomas Fenton* (fig. 7) that there he had learned to master the relief form. Typical of Warner's medallions from the late 1870s, the *Fenton* shows the influence of Henri Chapu (1833–1891), a leading French sculptor of the time, whose portrait of the painter *Tony Robert-Fleury* dates from 1863 (fig. 6). For Daniel Chester French, his period of study in Paris, in 1886 and 1887, came belatedly in his career. At the age of thirty-six, what he hoped to gain was a greater technical competence in modeling. Though he did not enroll at the École, a comparison of two of his bronzes—the *John Harvard* (fig. 8), executed in the United States, and the *Thomas Gallaudet Memorial* (fig. 9), created in Paris—reveals the huge benefit he derived from his ten-month Paris stay. Not only has he chosen for his *Gallaudet* figures a

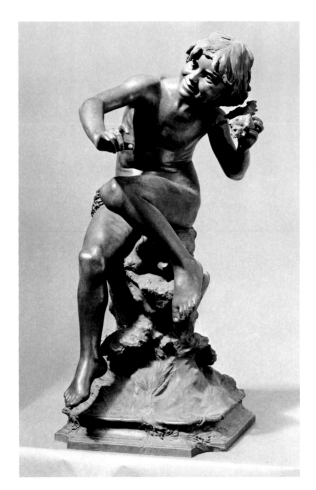
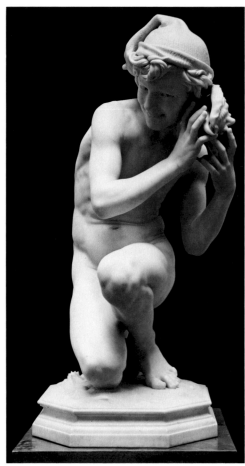

more relaxed pose than that of the *Harvard*, but his use of the bronze speaks of a greater degree of ease and confidence. If the shirt in the *Harvard* has repetitive, unmodulated folds, the vest in the *Gallaudet* hangs in a manner true to life: French has arrived at an understanding of how it should behave and how the anatomy beneath it works. Henry Hudson Kitson (1863–1947), who studied at the École in the early 1880s, learned there the importance of linking himself with a tradition. His youthful genre piece *Music of the Sea* (fig. 10) is a direct paraphrase of the *Neapolitan Fisherboy* (fig. 11) that Jean-Baptiste Carpeaux (1827–1875) first exhibited at the École des Beaux-Arts in 1858. Although Kitson claimed that the subject originated from an episode in his own childhood while he and his father were rambling on the west coast of England,[9] *Music of the Sea* was surely executed with an awareness of the nineteenth-century fisherboy theme. In selecting that subject, Kitson's clear purpose was to refer to previous versions of it and to establish his own place within a tradition begun in 1831 by François Rude (1784–1855) with his work also titled *Neapolitan Fisherboy*. MacMonnies, who had been an assistant to Saint-Gaudens before he went to Europe in 1884, developed during his two years of study at the École a particularly strong affinity for contemporary French sculpture. He went on to spend a large part of his life in France, producing such picturesque works as *Bacchante and Infant Faun* (fig. 12), which is marked by an exuberance perhaps influenced by a work such as *A Lucky Find at Pompeii* (fig. 13) by Hippolyte-Alexandre-Julien Moulin (1832–1884).

What Saint-Gaudens learned so well and with such consequence for his work at the Petite École and at the École des Beaux-Arts was the merit of shading the distinctions among the arts. The reforms of the curriculum that took place after 1863 at the École des Beaux-Arts encouraged the collaboration of all types of artists, a training then in effect for at least two decades at the Petite École, where sculptors and architects, say, could be assigned various exercises in design that ranged from candelabra to mausoleums.[10] As a consequence, in the early part of his career Saint-Gaudens was qualified to do a fair measure of decorative art that

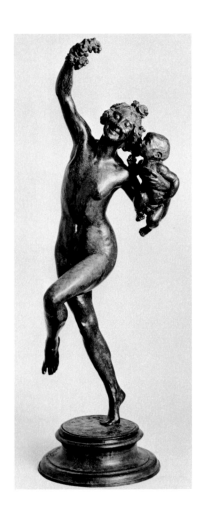

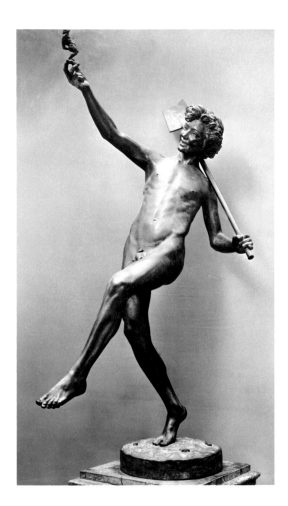

Fig. 10 (opposite, left). HENRY HUDSON KITSON, *Music of the Sea*, 1884, bronze statue, h. 43⅜ in. (Courtesy, Museum of Fine Arts, Boston, Gift of David P. Kimball, 1920).

Fig. 11 (opposite, right). JEAN-BAPTISTE CARPEAUX, *Neapolitan Fisherboy*, 1858; this version 1861, marble statue, h. 36¼ in. (Washington, D.C., National Gallery of Art, Samuel H. Kress Collection).

Fig. 12 (left). FREDERICK WILLIAM MACMONNIES, *Bacchante and Infant Faun*, 1893, bronze statue, h. 84 in. (New York City, The Metropolitan Museum of Art, Gift of Charles F. McKim, 1897).

Fig. 13 (right). HIPPOLYTE-ALEXANDRE-JULIEN MOULIN, *A Lucky Find at Pompeii*, 1863, bronze statue, h. 74 in. (Paris, Musée d'Orsay).

included the James Gordon Bennett Cup (figs. 56, 57) and portrait medallions in silver to embellish the Bryant Vase (fig. 58).

Saint-Gaudens had been introduced to the prominent American architect Henry Hobson Richardson in 1875, the same year in which it was his incalculable good fortune to meet the painter John La Farge and the architects Stanford White and Charles McKim. All four men shared Saint-Gaudens's profound understanding of the merits to be derived from the integration of various artistic disciplines, for all except White had studied in Paris. Saint-Gaudens collaborated with each of the four on various projects: with La Farge, on paintings for Richardson's Trinity Church, the St. Thomas reredos (fig. 66), the King family tomb, the Cornelius Vanderbilt II house (fig. 86). With Richardson, he worked on the memorial to Henry E. Montgomery (fig. 65), the Ames Gate Lodge decorations (fig. 83), the Ames Monument (fig. 84), the Oliver Ames relief. With McKim and White, he executed almost every important public statuary commission he received after 1875: with White, the Farragut monument (fig. 77; pl. I), "The Standing Lincoln" (fig. 120; pl. V), *The Puritan* (fig. 123; pl. IV), the Adams memorial (fig. 126; pl. IX), *Diana* (figs. 141, 143), and the Logan monument (figs. 159, 160; pl. XIII). White also designed the frames for many of Saint-Gaudens's portrait reliefs. With McKim, Saint-Gaudens did the Shaw memorial (fig. 151; pl. XI) and the Sherman monument (fig. 163; pl. XV).

The collaboration between Augustus Saint-Gaudens and Stanford White was to give birth to strikingly original concepts for the presentation of public monuments, or, as Wayne Craven, writing of the *Farragut*, put it, "A departure from the previous style of American statuary . . . [the base] not merely a support for the statue but an integral part of the memorial itself." He then summed up the import of the actual unveiling: "The covering fell away to reveal what marked a new era in American sculpture."[11] The "new era" was the result not just of White's imagination coupled with Saint-Gaudens's genius but of their manner of for-

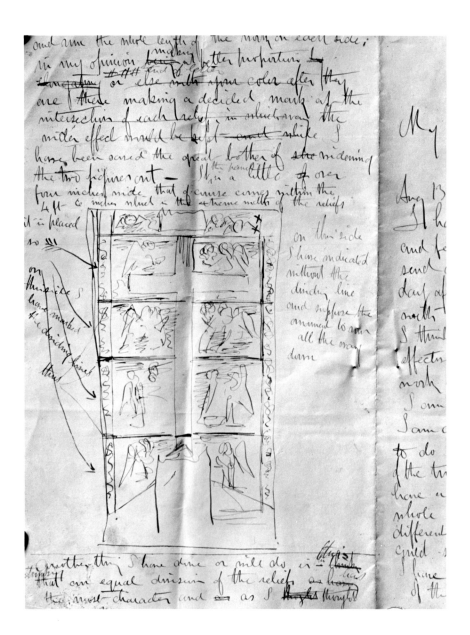

Fig. 14. Letter from Augustus Saint-Gaudens to John La Farge, August 29, 1877, Paris, showing a sketch for the St. Thomas reredos (Hanover, New Hampshire, Dartmouth College Library).

mulating ideas and constantly exchanging them, back and forth, to nurture their every project to fruition. The procedure from the first pencil sketch to the final unveiling was for them a crusade to elevate the perception of beauty in this country.

SAINT-GAUDENS AND HIS WORKING METHODS

Saint-Gaudens's own approach to his work reveals his constant struggle to achieve in actuality what he conceived of in his imagination. He seems rarely to have been entirely satisfied with anything he did; on the few occasions when he was, he usually changed his mind sometime afterward. He worked and reworked sketches and models in quest of the perfection that at least in his own mind always eluded him. He has been quoted as saying, "People think a sculptor has an easy life in a studio. It's hard labor, in a factory."[12] His torturous striving for the ideal presentation of his ideas is conveyed best by his manner of working.

His general method consisted of first making sketches or notations, often in letters (fig. 14) he wrote if someone he was working with on a project—La Farge or White, for example—was out of town or otherwise unavailable. When a working plan had finally been agreed on, whether in personal consultation or by letter, Saint-Gaudens would translate the concept into a small clay sketch. That was the stage at which he seems to have undertaken his greatest experimentation. The few sketches to have survived the fire that rav-

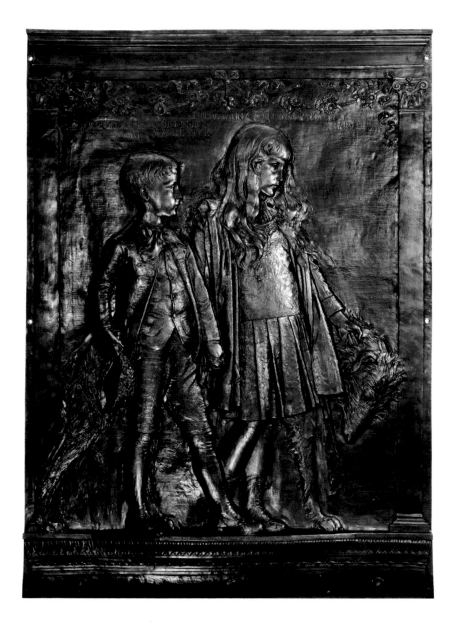

Fig. 15. AUGUSTUS SAINT-GAUDENS, *The Children of Jacob H. Schiff*, 1885, bronze relief, 67⁵⁄₁₆ in. × 50⅜ in. (Cornish, New Hampshire, Saint-Gaudens National Historic Site, National Park Service, U.S. Department of the Interior).

aged his New Hampshire studio in 1904 give no more than an approximation of the final appearance of a piece. He frequently created many sketches for one commission. A mere gesture could absorb him inordinately; he would subject it to a series of several different sketches in which he altered its movement by no more than an inch. Plaster sketches for the Peter Cooper monument and for the reliefs of the Schiff children and the McCosh memorial, to name but a few works, show that the repositioning of a figure, the angle of the view of a head, or even the movement of a hand was treated in a large number of variations. Illustrations of the Schiff children—Mortimer Leo and Frieda Fanny (fig. 15)—give an idea of how Saint-Gaudens worked out the composition (figs. 16–21). He tried positioning one of the children seated, the other standing; both children seated; he showed them frontally, holding hands; he had them lean against one another; and only in the more finished sketches did he approach the final presentation. What appear to be among his last attempts to fix the pose show his indecision over whether the childrens' heads should be seen in profile or frontally. In the end, he chose the profile view. Up to that point, the most complex elements in the final relief did not figure prominently in his studies: the juxtaposition of the children's legs as they step forward, but not in unison; the columns that flank their figures; and the dog added to the background to increase the relief's impression of three-dimensionality, which he achieved in the remarkably shallow depth of just under three inches. The studies, which never focus on any facet of the children's personalities, appear to be mere exercises in the sculptural aspects of the work.

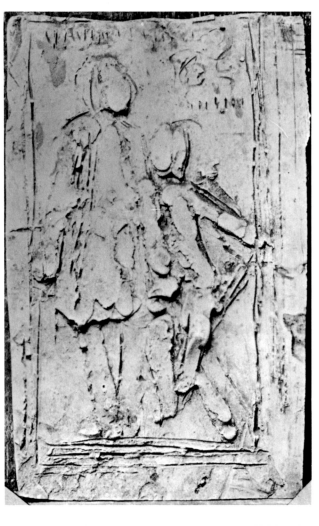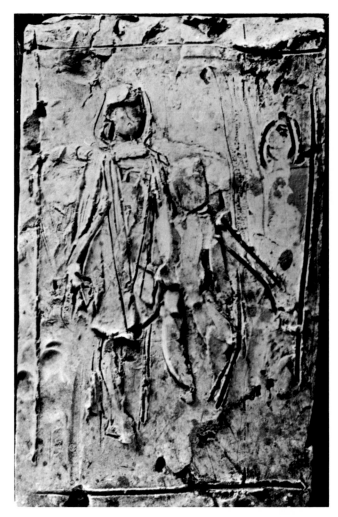
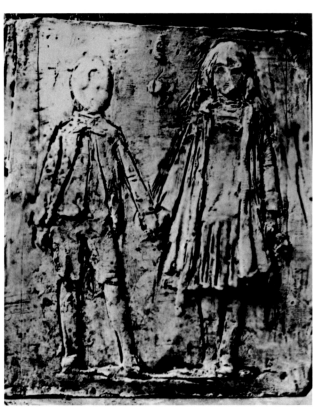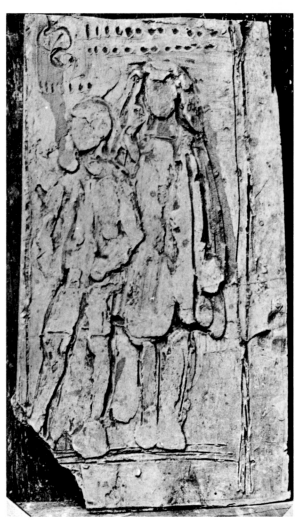

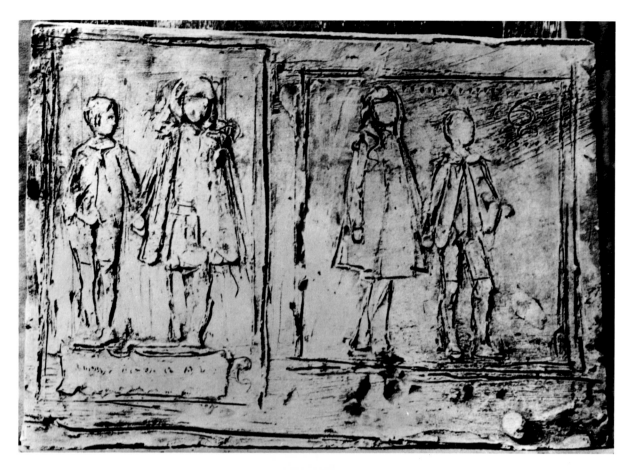

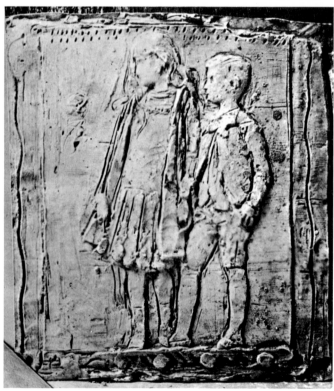

Fig. 16 (opposite, above left). AUGUSTUS SAINT-GAUDENS, *The Children of Jacob H. Schiff*, clay sketch, about 1884, destroyed; photograph (Hanover, New Hampshire, Dartmouth College Library).

Fig. 17 (opposite, above right). AUGUSTUS SAINT-GAUDENS, *The Children of Jacob H. Schiff*, clay sketch, about 1884, destroyed; photograph (Hanover, New Hampshire, Dartmouth College Library).

Fig. 18 (opposite, below left). AUGUSTUS SAINT-GAUDENS, *The Children of Jacob H. Schiff*, clay sketch, about 1884, destroyed; photograph (Hanover, New Hampshire, Dartmouth College Library).

Fig. 19 (opposite, below right). AUGUSTUS SAINT-GAUDENS, *The Children of Jacob H. Schiff*, clay sketch, about 1884, destroyed; photograph (Hanover, New Hampshire, Dartmouth College Library).

Fig. 20 (above). AUGUSTUS SAINT-GAUDENS, *The Children of Jacob H. Schiff*, clay sketches, about 1884, destroyed; photograph (Hanover, New Hampshire, Dartmouth College Library).

Fig. 21 (left). AUGUSTUS SAINT-GAUDENS, *The Children of Jacob H. Schiff*, clay sketch, about 1884, destroyed; photograph (Hanover, New Hampshire, Dartmouth College Library).

According to Homer Saint-Gaudens, his father made thirty-six sketches, each two feet high, for the McCosh memorial (fig. 22).[13] Though he always showed the figure in a standing position, he experimented with a number of different conceptions of it. The chief variations were in the hands (figs. 23–26): both hands clasped in front; both gesturing; one resting on a pedestal and one gesturing; the left hand resting on a pedestal, the right hand holding some papers at waist level; the right hand holding the papers now lowered. Saint-Gaudens's quest in all the details (of which these are just a few) seems to have been whether to show McCosh in the act of speaking or in a moment of contemplation. The final version portrays him as a dignified and imposing man, gesturing with his right hand as he prepares to speak or has just finished speaking. The figure would be laudable in another's oeuvre, but the work is not a masterpiece by Saint-Gaudens stan-

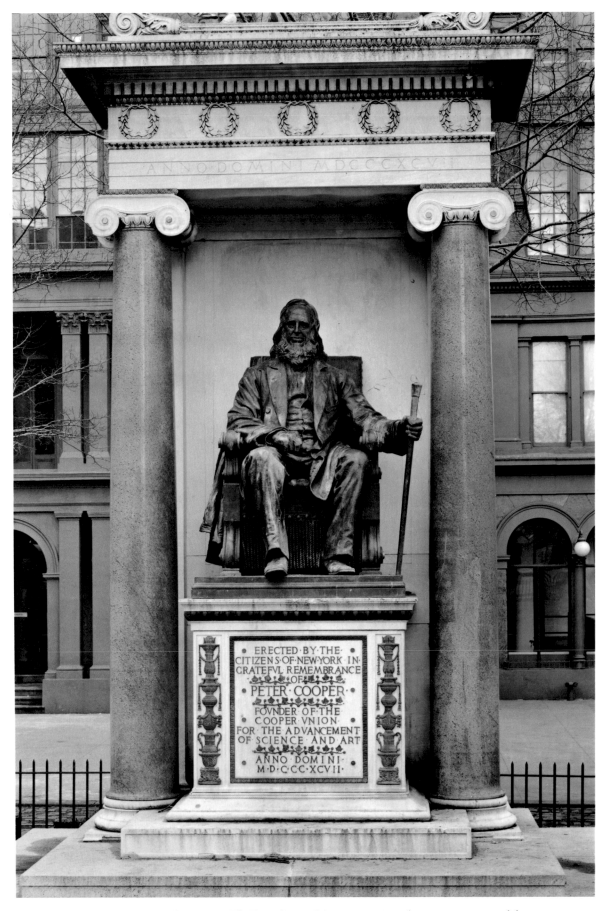

Fig. 27. AUGUSTUS SAINT-GAUDENS, *The Peter Cooper Monument*, 1894, bronze statue, over life-size; stone pedestal and marble canopy designed by Stanford White (New York City, Cooper Square Park).

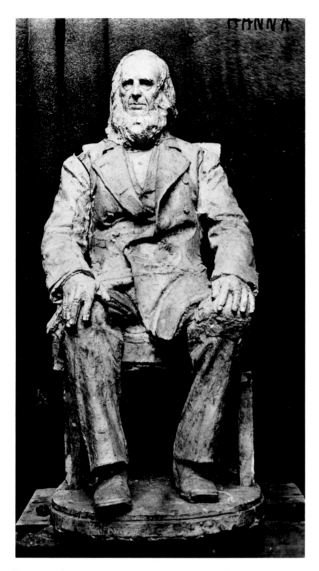

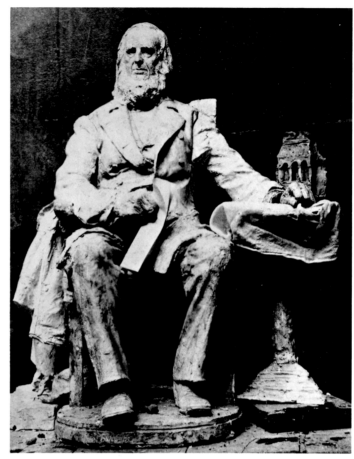

Fig. 28. AUGUSTUS SAINT-GAUDENS, *The Peter Cooper Monument*, clay sketch, about 1890, destroyed; photograph (Hanover, New Hampshire, Dartmouth College Library).

Fig. 29. AUGUSTUS SAINT-GAUDENS, *The Peter Cooper Monument*, clay sketch, about 1890, destroyed; photograph (Hanover, New Hampshire, Dartmouth College Library).

dards. It imparts to a viewer no real sense of emotion or excitement, perhaps because the sculptor overworked the theme to such an extent that he destroyed what energy it might otherwise have had.

For the monument to Peter Cooper (fig. 27), Saint-Gaudens again labored over the positioning of the figure. Homer Saint-Gaudens wrote that his father made up to twenty-seven sketches of it, each with a different composition.[14] From the beginning, Saint-Gaudens intended the statue to be of a seated figure. The primary variations in the sketches have to do with the accoutrements: Cooper alone, a hand on each knee (fig. 28); Cooper, holding a paper with one hand, with what may be a fragment of an architectural model on a table beside him (fig. 29). In the final version the table was dispensed with, probably because it detracted from the emphasis Saint-Gaudens wanted to direct to the figure. The sculptor must have been especially interested in doing justice to the man who had founded the tuition-free Cooper Union, for it was there that he had obtained his first education in art. By showing Cooper without attributes, Saint-Gaudens depicted not the professional man but the philanthropist.

After Saint-Gaudens had decided on the presentation of a work, his next step was a fairly routine one: to enlarge the sculpture in plaster so that it could be carved into marble or cast in bronze. For the attire of the figure in some of his works, such as that of Christ for the Phillips Brooks monument, he would drape it

Fig. 30 (left). Arrangement of draperies for the figure of Christ, study for *The Phillips Brooks Monument*, about 1907; photograph (Hanover, New Hampshire, Dartmouth College Library).

Fig. 31 (opposite, above left). AUGUSTUS SAINT-GAUDENS, *Frederick Ferris Thompson*, 1905, bronze relief, 63 in. × 38¾ in. (Williamstown, Massachusetts, Williams College, Center for Development Economics, St. Anthony Hall).

Fig. 32 (opposite, above right). Frederick Ferris Thompson, photograph (Hanover, New Hampshire, Dartmouth College Library).

Fig. 33 (opposite, below). Frederick Ferris Thompson at leisure, photograph (Hanover, New Hampshire, Dartmouth College Library).

with actual cloth, which he arranged according to how he wished it to fall (fig. 30), thus facilitating his modeling of the folds in his studies.[15] Occasionally, by pouring plaster over the fabric, he would actually incorporate the drapery into the model.

Before executing a memorial commission—the relief portrait of Frederick Ferris Thompson (figs. 31–33), for example—in order to acquaint himself with a sense of the subject's personality Saint-Gaudens would obtain as many photographs of him as possible from his relatives and friends.

An innovative use of photography, and one Saint-Gaudens used with increasing frequency as his career developed, was to have photographs taken of a work in progress and then enlarged so that he could estimate if his proportions were correct. He had photographs of the groups that were to be placed in front of the

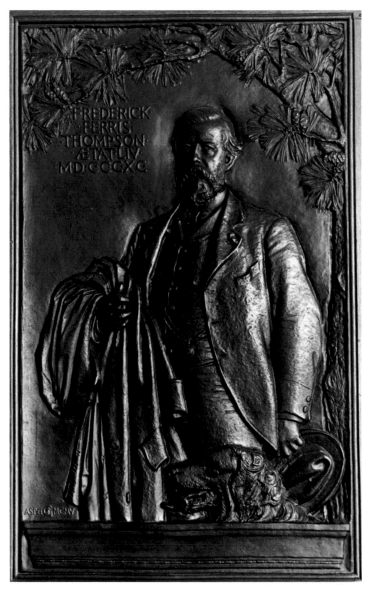

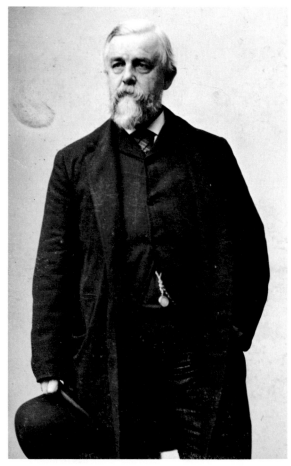

Fig. 34 (opposite, above). Painted reproduction of the Boston Public Library figures, used by Saint-Gaudens to plot the size of the group in relation to the setting; photograph (*The Reminiscences of Augustus Saint-Gaudens* 2, p. 304).

Fig. 35 (opposite, below). AUGUSTUS SAINT-GAUDENS, clay model, destroyed, of the square in Dublin in which *The Charles Stewart Parnell Monument* was placed; photograph (New York City, Collection of the American Academy and Institute of Arts and Letters).

Copley Square entrance of the Boston Public Library blown up and put on a pedestal in front of the building so that he could measure their scale (fig. 34).

In response to a suggestion in a letter from White, Saint-Gaudens used a variation of that technique. White, who was differing with him regarding the proper size of the *Farragut* statue, wrote: "My feeling would be to *lower it by all means*. I think the figure would be in better proportion to the pedestal. . . . But that is a matter for you to decide, and you can settle it very easily by having Louis [Saint-Gaudens] make a Farragut eight feet two inches in paper, and seeing the effect. With the paper pedestal already made that would be near enough to judge."[16] The height of the final statue was lowered from ten feet to just over eight, showing that, as usual, the two men were always ready to defer to each other's judgment in their search for perfection. Saint-Gaudens used a similar trick in order to judge how well a statue would fit its proposed site. A clay model he made of the square in which the Parnell monument was to be installed can be seen in a photograph (fig. 35).

As far as the actual carving and casting of his works were concerned, Saint-Gaudens largely adhered to the nineteenth-century custom of keeping the creative and technical processes separate: craftsmen did his carving and foundry workers his casting. With his bronzes, since he was interested in experimenting with different colorations, he would insist on collaborating very closely with the founder so as to see that the color of the patinas was varied according to his specifications.[17]

Saint-Gaudens used many different foundries in turn, no doubt in an effort to compare the capabilities of each. He appears to have felt that French foundries were the best for some types of works, since the whole

Fig. 36 (opposite, left). Bernard Paul Ernest Saint-Gaudens, father of Augustus, photograph (Hanover, New Hampshire, Dartmouth College Library).

Fig. 37 (opposite, right). Mary McGuiness Saint-Gaudens, mother of Augustus, photograph (Hanover, New Hampshire, Dartmouth College Library).

process of exploiting the properties of bronze, largely overlooked after the Renaissance, had been resurrected in nineteenth-century France.

When Saint-Gaudens was not able to be present at the casting of one of his pieces, mistakes sometimes occurred. In at least two reductions of *The Puritan* that were cast by the Gruet Foundry in Paris, the Roman numeral V was omitted from the date 1887—causing it to appear as 1882—an error possibly made by Saint-Gaudens but probably by the foundry. The latter is more likely, for casts of Saint-Gaudens's works usually went directly from Paris to his dealers, Tiffany & Company in New York and Doll & Richards in Boston, and therefore he could not have caught the error in time to have had it rectified.

As Saint-Gaudens's fame grew, he enlisted the aid of greater numbers of studio assistants. It may have been one of them who caused misspellings to appear in the poem of Stevenson's that was featured on the master plaster of one version of his relief portrait. The words "through," which appears as "throuoh," and "follov," for "follow," were apparently not noticed by Saint-Gaudens before they were cast by a Paris foundry, for in view of his obsessive habit of making numerous adjustments, it is impossible to believe that he would not have corrected them.

SAINT-GAUDENS: HIS LIFE AND HIS WORK

Augustus Saint-Gaudens started life in humble surroundings. His father, Bernard (fig. 36), was a shoemaker who had been born in Aspet, a village at the foot of the Pyrenees near Saint-Gaudens, in the south-

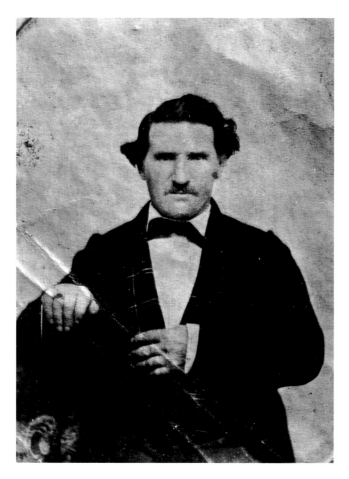 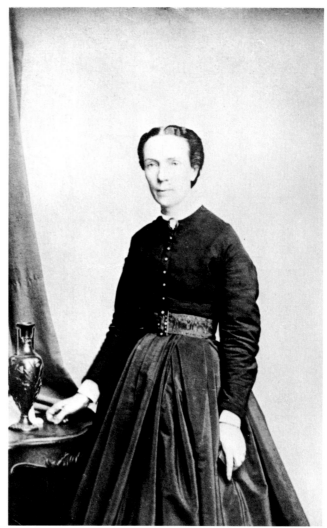

western part of France. Bernard, who had learned his trade from his brother Bertrand, traveled northward after completing his apprenticeship, and eventually arrived in England. He spent several years in London and then moved to Dublin. There he met Mary McGuiness (fig. 37), an Irish girl from County Langford who sewed bindings on slippers in the shop where he found employment. Bernard and Mary were married in 1841 and stayed in Dublin for seven years. Their first two sons lived only a short time: George, just over six years; Louis, only a few days. Their third son was born on March 1, 1848, and was christened Augustus Louis, in memory of his dead brother. (When the Saint-Gaudenses also named their fifth son Louis, Augustus stopped using his second name.)

The year 1848 was not the most fortuitous time to come into the world. With the potato famine spreading all through Ireland, conditions were so bad that Bernard determined to seek a better life for his family in the New World. In August, the Saint-Gaudenses departed for America with their five-month-old son. They landed in Boston, where Mary and small Augustus stayed with friends while Bernard went to New York to find work. Six weeks later, he sent for his family, having found a niche for them in a Franco-American community. Augustus and his younger brothers Andrew (1851–1891) and Louis (1854–1913) were therefore reared in a household where French and English were spoken with equal fluency. In the New York of that era there was a tremendous vogue for everything French: when Bernard, an astute and enterprising man, hung out his shingle, he took full advantage of his Gallic background by inscribing on it the legend "French Ladies' Boots and Shoes." He made not sturdy work boots but shoes and boots for both ladies and gentlemen, and he soon attracted a clientele that included members of the Astor and Belmont families

Fig. 38 (left). Augustus Saint-Gaudens, *John Tuffs*, about 1861, shell cameo, 1¾ in. × 1⁷⁄₁₆ in. (private collection).

Fig. 39 (opposite, left). Daniel Huntington, *Anna Watson Stuart*, after 1861, oil on canvas, 50 in. × 40 in. (New York City, The Metropolitan Museum of Art, Gift of Mrs. Denny Brereton, 1943).

Fig. 40 (opposite, right). Augustus Saint-Gaudens at a cameo lathe, photograph (New York City, Collection of the American Academy and Institute of Arts and Letters).

as well as Edwin D. Morgan and John A. Dix, both to be governors of New York and influential in helping to foster Augustus's career.

The Saint-Gaudens children all had artistic leanings: Andrew was later to work in a porcelain factory in Limoges; Louis became a sculptor who often worked with Augustus. Augustus, at the age of thirteen, had received an elementary-school education when Bernard discussed with him the need to prepare himself to earn his living. The boy expressed an interest in doing something that would help him to become an artist, which was his life's ambition, and Bernard arranged to have him apprenticed to Louis Avet, a French emigré and one of the first stone-cameo cutters in America.

That the young Saint-Gaudens worked with his hands conforms to a pattern. Many French sculptors were the sons of men who if not themselves sculptors were nevertheless occupied in trades that required a skillful touch, often as artisans—masons, plasterers, stonecutters, woodcarvers, jewelers, chasers, or blacksmiths.[18] The pattern was brought to the New World by immigrants from several countries, though to a lesser degree. Erastus Dow Palmer briefly followed in his carpenter father's footsteps. The father of Charles Grafly (1862–1929) had worked as a blacksmith, and Frank Edwin Elwell (1858–1922) was reared by his blacksmith grandfather. Other sculptors, including John J. Boyle (1851–1917), born in New York of Irish parents, and Alexander Milne Calder (1846–1923), born in Scotland, were the sons of stonecutters; John Massey Rhind (1860–1936), also born in Scotland, was a third-generation sculptor whose father and brother worked as decorative sculptors.

Saint-Gaudens's beginnings as an artist thus took the form of a traditional, almost prescribed course. In his role as an apprentice to Avet he prepared the stones for his master, cutting out and polishing the background, leaving the actual cameo part ready for Avet to carve. He also had the occasional opportunity to bring a cameo to completion himself. He made cameos in shell and in the more difficult medium of stone, and would then deliver the pieces by hand to Ball, Black & Company, Avet's chief employers, or to Tiffany & Company, for whom Avet also worked. He even earned wages, which were paid to his father.

Possibly Saint-Gaudens's earliest extant cameo is a portrait in shell of a John G. Tuffs (fig. 38), probably a commissioned piece that came into Avet's studio and that he allowed his apprentice to work on. Presum-

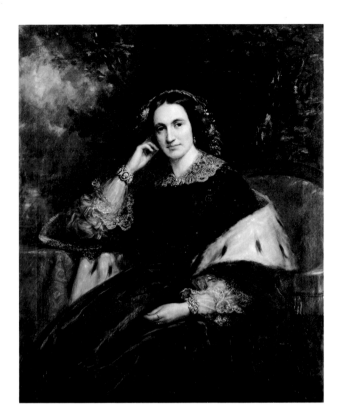

ably done from a photograph, since it was made for Tuffs's widow shortly after her husband's death, it is a full-face portrait, a most difficult view to achieve in relief form. It may have been an assignment imposed on the young Saint-Gaudens by his master. The boy would have known how great a challenge he had been given, but he probably welcomed it as an opportunity to prove himself; never in his life was he to harbor any doubts as to his ability to do whatever he set his hand to. He accomplished his assignment with a surprising degree of success, especially in his causing the wisps of hair on the right side of the head to stand out against the background.

During his time with Avet, Saint-Gaudens worked on a commission for Joseph Stuart, member of a New York banking family: a bracelet made up of six shell-cameo portraits—of Stuart, his wife, and each of his four children—which Stuart's wife, Anna, wears in the portrait Daniel Huntington painted of her (fig. 39). According to a Stuart family tradition, Saint-Gaudens was also responsible for a second family bracelet, a pair of earrings, and a brooch (after 1861, private collection). The Stuart cameos, in handsome settings and more proficiently executed than is the Tuffs portrait, demonstrate Saint-Gaudens's growing expertise. A tradition in the Sonntag family has it that Saint-Gaudens was the maker of a cameo-portrait pin (about 1864, private collection) of landscape painter William L. Sonntag of New York City. Avet's initials are cut into the obverse, and his signature and address are recorded on the reverse, but that merely bears out the theory that the apprentice worked on his master's commissions under his tutelage.

Avet, a stern taskmaster and a man of choleric temper, alternated between fits of rage at his apprentice and acts of almost paternal kindness. It was during one of his tantrums, in 1864, that he dismissed the young Saint-Gaudens for neglecting to sweep up some crumbs he had dropped on the floor while having his lunch. Half an hour later, Avet asked him to return, promising to increase his wages by five dollars a week if he would do so. Saint-Gaudens refused to be mollified. After three years of labor in often tempestuous circumstances he left, but he took with him the knowledge that he was capable of hard work to exacting standards. Though he afterward described his years with Avet as "miserable slavery," he recognized that during them he had acquired a discipline that was of everlasting benefit to his career.

He next found employment with Jules Le Brethon, another French emigré cameo cutter. Le Brethon

specialized in large shell cameos, which required less skill to execute than did those of stone. Though Saint-Gaudens, then sixteen years old, considered that he was lowering himself by reverting to a technique he had already thoroughly mastered under Avet, he enjoyed a more pleasant relationship with his even-tempered new master, who allowed him full access to his unused stone-cameo lathe (fig. 40) and even gave him instruction in modeling, thus introducing the boy to a means of expression that would absorb him for the rest of his life.

Saint-Gaudens's artistic aspirations increased along with his skill. Not content with being a mere craftsman, he was determined to obtain the formal education he would require before he could be considered an artist. He continued to work for Le Brethon during the day, but by night he began to pursue his studies; as early as 1864, apparently, he enrolled for a few months at the National Academy of Design.[19] During the school years of 1864/65 and 1865/66 he attended the drawing from life class at the Cooper Union for the Advancement of Science and Art.[20] The school, which had been founded in 1859 to provide a free education for members of the working class, had only two hundred art students among its total enrollment of two thousand students.[21] Saint-Gaudens's growing ambition combined with his new opportunity to learn caused him to put forth a tremendous effort. As he later said, "With such an incentive I became a terrific worker, toiling every night until eleven o'clock after the class was over, in the conviction that in me another heaven-born genius had been given to the world. I can remember thinking in public conveyances, that if the men standing on the platform around me could realize how great a genius was rubbing elbows with them in the quiet-looking boy by their side, they would be profoundly impressed. Indeed I became so exhausted with the confining work of cameo-cutting by day and drawing at night that, in the morning, mother literally dragged me out of bed."[22] In April 1866 Saint-Gaudens returned to the National Academy of Design, where he enrolled in the antique-school drawing class, reenrolling in October 1866; in November he also entered the life-school class, where he had his first opportunity to draw from the nude.[23] He was proving to be a "terrific worker" indeed.

Among the first portraits of classical subjects Saint-Gaudens did during his apprenticeship years was a

 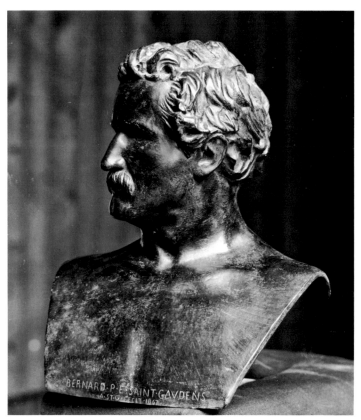

cameo of Hercules (fig. 41), which he signed with his initials. The piece displays the bulk and strength appropriate to Hercules within a remarkably small space—little more than an inch in diameter. Clearly delineated musculature conveys the neck's thickness, the modeling of the face is well handled, and the curly hair and beard are a fine contrast to the smoothness of the flesh. Saint-Gaudens, who has shown the head turned toward what is probably the upper part of a flexed arm, may have been copying from an antique cast. Though the result is not entirely successful, it does demonstrate his interest in expanding his repertoire of compositional design.

Saint-Gaudens put his training in drawing to use in several pencil sketches and portraits of members of his family, no doubt because they were accessible and willing sitters. One of the portraits is a drawing of his mother, executed in 1867 (fig. 42). Rendered with strong shadows and in great detail, it represents in three-quarter profile a somber, melancholic woman. (Her son, much later in his life, described her bequest to him as the "triste" undertone in his soul that came from his sweet Irish mother.) The drawing was greatly cherished by the artist, who called it "perhaps the possession I treasured most in the world." It and several other of Saint-Gaudens's drawings of members of his family were destroyed many years later in the fire that consumed his New Hampshire studio. A drawing of his father, shown in profile, gives an impression of a man of commanding personality and self-possession (Cornish, New Hampshire, Saint-Gaudens National Historic Site); a bust of Bernard (fig. 43) was probably done in plaster in 1867 and cast sometime later, for in 1867 Saint-Gaudens had not yet had any of his work cast in bronze. (Saint-Gaudens also did a self portrait, that obligatory exercise for students too poor to afford a professional model, but not until after he arrived in Paris.)

After six years devoted to mastering the art of cameo cutting and to attending drawing classes, Saint-Gaudens must have felt that the moment had come to start out boldly on his quest for an artistic career. In February 1867, ostensibly to see the Exposition Universelle, he departed for Paris. He arrived with a hundred dollars his father had saved for him out of his wages and a hundred gold francs that Le Brethon had given him to pay for a trip to Bernard's village in France. The true reason for the European voyage was

evidently Saint-Gaudens's keen desire to become a student at the École des Beaux-Arts: he later reported that a day or two after he got to Paris he sought admission to the École. He also looked for a job with a cameo cutter, which he soon found with an Italian jeweler named Lupi.

The Exposition Universelle of 1867 was undoubtedly a revelation to Saint-Gaudens, for there he had the opportunity to see several sculptures by Paul Dubois (1829–1905), a member of the group that came to be known as the néo-florentins. Dubois was exhibiting four pieces: the marble statue *Narcisse* (fig. 97); two bronze statues, *Saint Jean enfant* and *Chanteur florentin au xve siècle* (fig. 95); and a plaster group titled *La Vierge et l'Enfant Jésus*. The enduring effect of Dubois's then burgeoning style on Saint-Gaudens's imagination can be seen in several works he would execute. As he was to write: "The first of his sculpture I remember was the little 'St. John the Baptist,' which at the long-past time it was exhibited seemed extraordinary to me. . . . Then came his 'Chanteur Florentin,' which still remains a lovely masterpiece."[24]

Saint-Gaudens originally planned to stay in Paris about nine months, the longest period his hundred dollars could be expected to cover. He lived for a time at the home of his father's brother François, intending to maintain the same sort of schedule he had observed in New York: going to school in the mornings and evenings to further his education and carving cameos in the afternoon to earn his keep. When he learned that entry into classes at the École required a formal application through the American Consulate—a request that would require about nine months to process—he lost no time in pursuing other avenues of instruction.

The École Gratuite de Dessin, popularly known as the Petite École, was founded in the eighteenth century to provide instruction in mathematics and drawing to young workingmen, an early French counterpart

Fig. 44. AUGUSTUS SAINT-GAUDENS, Studies of
Greek costume from Saint-Gaudens's student
sketch book, about 1868, destroyed; photograph
(Hanover, New Hampshire, Dartmouth College
Library).

to New York's Cooper Union. During the mid-nineteenth century—roughly from 1843 to 1862—the
school's enlarging enrollment reflected its expanding instruction: the addition of courses in modeling and
ornamental design to those already offered in anatomy and drawing from nature and from casts. The
school's principal commitment was to train ornamental sculptors, but it attracted a fair share of fine-arts
students in painting and sculpture, the number of sculpture students tripling during the expansionary peri-
od. Within two months Saint-Gaudens had been accepted at the Petite École, where his classes included
sculptural composition and execution with Georges Jacquot (1794–1874) and drawing from casts, from life,
and from nature with Alexandre Laemelin (1813–1871). The young sculptor's participation in the decora-
tive-arts projects encouraged by all the school's faculties was an experience that would be of immense bene-
fit to him in the early years of his career in America.

Saint-Gaudens wrote later of one of the Petite École's life classes: "We worked in a stuffy, overcrowded,
absolutely unventilated theater, with two rows of students, perhaps twenty-five in each row, seated in
a semi-circle before the model who stood against the wall. Behind those who drew were about fifteen
sculptors. . . . Here I modeled my first figures from the nude, and laid an excellent foundation for the
future."[25]

After spending just over six months at the Petite École (fig. 44), where he won two first-prize medals for
proficiency in sculpture,[26] Saint-Gaudens entered the studio of François Jouffroy (1806–1882), a professor
of sculpture at the École des Beaux-Arts. Jouffroy's own work was of an academic nature, but because he
trained his students well (several of them went on to win the coveted Prix de Rome), his classes were well
attended. Royal Cortissoz wrote of Jouffroy's effect on Saint-Gaudens: "[He was] a safe master, who, for all

his classicism, was nevertheless near enough to such men as Rude to have seen, and turned away from, the quicksands of commonplace in which the conventional classicist is sooner or later lost. He was enough of an individualist in his art to keep Saint-Gaudens from falling into routine, and enough of an academician to nourish in his pupil the sense of measure which might have slumbered if he had fallen into the hands of a more naturalistic teacher. He set him on the right path, helped him to develop his technique along good lines, and did not for a moment attempt to repress or warp his ideas."[27]

The wily Saint-Gaudens had selected Jouffroy over the two other professors of sculpture, Augustin-Alexandre Dumont (1801–1884) and Pierre-Jules Cavelier (1814–1894), for Jouffroy's atelier was, as he put it, "the triumphant one of the Beaux-Arts, his class capturing, as a rule, most of the prizes."[28] Saint-Gaudens brought his drawings to his chosen professor and was admitted to his class, even though he was not yet enrolled in the school. He later confessed that he had by no means been a brilliant pupil, but had continued to submit drawings until his teacher allowed him to enter the *concours des places* held each year in March and October, a series of examinations that students were required to pass before they could be officially admitted to the École and that assigned them their standing in the class of entry. Finally, in March 1868, on Jouffroy's recommendation, Saint-Gaudens was accepted as a student at the École des Beaux-Arts.[29] He was then eligible to participate in its many competitions. Though he did not distinguish himself as a student, he found that "the steadiness of Jouffroy's compliments consoled me for my inevitable failures in direct competition. These failures did not for a moment discourage me, however, or create any doubts in my mind as to my assured superiority."[30]

Seeing his hard-earned money dissipated by his profligate uncle, Saint-Gaudens moved from François's house to a series of lodgings, including a short stay at the studio of the American sculptor and critic Truman Howe Bartlett, where he slept on a mattress on the floor. Of his Paris days Saint-Gaudens later recalled: "My life in the atelier was the regular life of a student, with most of its enthusiasms and disheartenings. But my ambition was of such a soaring nature and I was so tremendously austere, that I had the deepest scorn for the ordinary amusements of the light operas, balls, and what not."[31] Through the diligence of his efforts in Lupi's employ and because of the monastic routine he purportedly followed he was able to remain in Paris from 1867 until September 1870, even taking occasional excursions in France and to Switzerland with his friends Alfred Garnier and Albert Dammouse, also École sculpture students. When the Franco-Prussian War erupted in July 1870, Saint-Gaudens left Paris to spend the summer in Lieusaint, close enough to the capital for him to go back and forth. In September, he went to Limoges to see his brother Andrew, who was working there in a porcelain factory.

Because the French heritage that was his father's legacy would have put him on common ground with the French people, Saint-Gaudens had probably been very much at home in Paris. He wanted to enlist in

the army to fight for the French cause, a desire that also reflects the gratitude he must have felt for the profound influence that France and her sculptors and artists had exerted on him during his three and a half years there; with more and more of his French friends being called to the fray, he too wanted to be on the march. His mother, worried for his safety, was pressing him to return to America, but he neither acceded to her pleas nor did he enlist. Perhaps out of deference to her wishes, he decided not to join the army but to get on with his studies.

The most important among all the prizes and awards available to the French students at the École des Beaux-Arts was the Prix de Rome, which was awarded in each of the various disciplines, including painting, sculpture, and architecture. Each winner was given the opportunity to do advanced studies during a four-year sojourn in Italy and was given a small stipend to help defray his expenses.[32] No foreigner was allowed to enter the competition, but it seems likely that Saint-Gaudens wanted to follow in the tradition of the best of the French sculptors, for he left Limoges after only a few months and set off for Rome, expecting again to find work to support his continuing education while he immersed himself in the glories of the Eternal City. He met up with the Portuguese sculptor António Soares dos Reis (1847–1889), a fellow student from the École, and the two decided to share a studio in the gardens of the Palazzo Barberini. Because as foreigners they were not eligible to receive formal training at the French Academy in Rome, they had to study on their own. Following an assignment prescribed at one of the more advanced stages of training at the French Academy, each young man set about to produce a life-size statue. Saint-Gaudens chose Hiawatha as his subject.

Hiawatha (fig. 45), a work Saint-Gaudens vowed would "astonish the world," was the kind of statue he intended eventually to have put into marble. He may have hoped to send a plaster cast of it back to France to exhibit at a Paris Salon; further, he saw it as a piece to get before the American public, whereby he "would amaze the world and settle [his] future."[33] In taking as his subject Longfellow's Indian hero, he was possibly inspired by the poet's visit to Rome, which had just concluded.

Indian subjects, of great appeal in both Europe and the United States, were a favored theme to many American sculptors, including Thomas Crawford, with his *Indian Chief* (fig. 46), and John Quincy Adams Ward, who had portrayed them often, most notably in his *Indian Hunter* (1866, New York City, Central Park). Saint-Gaudens had seen a full-size plaster of Ward's statue in Snedicor's shop on Broadway in 1865, and described it as one of two "lasting aesthetic impressions" he had received at that time; he may also have

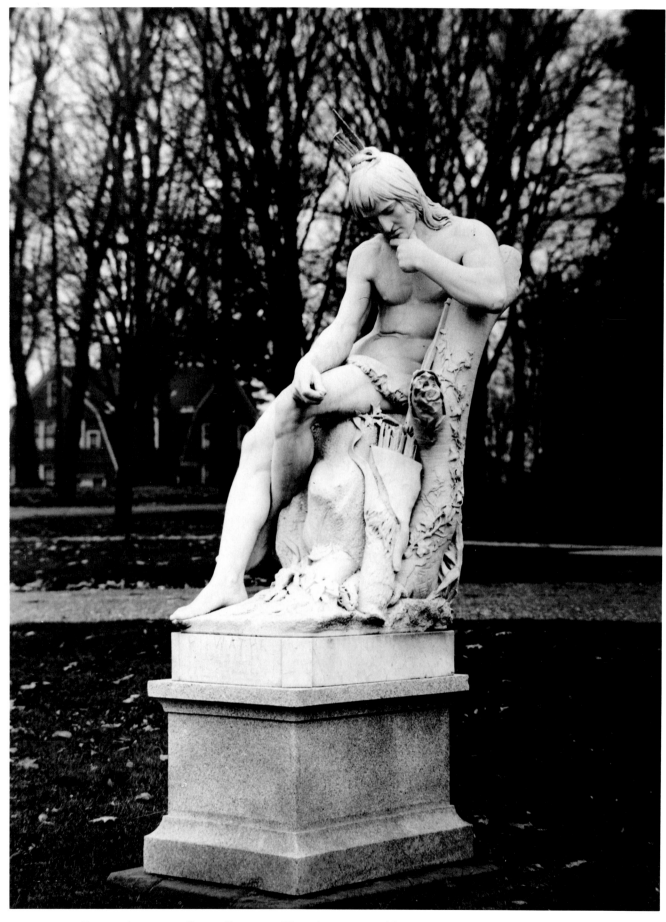

Fig. 45. AUGUSTUS SAINT-GAUDENS, *Hiawatha*, 1872, marble statue, life-size (private collection).

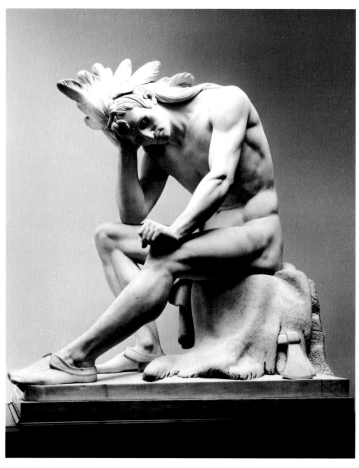

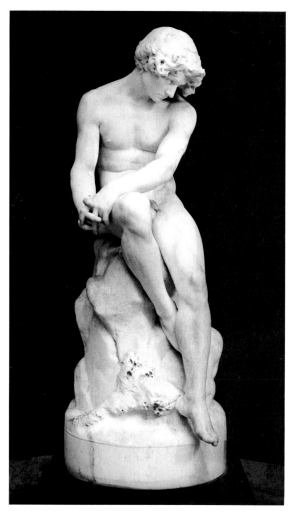

Fig. 46. Thomas Crawford, *The Indian Chief Contemplating the Progress of Civilization*, 1856, marble statue, h. 55 in. (New York City, Courtesy of The New-York Historical Society).

Fig. 47. António Soares dos Reis, *The Exile*, 1872, marble statue, h. 67 in. (Pôrto, Portugal, Museu Nacional de Soares dos Reis).

seen the finished bronze in Paris, for it was exhibited there at the Exposition Universelle in 1867. Of Crawford's figure, William Gerdts has written: "[It] is only superficially an Indian; both the square-jawed face and the heroic muscularity seem directly descended from classical prototypes."[34]

To a certain degree that description could apply to *Hiawatha*, though it is less severely classical in execution and speaks not so much of the influence of Crawford as that of Michelangelo, whose work the young sculptor was undoubtedly acquainting himself with in Rome. Saint-Gaudens nevertheless may have seen a cast of Crawford's figure: a large number of plasters were acquired by the Board of Commissioners of the Central Park after Crawford's death and, in 1861, were placed on view in a building then in the park; presumably *The Indian Chief* was among them, for it was one of Crawford's better-known figures.[35] Though the poses of the two Indians are not unlike and the attributes are of necessity similar (Saint-Gaudens uses a bow and arrow; Crawford, a tomahawk), the works reveal different intentions on the part of their creators. *The Indian Chief* is clearly metaphorical and elegiac, for what Crawford has represented is not just a dying Indian chief but the end of the realm of the American Indian; Saint-Gaudens, who was working out a three-dimensional muscular form, has produced a simple, introspective figure into which no further significance can be read.

Soares dos Reis sculpted for his full-figure exercise a statue called *The Exile* (fig. 47), which is said to have been inspired by a poem written by the sixteenth-century Portuguese poet Camoens (1524–1580),

Fig. 48 (opposite, left). AUGUSTUS SAINT-GAUDENS, *Belle Gibbs*, 1872, marble bust, h. 26¾ in. (Texas, Museum of Fine Arts, Houston, Gift of the Family of J. S. Cullinan).

Fig. 49 (opposite, right). AUGUSTUS SAINT-GAUDENS, *Florence Gibbs*, 1872, marble bust, h. 27 in. (California, The Los Angeles County Museum of Art, Los Angeles County Funds).

who was himself an exile.[36] The statues of the two young men have more than just a literary origin in common; the positioning of the legs and the manner in which the arms are crossed over them are also akin. They also share a quality of brooding and isolation; that each contains a personal reference can be readily inferred. Saint-Gaudens was later to say of *The Exile*: "Its melancholy was in complete accord with Soares' own nature"; of *Hiawatha*, "'pondering, musing in the forest, on the welfare of his people' . . . [it] accorded with the profound state of my mind, pondering, musing on my own ponderous efforts."[37]

Saint-Gaudens again supported himself in Rome by cutting cameos for a dealer named Rossi, but his routine was by no means as Spartan as that he recorded of his Paris days. He began to go out in society, enlarging his circle of friends, often at parties given by Mrs. Thomas Ridgeway Gould, wife of the neoclassical American sculptor and well known to Americans in Rome. He also attended concerts and was an habitué of the Caffè Greco, on the Via Condotti, famed meeting place for an international circle of artists and writers. In Italy, as in France, he went on walking trips: in the fall of 1871 he traveled to Naples with two friends, George Dubois, a landscape painter he had known in Paris, and Ernest Mayor, a Swiss architect. He could not have lost any time in exploring all the artistic riches that surrounded him. The great treasures of the Vatican were probably foremost on his list, since he is known to have made copies of busts in the Vatican collections. He renewed his acquaintance with Marius-Jean-Antonin Mercié (1845–1916), who had been a fellow-student in Jouffroy's atelier at the École and who, having won the École's Grand Prix in 1868, was then in Rome. The works Mercié was executing in Rome between 1869 and 1873 must have made a lasting impression on Saint-Gaudens, for their influence turns up later in his own work: the downward tilt of the head and the lowered eyes of Mercié's *David* (fig. 98) are evoked in the Vanderbilt mantelpiece caryatids (fig. 96); the profile and neck torsion of Mercié's figure of Fame in his *Gloria Victis* (fig. 139) are almost exactly those of Saint-Gaudens's *Diana* (fig. 140).

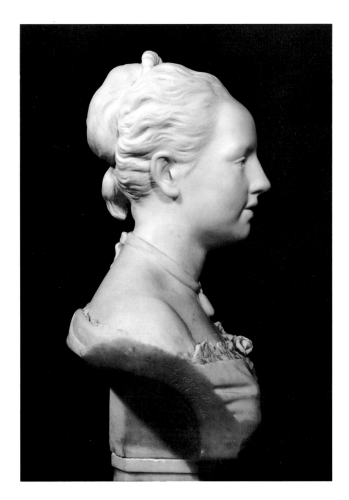 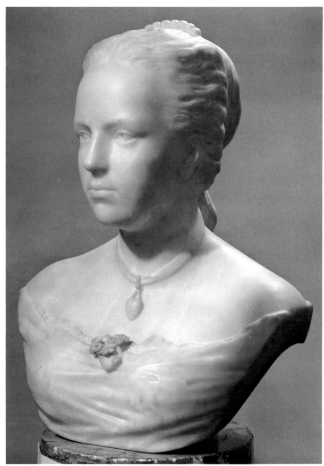

Saint-Gaudens and Soares dos Reis sometimes entertained friends in their studio. A guest at one of their parties was Eva Rohr, a singing student and sister of the Mrs. Tuffs for whom Saint-Gaudens had executed his first cameo. Eva, whose portrait bust Saint-Gaudens did during his first stay in Rome, apparently once contributed to the refreshments, for Saint-Gaudens returned to her two pie pans that he had decorated with portraits of John and Priscilla Alden, his first extant paintings. Though not particularly well done or in any way unusual, they are evidence that he had begun to paint, possibly in Paris, and are therefore of a certain interest. He is not known to have attended a painting class either at the Petite École or at the École des Beaux-Arts, and may have dabbled in oils either at the suggestion of some of his painter friends or while in their company.

In 1872 Saint-Gaudens had the good luck to be introduced to two wealthy Americans who were instrumental in launching him on his career. Montgomery Gibbs, a New York City lawyer who was traveling in Europe with his wife and two daughters, was brought to the studio in Saint-Gaudens's absence by a Reverend Mr. Nevin, an acquaintance in common. When Gibbs saw the model of the *Hiawatha*, he was so impressed that he decided to advance the money to have it cast in plaster. In return, Saint-Gaudens was to do portrait busts of the Gibbs daughters, Belle and Florence (figs. 48, 49).

The two young women sat for their portraits in Rome, but had to provide Saint-Gaudens with their photographs in order for him to complete the busts after their departure. Florence, the younger, wrote somewhat imperiously to Saint-Gaudens from Venice: "You are bound that my features including the purely *Grecian nose* shall go down to posterity in correct shape."[38] Despite her instructions, which probably reflected not only her own taste after all she had seen in Italy but her father's as well, Saint-Gaudens did not make the nose especially Greek. Instead, the features in both likenesses are faithfully and carefully rendered to life. Florence, whom the sculptor later confessed to having a soft spot for, communicates a

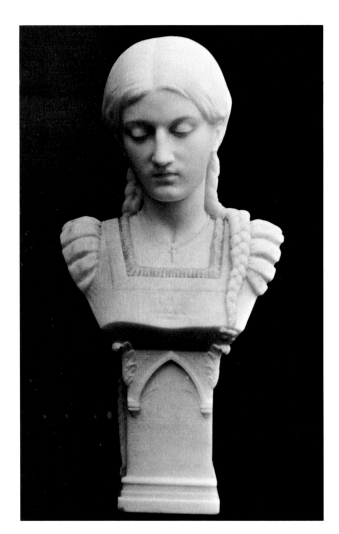

Fig. 50. Augustus Saint-Gaudens, *Eva Rohr*, 1872, marble bust, h. 18 in. (private collection).

forthright, self-possessed nature; Belle, her lips slightly parted, beguiles the viewer. It is difficult to imagine that the portraits of the two sisters, similarly dressed and coiffed, were not meant as companion pieces. The busts are unmistakably related to the portraiture of the late eighteenth century, that master period for the presentation not just of a subject's likeness but of his essential quality. The neo-rococo style of Carpeaux, at its height in the eighteen-sixties and early seventies, was surely known to Saint-Gaudens, as was probably the older sculpture of Augustin Pajou (1730–1809) and Jean-Antoine Houdon (1741–1828): the manner in which he has modeled the girls' hair, carefully delineating the waves swept close to their heads, recalls like treatment in works by Pajou; his handling of the girls' eyes is much like that in works by Houdon.

Eva Rohr's portrait bust (fig. 50), done about the same time, along with a cameo of her sister Hannah Rohr Tuffs, is a serene portrait of the young woman wearing her hair in braids and dressed as Marguerite in Gounod's opera *Faust*, possibly a role she was learning. On the pedestal is an inscription—an English translation of Marguerite's first words to Faust—which, though by no means an integral part of the actual portrait, may be the initial appearance in Saint-Gaudens's work of a device that was later to be one of his characteristics. Saint-Gaudens began work in the same period on copies of the busts of Dante and the young Emperor Augustus, which Gibbs had ordered. Gibbs also commissioned a cameo of Mary, Queen of Scots (fig. 51), the first of three Saint-Gaudens would do of that subject. Gibbs intended it as a present for his wife, and it had been his original reason for seeking out the young sculptor. The modeling of the lace edging on the collar that frames the queen's head and fills the background is so exceedingly delicate that it gives the illusion of translucence, a demonstration of the technical virtuosity Saint-Gaudens had by then achieved.

William Maxwell Evarts, a distinguished New York lawyer and political luminary, was also visiting Rome at the same time. Gibbs, who was a friend of his, wanted him to sit to Saint-Gaudens for a portrait, and introduced the young sculptor to him. He too became a frequent visitor to the studio and an enthusias-

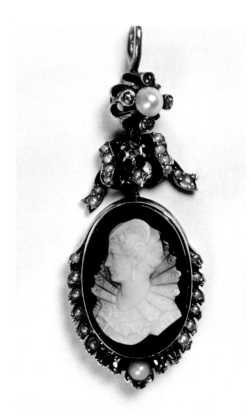

Fig. 51. AUGUSTUS SAINT-GAUDENS, *Mary, Queen of Scots Cameo*, Gibbs version, 1872, onyx cameo, ¾ in. × ½ in. (private collection).

tic patron, giving Saint-Gaudens commissions for various marble copies of ancient busts that included Cicero, Demosthenes, the *Psyche* of Naples, and the young Emperor Augustus. Copies of classical works were very popular among educated Americans, and though as copies they could show no invention on Saint-Gaudens's part, they at least brought in much-needed money. They also would have afforded him an opportunity to carve in marble—for which his experience with cameo cutting would have prepared him—though the preliminary blocking-out, and possibly even more of the work, may well have been done by a local artisan. Saint-Gaudens never exhibited those copies and none bears his signature, an indication that he saw the copies as having no value in the development of his own reputation.

In the summer of 1872, Saint-Gaudens fell prey to a bout of malaria, or, as it was then called, "Roman fever." When in September his condition had not improved, Gibbs provided him with the money to return home. He was probably ready to leave in any case: encouraged by the success of the commissions he had received from Gibbs and Evarts, and much surer of himself as a sculptor and as a man, he undoubtedly thought his work would attract numbers of patrons back in New York. He must also have felt that his period of training, both formal and self-directed, had come to a close—that he was ready to move on from busts to larger works, perhaps even the commission for a public monument. He left for New York from Liverpool, stopping in Paris on his way to renew old acquaintances. Finally, after an absence of five years, he walked in on his family unannounced and surrendered himself to a joyous reunion.

Back in New York and restored to health by his mother's care, he once more turned to cameo cutting in order to earn a living. His brother Louis, now a youth of eighteen, showed some artistic promise and expressed his wish to be a sculptor. Augustus started him off on the path he himself had followed by teaching him to cut cameos, and the two young men planned to return to Rome together. Pending that happy occasion, Augustus set about to find work in New York, and called on William Evarts, who had just moved into a

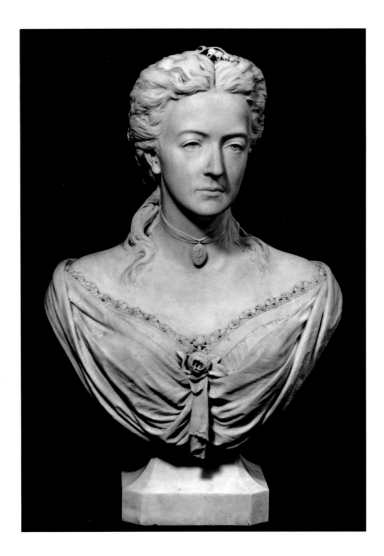

Fig. 52 (left). Augustus Saint-Gaudens, *Margaretta Willoughby Pierrepont* (Mrs. Edwards Pierrepont), 1874, marble bust, h. 27½ in. (Washington, D.C., National Museum of American Art, Smithsonian Institution, Gift of Mary Pierrepont Beckwith).

Fig. 53 (opposite). Augustus Saint-Gaudens, *William Maxwell Evarts*, 1874, marble bust, h. 23 in. (private collection).

new house on Fifth Avenue. Evarts had been very pleased with the copies of classical busts that Saint-Gaudens had done for him and arranged at last to find time to sit for his long-delayed portrait. Edwin W. Stoughton, Charles O'Conor, and Edwards Pierrepont, prosperous lawyer friends of Evarts, dropped in during the sittings and, impressed by what they saw evolving from the clay at the hands of the young sculptor, ordered portraits of themselves; Pierrepont also commissioned a portrait of his wife, Margaretta.

These basically realistic portraits of Saint-Gaudens's early career, created in New York and intended to be put into marble in Rome, are characterized by their quasi-neoclassical treatment. Saint-Gaudens portrayed his subjects either nude or clad in classical drapery, because that was still the vogue or because the sitter had requested it in order to evoke in his portrait classical associations that would ennoble him. Saint-Gaudens represented his female subjects in contemporary dress: the modish attire in the bust of Mrs. Pierrepont (fig. 52) is in marked contrast to the classical toga in which her husband is portrayed, though Mr. Pierrepont's mustache and bounteous muttonchops are distinctly anachronistic. The portrait bust of Stoughton (1873–74, Sarasota, Florida, The John and Mable Ringling Museum of Art) is not executed with any particular distinction; the undraped bust of O'Conor (1874, New York City, American Irish Historical Society) is noteworthy mostly for the deep-set eyes, their piercing gaze convincingly conveyed by sharply incised pupils that are actual holes bored into the stone. In general, these portraits are all well carved, sympathetic, and straightforward presentations, but, indistinguishable from most of the portrait busts then being created by other American sculptors, they show no trace of the unique quality of Saint-Gaudens's later work.

Perhaps the sole exception to that generality is the bust of William Evarts (fig. 53), which represents a major breakthrough in Saint-Gaudens's oeuvre. The bust's classical air is intensified by its herm base. The

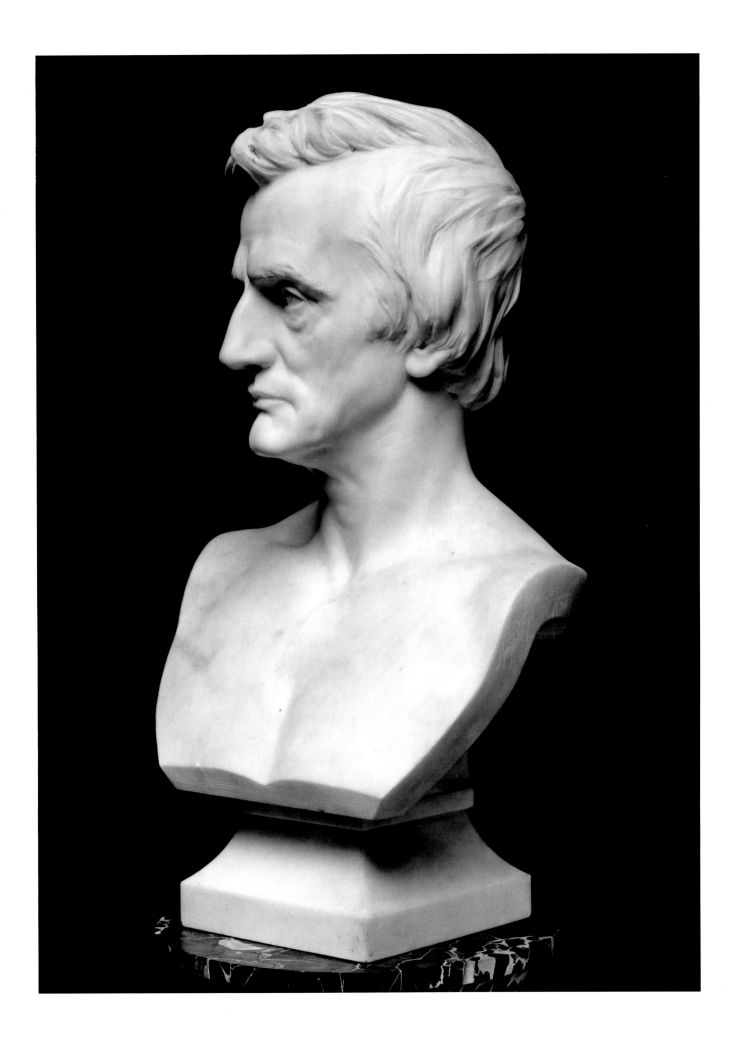

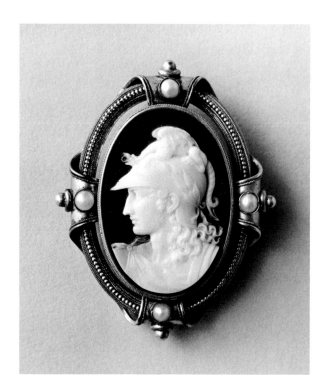

Fig. 54. AUGUSTUS SAINT-GAUDENS, *Youthful Mars*, about 1873, onyx cameo, 1 ½ in. × 1 in. (Cornish, New Hampshire, Saint-Gaudens National Historic Site, National Park Service, U.S. Department of the Interior).

sitter's powerful presence, evoked in realistically depicted features—sunken cheeks, aquiline nose, furrowed brows, and under-eye pouches—and a patrician turn of the head, infuses the piece with a vigor and authenticity that elevates it far above any other bust Saint-Gaudens executed during the early 1870s. Evarts could not have hoped for a more noble portrait. The work was of particular benefit to Saint-Gaudens's reputation because Evarts later lent it, no doubt at the sculptor's request, to the 1875 exhibition at the National Academy of Design in New York and to the Centennial Exhibition in Philadelphia in 1876, where it was widely admired.

Through his father and Le Brethon, both of them Freemasons, Saint-Gaudens was introduced to Levi H. Willard, who commissioned him to do a full-size statue for the grand staircase of a new Masonic temple then being built in New York. Since he could work on it just as easily in Rome as in New York, he decided to return to Italy, this time preceded by Louis, who had sailed for Liverpool a month earlier and was waiting for him in Rome. Saint-Gaudens had been home for only about a year.

Back in Rome, he found the studio empty that he and Soares dos Reis had shared, and he lost no time in renting it for himself. He was soon busily engaged on work that came his way: a second cameo portrait of Mary, Queen of Scots, this one commissioned in Rome in 1873 by Abigail Williams, an American painter, and differing from the Gibbs cameo only in its setting and in being a reversed image. At about the same time, Saint-Gaudens executed an exquisite cameo of *Youthful Mars* (fig. 54). A signed piece, it displays his increasing authority in modeling and cutting. He has shown the god in profile, treating him to classical features and attire (he wears an Athenian helmet). Saint-Gaudens continued to work on copies of classical busts for American patrons, and, in collaboration with sculptor Jonathan Scott Hartley (1845–1912), he produced a marble bust of Captain John Ericsson, apparently a commission from Stoughton. He also executed a historical portrait of Samuel Johnson.

Near the end of 1873, Edwin D. Morgan, a former governor of New York then visiting Rome, called on the son of his New York bootmaker and saw the plaster cast of *Hiawatha*. He immediately commissioned Saint-Gaudens to produce it in marble. That commission was the first major milestone in the young sculptor's career. It was a great honor, for Morgan was an important man in America. In addition, because a statue is a highly visible work—especially in a house frequented by many visitors, as Morgan's was—it was a means of focusing a great deal of attention on its creator.

In about 1870, Paul Dubois, the French néo-florentin whose work Saint-Gaudens had seen in his first

days in Paris at the Exposition Universelle and who became one of the sculptors he admired most among his contemporaries, had done the child Mozart playing his violin. His *Young Mozart*, which was widely distributed commercially, no doubt influenced Saint-Gaudens in his choice of the subject he described in a letter to Montgomery Gibbs before leaving Rome for America in 1872. In proposing to do a statue of the young Mozart, he probably had the idea that through that popular subject he, like Dubois, could make himself better known: "During the last four days I have made a small composition in which I have been very happy. I call it Mozart. I represent him as a boy about 12 years of age—just jumped up from his sleep seized his violin and is playing away vigorously as if he has just had a sudden inspiration—his hair is all mixed up and he has his legs muddled up in the sheets and [is] supposed to be seated on the corner of his bed."[39] During his second stay in Rome Saint-Gaudens began again to make sketches for the statue, though he apparently never finished it. Nor did he do final versions of several other sketches he started at the same time: "A Roman Slave holding the young Augustus on the top of a Pompeian column and crowning him with laurel"; "a little Greek girl . . . lying on a low Pompeian bed and kissing an infant."[40] Among the original portrait busts he did in Rome in that period was one of six-year-old Frederick C. Torrey, son of a railroad builder who was serving as United States consul at Leghorn. When he was in need of money, Saint-Gaudens turned again to his cameos, having "established himself as the most skillful cameo-engraver in Paris or Rome." Louis and he worked together, the beginning of a long collaboration between the two brothers and the first instance of Saint-Gaudens's willingness to impart his knowledge to younger men. One of their most successful joint commissions was a cameo for Edwin Stoughton, which Louis did under his brother's eye. It "brought the young men one hundred and fifty dollars, and was especially admired."[41]

What was occupying Saint-Gaudens's time more than anything else was his *Silence* (fig. 4). The work was a propitious one in his career. His second full-size statue, it gave him the opportunity to investigate an allegorical subject, this one apparently selected because silence is a virtue prized by Freemasons, who hold that more can be learned through listening than through speaking. Willard, his patron, was apparently not entirely pleased with the work, and Saint-Gaudens, responding some time later to a letter from John Quincy Adams Ward, who had seen the work in New York and had written to praise it, told of the modifications that he had been obliged to make: "I am satisfied with it only in having obtained as much as I did from the restrictions forced upon me in regard to making it. Had I had my own way completely I would have created an entirely different thing, with broad, heavy drapery instead of its being very fine. The left hand would

Fig. 55 (left). Augusta Homer, at the time of her engagement to Augustus Saint-Gaudens, 1874, photograph (Hanover, New Hampshire, Dartmouth College Library).

Fig. 56 (opposite, left). Pencil drawing of the James Gordon Bennett Cup for Schooners, from a letter from Thomas Moore to Homer Saint-Gaudens, February 16, 1910 (Hanover, New Hampshire, Dartmouth College Library).

Fig. 57 (opposite, right). AUGUSTUS SAINT-GAUDENS, The James Gordon Bennett Cup for Schooners, 1875, finial, un-located; photograph (Hanover, New Hampshire, Dartmouth College Library).

have crossed the body sustaining the drapery and would have been entirely concealed. The hands which are bad, particularly the right one, I have yet to work upon a great deal. . . . So I am still anxious to have you suspend judgment till you have seen the 'Injun' [*Hiawatha*] which I modeled in '71."[42]

Silence marks the first appearance in Saint-Gaudens's oeuvre of a figure that would reappear later which he described in a letter to Willard: "She has fine drapery over her body that gives a pleasing character, and a heavy kind of veil that covers her head, drooping over the face so that it throws the face in shadow and gives a strong appearance of mystery." Wayne Craven, in his *Sculpture in America*, describes *Silence* as "a new kind of personification," an imagery "freed of the hackneyed motifs of revival styles," that was "the prototype for the many allegorical and personifying maidens that were to follow in the next decades. They became abstract symbols of things Americans thought and felt and did, and they replaced the Nydias, the Medeas, and the Clyties. Augustus Saint-Gaudens played a leading role in the invention of this new kind of American sculptural imagery."[43]

In December 1873, at one of Mrs. Gould's receptions, Saint-Gaudens made the acquaintance of Augusta Homer (1848–1926; fig. 55), a Boston art student who was then living in Rome. She was partly deaf, a hereditary condition, but her slight handicap did not deter Saint-Gaudens from a swift courtship; the couple had an "understanding" within three months. Augusta came from a fine old family, and the match was perhaps not what her parents might have hoped for. But the two young people had much in common, beginning with their given names (they were even born in the same year), and artists were not entirely unknown to the Homer family: Winslow Homer was a distant cousin. Augusta returned to the United States in June 1874 with an engagement ring that her fiancé had made for her: the stone was his third cameo portrait of Mary, Queen of Scots.

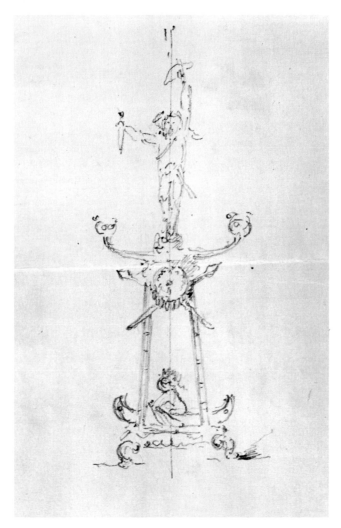

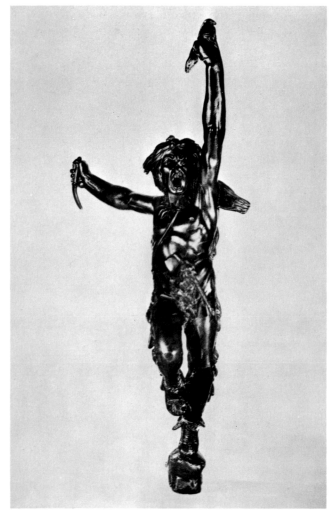

Saint-Gaudens left again for the United States in 1875. On a brief stopover in Paris, his worst fears were realized when he received in a letter from Louis in Rome the news that his mother was dead. Her loss crushed him, for the two of them had been especially close. In his own *Reminiscences*, written many years later, he recalled leaving her before that second trip to Rome: "The day of my departure was a sad one, for it was the last I saw of my mother when she stood weeping on the dock, and it seems as if I had a presentiment that it would be so."[44]

Back in New York, he shared a studio with the painter David Maitland Armstrong (1836–1918), whom he had met in Rome on his first sojourn in that city. Eager for work, he embarked on a series of decorative projects that came his way, and almost immediately began a sketch of Charles Sumner, United States senator from Massachusetts and famed advocate of the emancipation of the slave, for a commission being awarded by the city of Boston. The first of the decorative projects was the James Gordon Bennett Cup (fig. 56), which Bennett, commodore of the New York Yacht Club, was donating as a prize to the winner of a club schooner race. The cup's designer was Edward C. Moore of Tiffany & Company. Thomas Moore had known Saint-Gaudens at Cooper Union, and introduced him to his brother, who invited the young sculptor to help out with work being done at the Tiffany company. The Bennett "cup" was in the form of a candelabrum whose base was a figure of an American Indian wearing a feather headdress and paddling a canoe and whose finial was another Indian figure—this one open-mouthed, as if in full war cry, and running, a scalp in one hand, a knife in the other (fig. 57). Saint-Gaudens also worked on the Bryant Vase (fig. 58), a testimonial object in silver also made by Tiffany. Saint-Gaudens is believed to have executed a portrait medallion of the vase's intended recipient, William Cullen Bryant, and five additional medallions: two to represent poetry and nature-study, Bryant's chief interests, three to illustrate different phases in his life. That

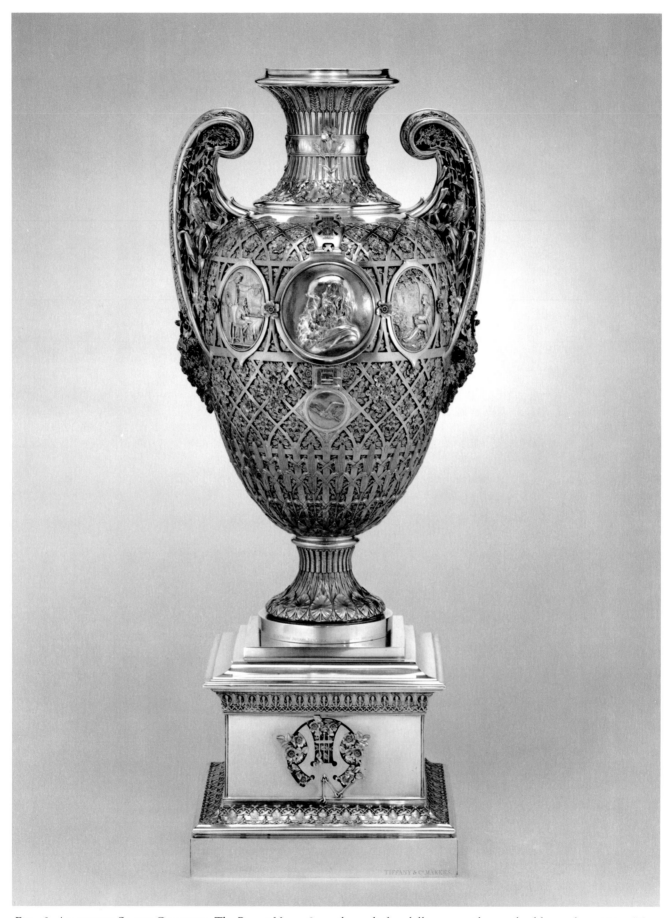

Fig. 58. Augustus Saint-Gaudens, The Bryant Vase, 1875, silver relief medallions on a silver and gold vase, h. 33½ in. (New York City, The Metropolitan Museum of Art, Gift of William Cullen Bryant, 1877).

Saint-Gaudens performed these small commissions, a demonstration of his need for work, fits a standard pattern: sculptors setting out on what is a difficult career to establish are well known for their willingness to accept any decorative assignments that present themselves, but Saint-Gaudens was particularly suited to both forms of expression. If he did indeed execute the Indian figures, it was in the mode of his work on *Hiawatha*, which had already attracted attention in New York; the medallions on the vase echoed the recurring theme that permeated his entire oeuvre and for which he is uniquely celebrated: the exquisite decorative quality that he excelled in from his early days as a cameo cutter.

In March, he entered his first competition, for the statue of Sumner.[45] He was not the successful candidate. Reportedly, after reviewing the models for a specified seated statue, the jurors decided that what they really wanted was a standing figure, and they selected a model submitted by Thomas Ball, an expatriate Bostonian then living in Florence. As Homer Saint-Gaudens later wrote: "The lack of faith shown by those in charge so angered my father that he not only never again went into a competition, but even refused to submit sketches of any idea until a work had been definitely awarded him; while with the tenacity with which he clung to any thought or feeling, he fought through all his life, and up to the month of his death, for some just method of guiding competitions in this country, so that younger sculptors should have fairer opportunities."[46] While that may well be true, Saint-Gaudens's attitude probably speaks more of his own fierce pride than of his sense of fairness. However lofty his sentiments, he nevertheless abandoned them almost immediately to find other work.[47]

He had been seeking his first major commission for some time, that of the Farragut monument for the city of New York. He had heard of the proposed statue through Edwin Morgan when he was still in Rome, and had immediately made a sketch of Farragut's head. Now, aware that the Homers were withholding permission for his marriage to Augusta until he had received at least one important commission, he asked Morgan to exert influence in his favor. He followed every lead and pulled every string he could in order to see that the *Farragut* came to him. As he recorded, "If I fail I will have my mind clear on one point. I have never moved around about anything as I have about this. I have made two models, a large drawing and a bust, and I have not allowed the slightest or most remote chance for my bringing influence to bear to escape me. I cannot think of a step that I have neglected to take."[48] All his efforts notwithstanding, the work was given to John Quincy Adams Ward by a vote of six to five. Ward, however, was busy at the time and, ever a champion of young talent, he declined the commission in December 1876 in Saint-Gaudens's favor.

In 1875, while Saint-Gaudens was working in a studio he rented in the German Savings Bank Building, he met, as he later recalled, "a couple of red-heads who have been thoroughly mixed up in my life ever since; I speak of Stanford White and Charles F. McKim. . . . [White] was drawn to me one day, as he ascended the German Savings Bank stairs, by hearing me bawl the 'Andante' of Beethoven's Seventh Sym-

phony, and 'The Serenade' from Mozart's 'Don Giovanni.' He was a great lover of music."⁴⁹ The young men quickly became friends; perhaps through White, who was working with Henry Hobson Richardson at the time, he also met Richardson and John La Farge, for in that same momentous year Saint-Gaudens came into the direct orbit of those two men, a happenstance that proved to be of inestimable value to him. Because they were among the most advanced in their fields, they broadened his outlook, enlarged his sphere of influence, and greatly aided his development as a creative artist. What brought the three of them together was the decoration of Trinity Church, in Boston, the project that established Richardson's reputation as the leading American architect of his day. La Farge, who was in charge of the murals, enlisted Saint-Gaudens's assistance with the figures of saints James and Paul. Saint-Gaudens, not a painter and not even known to have painted, may have been included with the painters Francis D. Millet and George Willoughby Maynard, who were also working on murals, as a favor to Augusta's parents, for it has been said that it was through them that he met Richardson, who gave him the job.⁵⁰ The decorative plan for the church was an extremely complex venture, and the group of men who participated in it became friends who stayed close through the years—a network of artists that recommended each other for many different schemes at many different times.

In the same year, Saint-Gaudens was included among the sculptors represented at the Philadelphia Centennial, where his bust of Evarts was exhibited, bringing his work before a large number of visitors. In the following year, he joined the Tile Club, whose members, White among them, came from the artistic and literary communities. He also joined with La Farge, Will Low, Olin Warner, Helena de Kay, and several other artists in founding the Society of American Artists—an American version of the Salon des Refusés in Paris —in part because the jury of the National Academy of Design refused to accept one of his works for their annual exhibition; in part to join with his contemporaries in their refusal to be bounded by the strictures of the Academy system of artistic control. As Homer Saint-Gaudens was to write, "Let no one doubt the courage of that act [the founding of the Society], for my father and his friends threw down the gauntlet

to an old and powerful organization with money and social prestige and every apparent reason to resent the action of an unmannerly group of youngsters."[51]

Saint-Gaudens's relationship with La Farge continued with a series of commissions the two men would carry out together: the King family tomb in Newport, Rhode Island, and reredos for St. Thomas's Church in New York, both of which Saint-Gaudens would work on in Paris. He also was awarded the statue of a second naval man, Robert R. Randall, a privateer and philanthropist who had left a bequest to the Marine Society of New York, which his father had founded, for the Sailors' Snug Harbor, a home on Staten Island for retired seamen. The monument, which had been commissioned by the institution's board of trustees, was modeled in Paris. In addition, Saint-Gaudens was asked by Edwin Morgan, who had had the *Hiawatha* put into marble, to execute the Morgan family tomb, which would be erected in Hartford, Connecticut. Saint-Gaudens was finally launched in his career. In June, having in hand enough commissions to assure the Homers that he could provide for their daughter, Saint-Gaudens married Augusta at her home in Roxbury, Massachusetts. The couple departed for Paris soon after.

That second Paris stay, of three years' duration, was entirely different from Saint-Gaudens's first. He was looking at the world with new eyes. Ten years older, married, trained, and armed with commissions, he could afford a residence as well as a studio. The ensuing period he devoted to the demonstration of what he could achieve by applying his genius, now educated, to the work at hand. In that first summer he began to make the bronze reliefs that were to win him great acclaim. The impetus for making them had come chiefly from La Farge, who during a visit with Saint-Gaudens in his New York studio had seen some of his casts of fifteenth-century reliefs. Homer Saint-Gaudens called them "Pisani" reliefs.[52] He was surely referring to Antonio Pisano, known as Pisanello (before 1395–1455), whose oeuvre included many superb medallions. One example of Pisanello's influence can be seen in Saint-Gaudens's 1881 portrait of Sarah Redwood Lee (fig. 59), which bears a strong resemblance to Pisanello's medallion of Cecilia Gonzaga (fig. 60). As the sculptor recalled of La Farge many years later: "[When I expressed] despair of ever attempting to do medal-

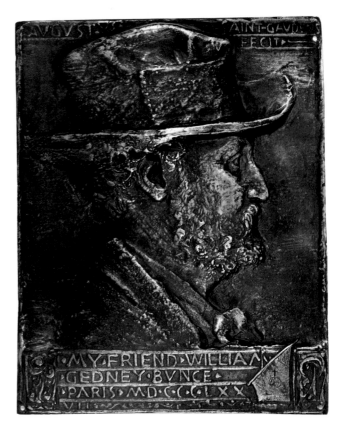

Fig. 61. AUGUSTUS SAINT-GAUDENS, *David Maitland Armstrong*, 1877, bronze relief, 7⅞ in. × 4⁹⁄₁₆ in.; wood frame painted by Helen Maitland Armstrong (New York City, Collection of Mr. Maitland A. Edey).

Fig. 62. AUGUSTUS SAINT-GAUDENS, *William Gedney Bunce*, 1877, bronze relief, 7 in. × 5 in. (Hartford, Connecticut, Courtesy, Wadsworth Atheneum, Gift of Mrs. Stanley W. Edwards).

lions after looking at those achievements, he said quietly and incisively, 'Why not? I don't see why you should not do as well.' This is no doubt the reason I have modeled so many medallions since."[53] Among the portrait reliefs were those of the painters David Armstrong (fig. 61), which was modeled in New York, William Gedney Bunce (1840–1916; fig. 62), and George Maynard (1843–1923; fig. 63), which were done as gifts to the subjects and were all cast in Paris. Saint-Gaudens incorporated into the *Armstrong* an inscription, a device that would become a constant in all his future portraits. The *Maynard* has wonderful surface detail, a light-reflecting, undulating surface, and a charming border of ivy. The inscription consists of Saint-Gaudens's name and the date on the top of the relief; *Mon Ami*, on a banderole behind Maynard's neck; and Maynard's name on the bottom. The piece pulsates with tactility and energy. The irregularity of the surface, intended to create the liveliest possible effect, is done in a fashion not previously seen in American sculpture. Saint-Gaudens in this period was obviously moving away from the dutiful and dull character of most preceding American sculpture in favor of a style in which the actual modeling would dominate. He seems to have derived fresh ideas for what he wanted to accomplish in his work during his second sojourn in Paris, perhaps largely the result of his reexamination of the work of Henri Chapu (1833–1891), especially Chapu's "Medallion of a Man with a Hat" (fig. 64).[54] There is much interest in the design, the format, and the inscribed borders of all these reliefs which, though small in size, are skilled and adventurous in concept. Nothing Saint-Gaudens had done previously looks anything like what he began to turn out after his return to the city that was the wellspring of his inspiration.

The Montgomery memorial (fig. 65) was made in 1876, two years after the subject's death. Saint-Gaudens had modeled the relief in New York, but according to his wife, was "still fiddling over it" in Paris, where it was cast in bronze.[55] Though it was executed before the portraits of Armstrong, Bunce, and

Fig. 63. Augustus Saint-Gaudens, *George Willoughby Maynard*, 1877, bronze relief, 8¼ in. × 5⅞ in. (New York City, The Century Association).

Fig. 64. Henri Chapu, *A. Gibert*, 1869, bronze medallion, diam. 3¹⁵⁄₁₆ in. (Paris, Musée d'Orsay).

Maynard, it seems considerably less daring. Because it was done in collaboration with H. H. Richardson, who had been given the commission and who made a large architectural frame for its placement in the Church of the Incarnation in New York City, it is neither a portrait of a friend nor an experiment in the style the sculptor was then forging. The decorative part of the framework may owe more to White, who was designing much of Richardson's decorations at the time; the lettering on the medallion, on the bronze tablet below it, and on the foundation is perhaps a collaborative effort between Saint-Gaudens and White, for the decorative stonework is similar to that of the fireplace at the Ames Library, which has been attributed to White and for which Saint-Gaudens was to contribute the relief of Ames that surmounts it.

Saint-Gaudens finished the St. Thomas Church reredos that first year. The reredos consisted of eight panels, each depicting kneeling angels who faced the central cross (fig. 66). The painter Will Low, who was in Paris and sharing Saint-Gaudens's studio, assisted Saint-Gaudens in coloring the cement-composition reliefs. Having the panels colored was principally La Farge's idea; his desire to mesh sculpture with mural painting and stained glass was the basis of the whole concept, as it was later to be, in an expanded format, of the decoration of the Cornelius Vanderbilt II house in New York, where La Farge and Saint-Gaudens again were collaborators. Because Saint-Gaudens was working in Paris and La Farge in New York, there was much correspondence between the two men. On August 29, Saint-Gaudens wrote to La Farge: "I have commenced on the sculpture and I feel very sanguine about it. . . . I only regret that instead of the time I have I could not have a year. Probably the effect of the whole, when finished, would not be very different from what it will be now; but I could study up the reliefs 'avec plus de soin.' I have been to the Louvre to see the pictures of the early Renaissance, and the next relief will be more in that character."[56] On September 20, he wrote again to La Farge: "Have you noticed how much like the proportions of the doors of Ghiberti the

Fig. 65. Augustus Saint-Gaudens, *The Henry Eglinton Montgomery Memorial*, 1876, bronze relief, diam. about 32 in.; architectural framework designed by Henry Hobson Richardson (New York City, Church of the Incarnation).

work becomes by putting the molding in between, and how, unconsciously, by putting the frieze on the side and the cherubs' heads on top I am above reproach."[57] La Farge replied: "Your bas-relief is thought by others as well as by myself to be a great success. . . . It is a living work of art." He followed his praise, however, with criticism: "By changing the proportions of the angels from my drawing, you have in the first place . . . made the angels look small compared to the stained glass and the pictures. . . . The band of angels' heads above looks small and childlike and separates the work from the crown, which now has no support and seems to fall." He continued with other complaints, softening them by saying: "It seems to me that you have some poor advisers. I should mistrust the French ambitions anyhow. It is by nobody's taste you must go, unless you find a mind just at sympathy with yours."[58] These differences of opinion notwithstanding, when the work was opened to the public in New York the painter Wyatt Eaton wrote to Saint-Gaudens that they were one of the two things talked of at the time.[59] The entire work was destroyed when St. Thomas's Church was burned in 1905.

Despite the minor disagreements between Saint-Gaudens and La Farge, La Farge did not renege on his

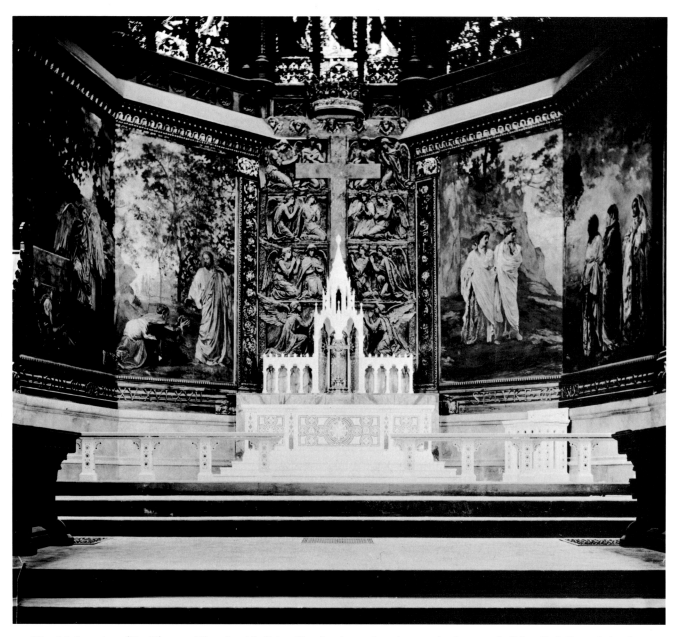

Fig. 66. Interior of St. Thomas Church with Saint-Gaudens's reredos, destroyed; photograph (New York City, Columbia University, Avery Architectural and Fine Arts Library, Upjohn Collection).

invitation to have Saint-Gaudens join him in executing the King family tomb in Newport, Rhode Island. The concept for the tomb, which was commissioned by Edward King's widow, was largely the product of La Farge's imagination. In essence, it consists of a stepped, rectangular base from which rises a Corinthian column surmounted by a cross. Of particular interest is the manner in which the decoration—acorns and oak leaves, the latter a motif that appears on other works La Farge and Saint-Gaudens executed together; both motifs added at Mrs. King's request—and the inscriptions, the names of the King family members, are incorporated into the design of the whole. Both concept and form are not consistent with Saint-Gaudens's singular style but are merely a reflection of Mrs. King's wishes that he executed in sculptural form.

At the end of 1877 the Saint-Gaudenses left Paris to winter in Rome. Saint-Gaudens continued to work on several commissions, which in addition to the King family tomb included a half-length figure (an innovation in American sculpture) of Theodore Dwight Woolsey, tenth president of Yale University, which had been modeled in New York and was put into marble in Italy. The gift of Edwards Pierrepont, it was installed in Woolsey Hall at Yale in 1880. The sensitive modeling of the subject's face does full justice to his ascetic

Fig. 67. Augustus Saint-Gaudens, *William L. Picknell*, 1878, bronze relief, 7½ in. × 5 in. (Courtesy, Museum of Fine Arts, Boston, Gift of George W. Picknell, 1936).

features. The vertical folds of the academic robe Woolsey wears are luxuriously treated and provide an effective counterpoint to the subject's crossed arms, which define the composition so satisfactorily that the lower part of the body is not even missed.

What was undoubtedly foremost in Saint-Gaudens's mind throughout the entire period was the *Farragut* commission. To prepare for it he continued to work on a bust of the admiral that he had begun in New York two years earlier. His move to Rome must have been made with an eye toward taking a fresh look at the Renaissance masters, for after his return to Paris the influence of that period began to exert itself increasingly on his work, especially in the concept of the *Farragut*.

Saint-Gaudens again contracted malaria in Rome, and had to return to Paris in March 1878. There he was invited by his painter friend David Armstrong to assist in selecting the American entries to that year's Exposition Universelle. It was ironic that after suffering only a few months previously at the hands of the National Academy jury he was now catapulted into a decision-making position. (That must have been balm to his wounded pride.) In the same year Saint-Gaudens is said to have exhibited in the first annual exhibition of the Society of American Artists in New York, which would be a regular outlet for the display of his sculpture for the next twenty years.[60] Since he now had an income derived from commissions, he could afford to experiment further on his own with independent pieces, mostly bronze portraits of such artist friends as William L. Picknell and Andrew E. Bunner. For the *Picknell* (fig. 67), a profile portrait, Saint-Gaudens scored and modeled the ground, creating an extremely active effect; the inscription and signature are lettered in a highly visible and assertive fashion. The surface, irregular and deeply undercut, is remarkable for its lack of demarcation between foreground, middle ground, and background—an unexpected, un-American method of conveying depth in a relief and one that was to become a trademark of Saint-Gaudens's style.

Though working hard, he was enjoying a great sense of well-being in his new position as successful sculptor. He and Augusta were playing host not only to brother Louis but also to Stanford White, who was in Europe for over a year and who made the Saint-Gaudens home his headquarters on and off for about six months. White and Saint-Gaudens, along with Charles McKim, who was also in Europe, seized the opportunity to travel around France in the summer of 1878, getting to know her architecture and her people. To commemo-

Fig. 68. Augustus Saint-Gaudens, *Augustus Saint-Gaudens, Stanford White, and Charles F. McKim* (caricature), 1878, bronze medallion, diam. 6½ in. (New York City, The New York Public Library, Art, Prints and Photographs Division, Astor, Lenox and Tilden Foundations).

Fig. 69. Augustus Saint-Gaudens, *Charles F. McKim*, 1878, bronze relief, 7½ in. × 5 in. (New York City, The New York Public Library, Art, Prints, and Photographs Division, Astor, Lenox and Tilden Foundations).

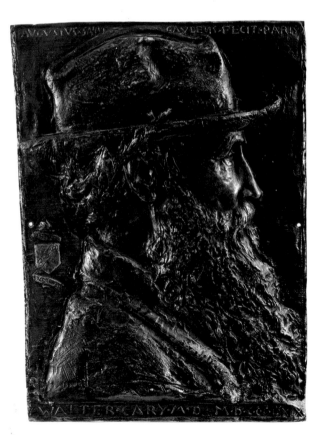

Fig. 70. Augustus Saint-Gaudens, *Dr. Walter Cary*, 1879, bronze relief, 9⅜ in. × 6¾ in. (private collection).

Fig. 71. Augustus Saint-Gaudens, *Maria Love*, 1879, bronze relief, 9⅝ in. × 6⅝ in. (private collection).

Fig. 72. Augustus Saint-Gaudens, *Dr. Henry Shiff*, 1880, bronze relief, 10¹¹⁄₁₆ in. × 11¼ in.; wood frame designed by Stanford White (Cornish, New Hampshire, Saint-Gaudens National Historic Site, National Park Service, U.S. Department of the Interior).

rate their trip Saint-Gaudens executed a bronze medallion (fig. 68) featuring caricatures of the three of them and suitably inscribed with the towns they had visited and three brief mottoes referring to amusing episodes each had experienced. He also did a serious bronze relief portrait of McKim, though its inscription also refers to the trip the trio had taken, apparently a great lark for all of them. In the cast he gave to McKim (fig. 69), the upper left-hand corner of the relief had been cut off in a highly irregular fashion. Saint-Gaudens left it alone, possibly because its resemblance to an archeological find might be seen as bestowing immortality on his subject.

In 1878 and 1879 Saint-Gaudens was commissioned by Dr. Walter Cary, a wealthy American then living in Paris, to make two bronze reliefs of him—one bareheaded (fig. 5); one with a hat (fig. 70). On the former, the inscription is varied by containing not only actual text but additional decoration: a row of ivy leaves and an armorial device. The latter is inscribed with the names of the artist and the subject, with a coat of arms behind Cary's shoulder on the relief itself. In both works, the extraordinary virtuosity in Saint-Gaudens's handling of

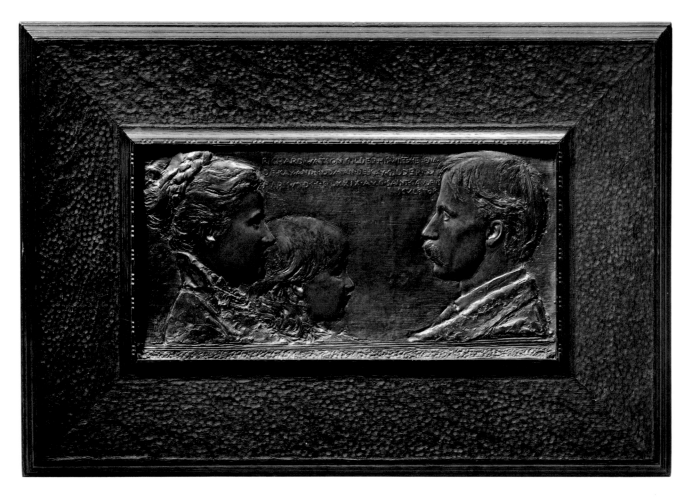

Fig. 73 (above). AUGUSTUS SAINT-GAUDENS, *Richard Watson Gilder, Helena de Kay Gilder, and Rodman Gilder*, 1879, bronze relief, 8⅝ in. × 16⅞ in.; wood frame probably designed by Stanford White (private collection).

Fig. 74 (opposite). AUGUSTUS SAINT-GAUDENS, *Rodman de Kay Gilder*, 1879, bronze relief, 13½ in. × 16⁵⁄₁₆ in. (private collection).

the beard imparts to the surface a shimmering, living quality. That surface activity reaches its zenith in the relief executed in 1880 of his great friend and advisor Dr. Henry Shiff (fig. 72) in which the beard measures half the length of the subject's body. The *Shiff* inscription takes on more importance, occupying in its extravagance the entire left side of the relief. These seem to be among Saint-Gaudens's first bronzes of subjects other than members of his intimate circle of artist friends. It was apparently Cary who was instrumental in obtaining commissions for Saint-Gaudens to execute reliefs of William E. Johnston, an American physician and journalist living in Paris, and of Maria Love (fig. 71), whose eldest sister was married to Cary. Maria's portrait relief too is decorated with ivy and a coat of arms, but floral motifs are now added.

Saint-Gaudens's first group-portrait relief—a form he was successfully to explore in later years—is dated 1879. A portrait of the Gilder family, Richard Watson, his wife, Helena de Kay, and their son, Rodman, it has been given the finishing touch of a beautiful wooden frame no doubt by Stanford White (fig. 73). Richard Gilder, who was then working for *Scribner's Magazine*, was to become editor of *Century Illustrated Monthly Magazine* within two years; Helena, who had been an art student at the Cooper Union, had been associated with Saint-Gaudens in founding the Society of American Artists. The Gilders were close friends of Saint-Gaudens's. The sculptor also did a portrait of young Rodman alone (fig. 74), in which the child's head, occupying only a small part of the surface, seems to float on a field of bronze. The representation of his appearance closely resembles that in the group portrait.

The last reliefs from that Paris era are those of the painters John Singer Sargent (1856–1925), the illustrious American, and the gifted young Frenchman Jules Bastien-Lepage (1848–1884). Both portraits are done

in profile. In the *Sargent*, a small bronze medallion, the simple lettering of the inscription is almost as large as the portrait itself. In the *Bastien-Lepage* (fig. 75), where the artist is shown with the attributes of palette and brush, what appears to be a deep outline of the shoulder against the background has been achieved in a variation of only a few millimeters: only Saint-Gaudens's extraordinarily gifted handling of the relief form creates the illusion of depth. The portrait reveals Bastien at his youthful peak, and offers no hint that his appearance, then so robust, would be sadly altered by the cancer that ended his life four years later. Saint-Gaudens's use of an undulating surface in his portrait of Bastien is a familiar device not only in his reliefs but also in those of other sculptors. The French Alexandre Charpentier, for one, carried the irregular format to an extreme in his 1891 portrait of the painter Maximilien Luce (fig. 76). Though the effect Charpentier achieved is more impressionistic, it is evident that both sculptors were seeking to exploit the play of light and shadow in the richly modeled forms of their reliefs.

In 1880, Saint-Gaudens continued his decorative assignments by making sketches of interior embellishments for Ames Gate Lodge, the house Henry Hobson Richardson was designing for Frederick Lothrop Ames in North Easton, Massachusetts. He was also working on the funerary figures for the Morgan family tomb, which White was designing. The project was one of the first the two friends worked on together, and they certainly discussed it in Paris, probably beginning there to make drawings and sketches for it.

The year 1880 was especially important for Saint-Gaudens, for it marked his first participation at a Paris Salon. He chose to exhibit the statue of the *Farragut*, which he had completed in plaster; he also showed five of his reliefs.[61] His work was accorded honorable mention. Later in the year he had the *Farragut* cast in bronze in

Fig. 75 (opposite). Augustus Saint-Gaudens, *Jules Bastien-Lepage*, 1880, bronze relief, 14⁹⁄₁₆ in. × 10³⁄₈ in. (Courtesy, Museum of Fine Arts, Boston, The Everett Fund, 1881).

Fig. 76 (left). Alexandre Charpentier, *Maximilien Luce*, 1891, bronze relief, 9¹³⁄₁₆ in. × 7⁷⁄₈ in. (Paris, Musée de la Monnaie).

Paris by the Gruet Foundry. He had probably waited that long in order to benefit from the response to the piece at the Salon: if any final adjustments were to be made, they could then have been done before the work was irrevocably committed to bronze.

The Saint-Gaudenses returned to New York that summer. On the way home, Saint-Gaudens exhibited several works at the Grosvenor Gallery in London, extending both his professional domain and his international reputation. His personal world was also expanding: his son Homer (1880–1958) was born in Boston in late September.

The return to New York marked the beginning of Saint-Gaudens's putting down roots in that city. He rapidly became a force within New York's artistic community, his role as spokesman for progressive artists reinforced by his being elected president of the Society of American Artists in 1881. In May of that year Saint-Gaudens's first major public monument, that to Admiral David Glasgow Farragut, was unveiled in Madison Square Park in New York (fig. 77; pl. 1). With its successful reception, his renown as a sculptor was established and began immediately to broaden.

The concept of the work was undoubtedly the result of discussions between Stanford White and the Beaux-Arts-trained Saint-Gaudens, both men still under the influence of all they had absorbed from the European monuments they had seen on their travels together in 1878, with McKim, and again in the summer of 1879, when they visited Italy before White's September departure for the United States.[62] The figure and its pedestal form such an integrated unit that one would be unthinkable without the other. The bluestone from which White's pedestal is hewn is a reference to the ocean; the bronze figure of Farragut, whom Saint-Gaudens portrays as if standing on the prow of his ship, seems to be supported by the underwater world suggested by the swirling stylized waves beneath him. Perhaps the most inspired touch is the downward pointed sword that stands out in stark relief against the waves at the base of the statue. Allegorical figures of Courage and Loyalty (figs. 78, 79) interspersed with inscriptions flank the central pedestal; the sides of the monument on which they appear curve out to form an exedra with an open-mouthed dolphin plunging into

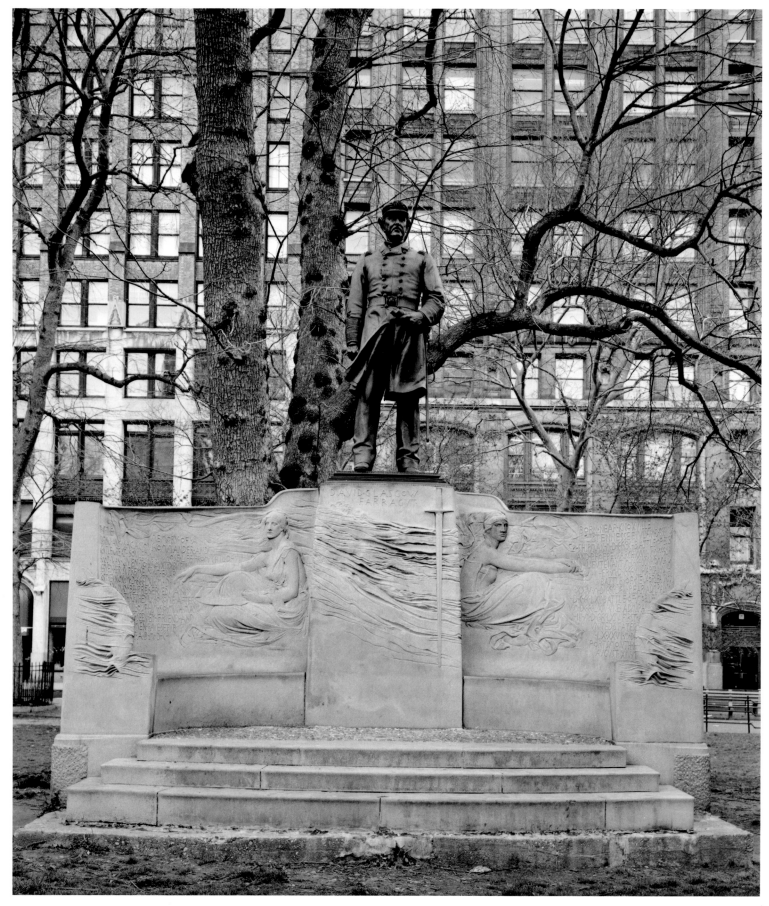

Fig. 77. Augustus Saint-Gaudens, *The Farragut Monument*, 1879–80, bronze statue of Admiral David Glasgow Farragut, over life-size (New York City, Madison Square Park). The granite exedra is a copy of the original bluestone base designed by Stanford White.

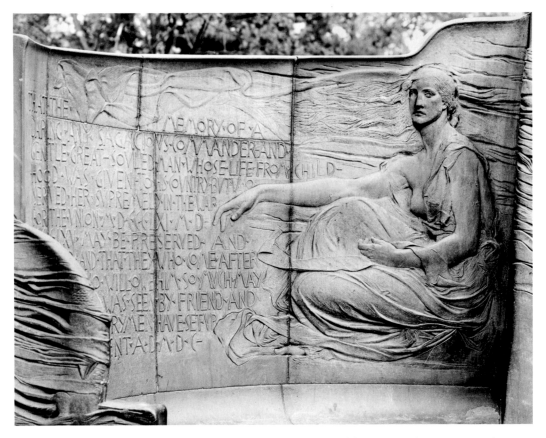

Fig. 78. *The Farragut Monument*, figure of Courage on the original base (Cornish, New Hampshire, Saint-Gaudens National Historic Site, National Park Service, U.S. Department of the Interior).

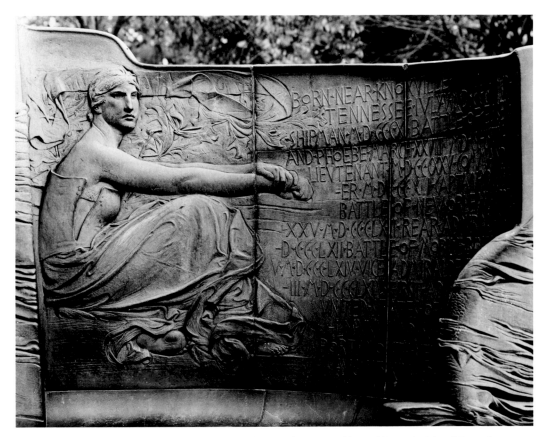

Fig. 79. *The Farragut Monument*, figure of Loyalty on the original base (Cornish, New Hampshire, Saint-Gaudens National Historic Site, National Park Service, U.S. Department of the Interior).

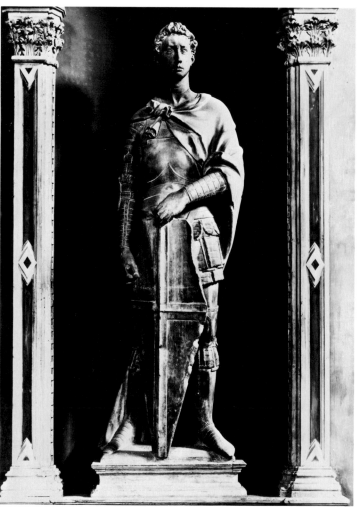

Fig. 80 (opposite, above). STANFORD WHITE, Base for *The Farragut Monument*, red pencil drawing, about 1878, 8½ in. × 23 in. (Cambridge, Massachusetts, Harvard University, by permission of The Houghton Library, Henry Hobson Richardson Architectural Office Drawings Collection).

Fig. 81 (opposite, below left). Figures of Courage and Loyalty for *The Farragut Monument*, clay sketch, about 1879, destroyed; photograph (Hanover, New Hampshire, Dartmouth College Library).

Fig. 82 (opposite, below right). DONATELLO, *St. George*, 1415–17, marble statue, h. 82 in. (Florence, Museo Nazionale del Bargello).

the depths at either end. On the pebble-strewn ground just above the three shallow steps that lead into the base is a bronze crab inscribed with the two artists' names. A seating area is contained on either side of the central pedestal. As Royal Cortissoz said of the work: "The whole spirit of this monument is delightfully significant of the quarter-deck. . . . Saint-Gaudens [has] produced . . . a figure instinct with the energy of a man fronting perils in the open air, amid great winds and under a vast sky." He continued: "The pedestal . . . is at once charmingly decorative and quite weighty enough to provide a true monumental base for the bronze." He accounted for the impact the work had had on the public: "At that time we were still more or less held in thrall by the facile makers of 'soldiers' monuments,' those dreary, lifeless productions which cheered our patriotism and ought to have shocked our taste."[63]

Both Saint-Gaudens and White made a series of sketches and drawings (fig. 80). Some of the clay models the sculptor produced are preserved in photographs. Saint-Gaudens altered the figure of Courage several times: he made a rough drawing of her in which her pose resembles that of Michelangelo's Sistine Chapel figure of Jesse; in one clay sketch, her arms are wrapped around her knees and her face is turned toward the viewer; in another, she and Loyalty are placed very close together (fig. 81). The figure of Farragut derives its stance from Donatello's *St. George* (fig. 82). The saint's left hand rests on his shield as he stares with troubled brow at his adversary; Farragut's left hand holds his spyglass, and he scans the sea with a sailor's knowledgeable eye. The impression he conveys is one of steadfastness and vigilance. Saint-Gaudens labored over the likeness and costume, writing from Paris to the War Department in Washington, D.C., for photographs of Farragut and asking about Farragut's sword. He was later able to arrange with Mrs. Farragut to send the sword to his father-in-law so that Augusta's sister Lizzie could take it to Paris when she went to visit. Augusta searched Paris for brass buttons to put on Farragut's coat, which was being altered to fit the model who was posing for the sketch. This preoccupation with the accuracy of his subjects' likenesses and attire was to be a constant factor in Saint-Gaudens's studies throughout his career. Though the praise accorded the *Farragut* in Paris and New York certainly helped to attract commissions to him, the usefulness of the recommendations of his friends White, Richardson, and La Farge in the expansion of his career cannot be overemphasized.

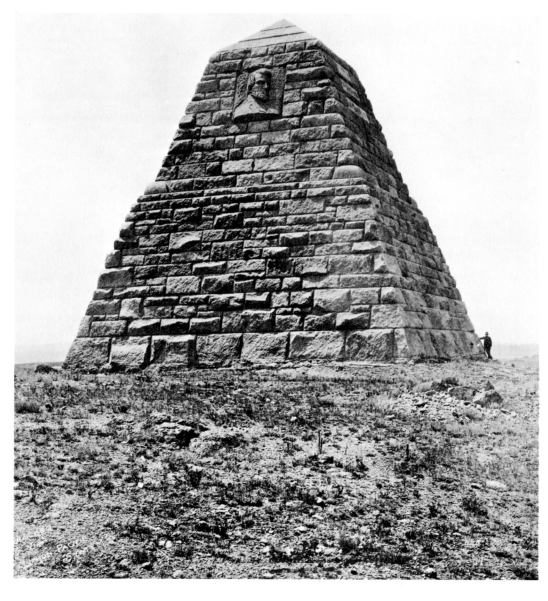

Fig. 83 (opposite above). AUGUSTUS SAINT-GAUDENS, Bachelor's Hall
Mantelpiece for *Ames Gate Lodge*, 1881, sandstone, w. about 72 in.
(North Easton, Massachusetts, Ames Gate Lodge).

Fig. 84 (opposite below). AUGUSTUS SAINT-GAUDENS, Relief of Oakes Ames
for Henry Hobson Richardson's *Ames Monument*, 1881, stone,
120 in. × 120 in. (near Laramie, Wyoming).

Saint-Gaudens participated during the early 1880s in a series of decorative projects that began with the Ames Gate Lodge, which Frederick Lothrop Ames commissioned Henry Hobson Richardson to build. There, the sculptor's greatest contribution was his treatment of the fireplace (fig. 83) in a second-floor hall that was called the "Bachelor's Hall" in Richardson's plans because it was to be set aside for the use of the Ames sons and their guests. On the stone mantel is an intricately combined design in relief of the signs of the zodiac interspersed with the names of the zodiac figures and the months of the year spelled out in stylized lettering. On either side of the mantel is a rattlesnake swallowing his tail—a symbol of rebirth that is balanced by the Greek letters Alpha, contained within one coiled serpent, and Omega, in the other. (The letters are also the reversed initials of Frederick's father, Oliver Ames II.) The zodiac motif, a symbol of the universe, signifies that the house is the owner's world, and was to turn up again in other of the sculptor's decorative schemes, including those for the Villard house. Louis, who had just returned to the United States from Rome, helped him with the modeling. Saint-Gaudens's affiliation with the Ames family had begun in 1881, when he did portrait reliefs in stone of Oakes Ames and his brother Oliver, father of Frederick and a president of the Union Pacific Railroad. These were set in a pyramidlike monument (fig. 84) that the railroad commissioned Richardson to build near Laramie, Wyoming, the highest point on the line. The sculptor later did another relief of Oliver Ames, this one in bronze, to be set over the mantelpiece in the Ames Library, North Easton, Massachusetts, Ames's bequest to the town carried out by his children, Frederick and Helen. (After Frederick's death, in 1893, Saint-Gaudens also executed his granite-slab tombstone.)

Through La Farge, who was responsible for the interiors of some of the rooms, Saint-Gaudens was asked to participate in decorations for the Fifth Avenue house of Cornelius Vanderbilt II, designed by George B. Post. Saint-Gaudens later recalled the project: "The undertaking required not only the two caryatids for the monumental mantelpiece and the mosaic that surmounted it, but as well the superintendence of the models for all

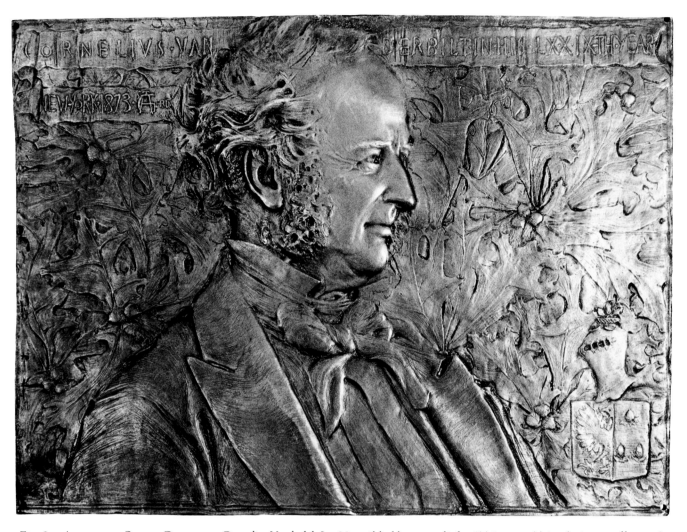

Fig. 85. Augustus Saint-Gaudens, *Cornelius Vanderbilt I*, 1882, gilded bronze relief, 16½ in. × 22½ in. (private collection).

the wood-carving in the hall, which was enormous, beside the creating of medallion family-portraits (fig. 85) to be introduced in certain of the panels. For some reason these were not entirely completed. . . . Beside these, I, with my brother, Louis Saint-Gaudens, was associated with Mr. La Farge in composing the models for the superb ceiling that he designed for the main dining-room. Mr. Post evidently had the same confidence in me that I had in myself."[64] To La Farge's designs and under his direction Saint-Gaudens modeled decorative panels for the hall and dining room, but his chief contribution was the caryatids *Amor* and *Pax* that supported the magnificent entrance-hall mantelpiece (fig. 86) and the dining-room panels—made of precious wood with elaborate inlays of marble, bronze, ivory, mother-of-pearl, and coral—of Pomona, Actaeon, Bacchus, and Ceres. In his sketches for the mantelpiece (figs. 87, 88) he was apparently working out an allegorical theme, an evocation of greeting and welcome for the guests of the house that is borne out in the Latin inscription ("The house at its threshold proclaims the master's good will. Welcome to the guest who arrives, farewell and support to him who departs.") flanking the classical figure on the large over-mantel mosaic entablature. Rough notes in Saint-Gaudens's hand on a preliminary drawing of the mantel, "Sienna marble face and arms and feet drapery gilded or silvered bronze or sienna—gild in parts mantel white marble (gold shield partly *stained*)" show that he toyed with the idea of a more colorful effect before he settled on the final red Numidian marble. The entrance-hall fireplace and the dining-room panels ended up in the billiard room in 1894 (fig. 89), when the house was being enlarged. The house was demolished in 1927, but the mantelpiece, now installed in the Charles Engelhard Court at the entrance to the Metropolitan Museum's American Wing, still invokes in visitors the sense of opulence and hospitality it was designed to convey.

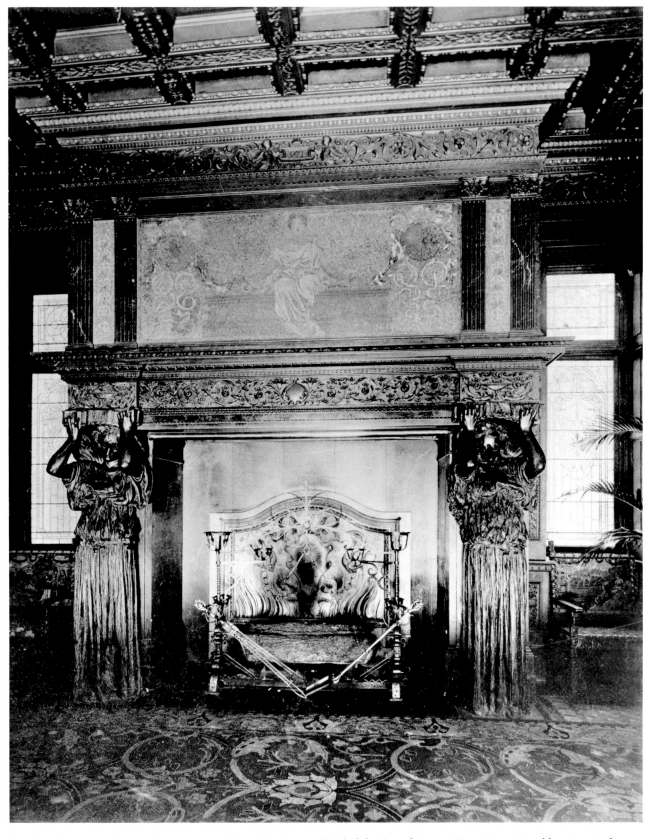

Fig. 86. AUGUSTUS SAINT-GAUDENS and JOHN LA FARGE, Vanderbilt Mantelpiece, 1882, in its original location in the entrance hall of the Cornelius Vanderbilt II house; photograph (New York City, The Metropolitan Museum of Art).

The Vanderbilt project brought into Saint-Gaudens's orbit two other artists who would be associated with him for several years: Philip Martiny, then working as a wood carver in the house, and young Frederick MacMonnies, who was first in line when Saint-Gaudens was hiring assistants and whose talent caused the sculptor to take a great interest in him. [65] Both young men kept in touch with the sculptor (MacMonnies worked with him on other projects) and later came to him as studio assistants.

In 1882, the firm of McKim, Mead and White was commissioned to design the house of Henry Villard, who had just made a great fortune in railroads and shipping and wanted a residence suited to his new station in life. The architects created a splendid Renaissance palazzo in the heart of New York City; White was responsible for the interior decoration. Saint-Gaudens helped with some of the elements, though Louis did most of the actual execution under his supervision. Work included the dining-room fireplace, set in a wall of marble that contained ideal reliefs and flanked by fish-fonts (fig. 90) that held running water (a most unusual concept, which together with the earth and the air that surround it may be representative of the four elements, here symbolic of the hearth and home being Villard's universe). There was also a Pax tympanum (fig. 91) in an arch over the large marble fireplace in the first-floor foyer, and, on the main staircase landing, a sculptured clock surrounded by the signs of the zodiac (fig. 92), another instance of the use of that device in Saint-Gaudens's work. Again, these elements did not reflect Saint-Gaudens's own creativity but were the execution of someone else's ideas, this time White's. Nevertheless, the sculptor must have participated in the project gladly, since it was not just a means of gaining favor with the prominent friends who had given him the work but also because it was a further exercise in the collaboration of the arts, a theme always close to his heart. Villard lost his fortune after he had occupied the house for only a short time, and Whitelaw Reid bought it; its space was later divided into offices for the Archdiocese of New York and Random House, and it is today the Palace Hotel. The fireplace has been moved to a staircase landing; the zodiac clock remains at its original site.

Fig. 90 (opposite). Augustus Saint-Gaudens and Louis Saint-Gaudens, Mantelpiece for the Villard house dining room; photograph (New York City, Museum of the City of New York, McKim, Mead and White Collection).

Fig. 91 (left). Augustus Saint-Gaudens and Louis Saint-Gaudens, Pax tympanum for the Villard house hall; photograph (New York City, Museum of the City of New York, McKim, Mead and White Collection).

Fig. 92 (below). Augustus Saint-Gaudens and Louis Saint-Gaudens, Zodiac clock for the Villard house stairway wall; photograph (Chicago, Wayne Andrews).

Fig. 93 (right). Augustus Saint-Gaudens, Central figure for the Morgan tomb; photograph (Hanover, New Hampshire, Dartmouth College Library).

Fig. 94 (opposite, left). Augustus Saint-Gaudens, Angel for the Morgan tomb, about 1880, plaster model, h. 39 in. (Cornish, New Hampshire, Saint-Gaudens National Historic Site, National Park Service, U.S. Department of the Interior).

Fig. 95 (opposite, right). Paul Dubois, *Chanteur florentin au XVe siècle*, 1865, silver-plated bronze statuette, h. 61 in. (Paris, Musée d'Orsay).

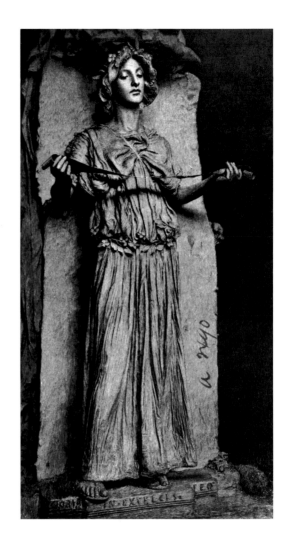

Saint-Gaudens's commission from Edwin D. Morgan to do his tomb, which he had in hand when he and Augusta left for Paris, had been the subject of much correspondence between him and Stanford White, architect of the project and apparently its director, since it was he who was in constant touch with Morgan over various details. In their letters Saint-Gaudens and White discussed everything from the fee they would ask[66] to what they envisioned as the decorative scheme for the tomb, which was eventually built of gray granite, with bronze doors and Tiffany-glass windows.[67] According to White's original plan, Saint-Gaudens was to model a small symbolic figure for each of the four corners of the tomb and a band of angels around its column. White later suggested reducing the number of angels from eight to just five, for the front of the tomb, with foliage or flowers for the sides and back. Saint-Gaudens came up with models of three angels, which were greeted with much enthusiasm when photographs of them reached New York.[68] The Morgan commission was relegated to the background while the two men concentrated their efforts on the *Farragut*, and it did not occupy much of their attention until Saint-Gaudens was back in New York and making models of the tomb figures for the project, which next to the *Farragut* he regarded as his most important work of the time.[69] The nine-foot-high angels were modeled in Saint-Gaudens's studio (fig. 93), and were sent to Cedar Hill Cemetery, in Hartford, Connecticut, to be cut in Italian marble. To protect the work in progress from the ravages of winter, the marble figures were kept at the site in a wooden shed.[70] Only three weeks before their completion, the shed caught fire and most of the marble, which had been obtained only after much protest by Morgan over its cost, was so badly damaged as to be useless. To replace it was impossible: Morgan lay in the tomb that awaited its angelic figures. He had died in February 1883, leaving an estimated eight to ten million dollars to his heirs and a debt of five thousand dollars still due the sculptor.[71] Desolated by the tragedy, Saint-Gaudens abandoned the project. His financial loss, though severe, did not trouble him nearly as much as the knowledge that the effort he had ex-

pended on the creation of purely imaginative compositions, which he had considered much more of a challenge than the series of portraits "that fate thrust upon him,"[72] had been in vain. His only comfort lay in the knowledge that he had some plaster casts of the figures in his studio. What he had achieved remained in his imagination; he could resurrect it at an appropriate time.

With the figures for the Morgan tomb Saint-Gaudens arrived at an image that preoccupied him throughout his career. Its initial appearance in his work can be traced to the somber expression and downcast eyes in his portrait of Eva Rohr and again incorporated into his statue of *Silence* (fig. 4). The image, now in the form of a draped figure, reappears in the eighteen-eighties, when the same features can be seen in the Morgan tomb angels (fig. 94) and the Vanderbilt mantelpiece caryatids (fig. 96). The downcast eyes, possibly inspired by those in Michelangelo's Medici Chapel *Night*, were treated by the néo-florentins Paul Dubois, in his *Chanteur florentin* (fig. 95) and *Narcisse* (fig. 97), and Mercié, in his *David* (fig. 98), and even by the English Alfred Gilbert, in his *Icarus*. In the classicized drapery of the Morgan tomb angels Saint-Gaudens began to explore the decorative possibilities of the figure. As he continued to use it—in the Smith Tomb, the *Amor Caritas* (fig. 99; pl. xiv, this the finest example of the type), the Maria Mitchell Memorial, and the angels in the Baker Tomb—he became so interested in the decorative aspects of the drapery that he continued to develop it. His constant use of the image reflects not a dearth of imagination on his part but rather his ability to refine an idea until he arrived at its ultimate expression. This leit-motiv of his oeuvre, its quattrocento derivation gradually

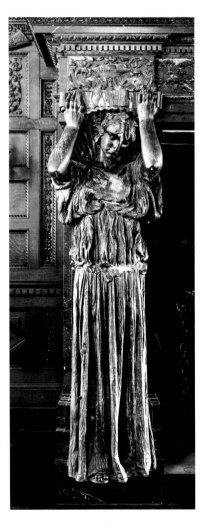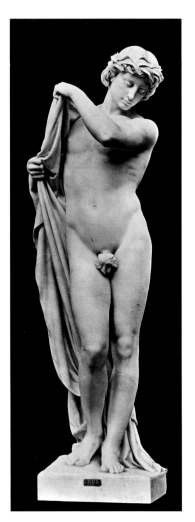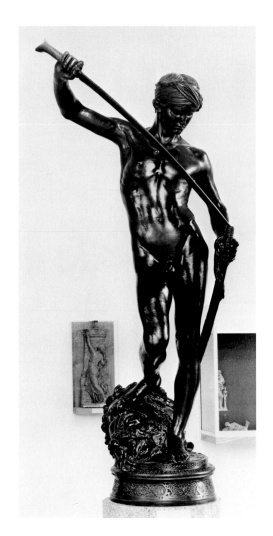

taking on an unmistakably nineteenth-century inflection, became a quintessential Saint-Gaudens figure. A similar interest in antique drapery can be found in the work of other American sculptors—Daniel Chester French in his Milmore Memorial angel and Olin Levi Warner in the Skidmore fountain figure among them. The closest approach to Saint-Gaudens's interest in drapery, however, appears in the work of a painter: his friend Abbott Thayer also experimented with it in several of his works, especially in his *Caritas* of 1893, which is now in the Museum of Fine Arts, Boston.

Homer Saint-Gaudens wrote of the figure: "To speak of these commissions . . . I will begin with the Smith tomb, which, while a step on the way to the ultimate 'Amor Caritas,' in turn emanated from the angels for the tomb of Governor Morgan. That is, though the Morgan tomb figures stood almost in the round, their drapery possessed much the same quality that my father used in the Smith relief; a drapery perhaps finding its suggestion in the English Burne-Jones School, which he admired, though he developed their ideas to more conscientious limits. Also, at about this time, he made a number of other changes in this theme. For instance, the Smith angel held in her raised hands a tablet with a long inscription beginning: 'Blessed are the dead.' So on another occasion, he lowered her hands and reduced the size of the tablet, that it might present only the words, 'Gloria in Excelsis Deo.'"[73]

Throughout most of his career, no matter what project Saint-Gaudens was concerned with, he continued to execute the portrait reliefs that were greatly in demand and that provided him with an immediate income.

Fig. 96 (opposite, left). AUGUSTUS SAINT-GAUDENS, *Amor* caryatid, the Vanderbilt Mantelpiece; photograph (Peter A. Juley and Son Collection, National Museum of American Art, Smithsonian Institution).

Fig. 97 (opposite, middle). PAUL DUBOIS, *Narcisse*, 1867, marble statue, h. 73 in. (Paris, Musée d'Orsay).

Fig. 98 (opposite, right). MARIUS-JEAN-ANTONIN MERCIÉ, *David*, 1872, bronze statue, h. 72½ in. (Paris, Musée d'Orsay).

Fig. 99 (right). AUGUSTUS SAINT-GAUDENS, *Amor Caritas*, 1880–98, this cast 1918, gilded-bronze relief, 113⁵⁄₁₆ in. × 50 in. (New York City, The Metropolitan Museum of Art, Rogers Fund, 1918).

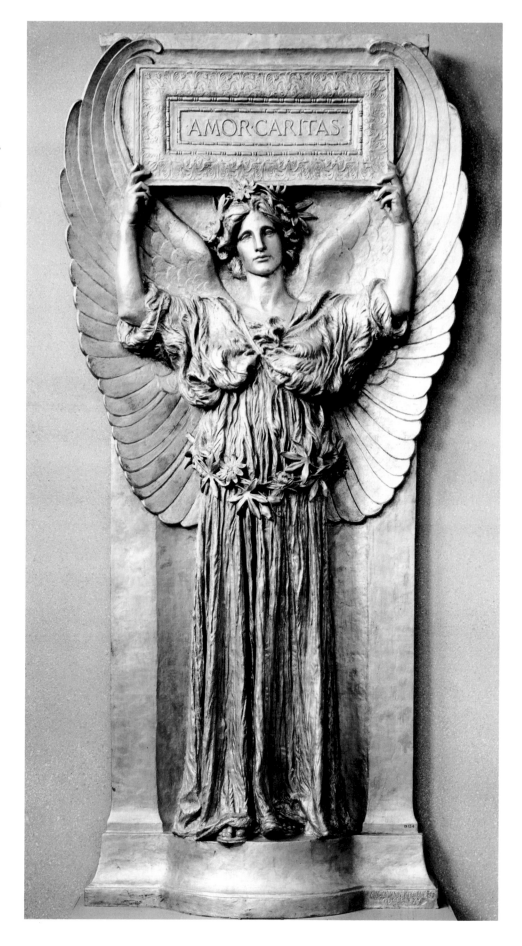

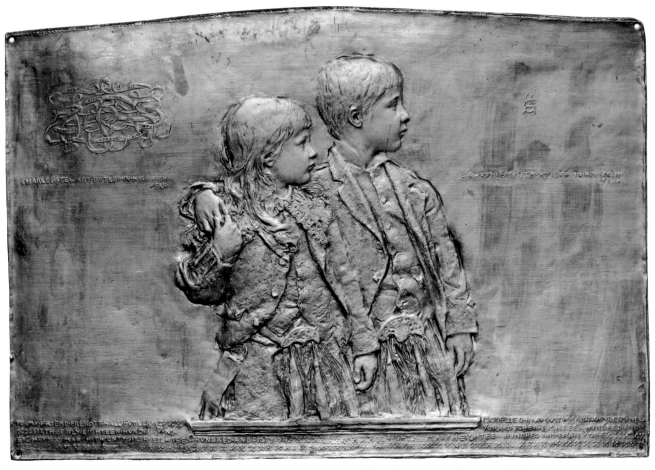

Fig. 100. Augustus Saint-Gaudens, *The Children of Prescott Hall Butler*, 1880–81, bronze relief, 23¾ in. × 35¼ in. (Property of Prescott Butler Huntington).

Fig. 101 (above). Augustus Saint-Gaudens, *Novy* (Louis P. Clark), 1892, plaster medallion, diam. 12 in. (Cornish, New Hampshire, Saint-Gaudens National Historic Site, National Park Service, U.S. Department of the Interior).

Fig. 102 (right). Augustus Saint-Gaudens, *Homer Schiff Saint-Gaudens*, 1882, this marble relief version carved in 1907, 20¹⁄₁₆ in. × 10⁵⁄₁₆ in. (New York City, The Metropolitan Museum of Art, Gift of Jacob H. Schiff, 1905).

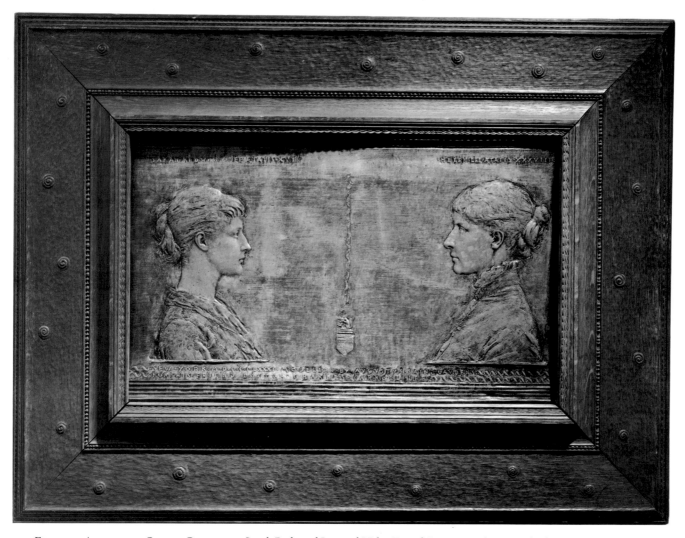

Fig. 103. Augustus Saint-Gaudens, *Sarah Redwood Lee and Helen Parrish Lee*, 1881, bronze relief, 14⅝ in. × 24⅛ in.; wood frame probably designed by Stanford White (Emmitsburg, Maryland, Mount Saint Mary's College, Special Collections House, Lee–LaFarge Collection).

Both Renaissance and contemporary European sources are invoked in his group portraits of families or children, beginning with that of the Gilders (fig. 73), which he had done in Paris. In New York, in 1880, White was instrumental in having him do a relief of the children of Prescott Hall Butler (fig. 100), White's brother-in-law and a prominent New York lawyer. Modeled in 1880–81, the charming portrait of the little boys—one three years old, the other five—shows them in Highland costume. Their chubby cheeks and slightly prominent upper lips give them a faint resemblance to Rodman Gilder (fig. 74) as well as to Saint-Gaudens's son Homer (fig. 102). (Those facial features seem part of Saint-Gaudens's perception of childhood—they are also found in a relief the sculptor did in 1892 of Louis P. Clark [fig. 101], his son by Davida Clark.) The inscription, in the upper left background of the Butler children relief, consists of an armorial device over a legend in Latin. Saint-Gaudens also did a portrait of Helen Parrish Lee and her daughter Sarah (fig. 103), in which the pose of the two figures, shown facing each other, is similar to that in the double portrait that Oscar Roty (1846–1911), who in his contemporaries' eyes was chiefly responsible for the extraordinary renaissance of French interest in medallic art,[74] made of his parents, *J. B. Roty and Elisabeth Virginie Roty* (1886, Paris, Cabinet des médailles, Bibliothèque Nationale). Saint-Gaudens was so captivated by the freshness of young Sarah that he sculpted her again, that time alone (fig. 59). A comparison of the two Lee reliefs shows that by disassociating Sarah from her mother the sculptor was able to concentrate on portraying a young girl, composed but touchingly fragile, poised on the brink of womanhood. The portrait of Mortimer Leo and Frieda Fanny Schiff (fig. 15), the children of Jacob H. Schiff, reveals Saint-Gaudens's command of work in relief by its grad-

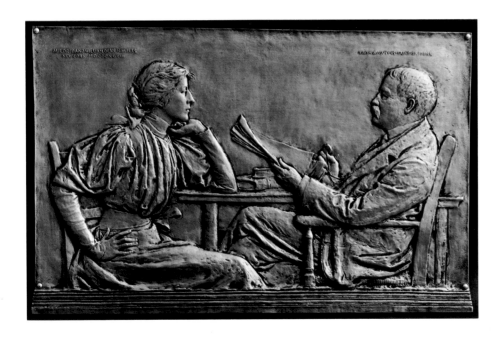

Fig. 104 (left). AUGUSTUS SAINT-GAUDENS, *Mildred and William Dean Howells*, 1898, bronze reduction, 8⅛ in. × 13¼ in. (Washington, D.C., National Portrait Gallery, Smithsonian Institution).

Fig. 105 (below). AUGUSTUS SAINT-GAUDENS, *Mildred Howells*, 1898, bronze medallion (variant), diam. 21 in.; wood frame probably designed by Stanford White (Courtesy, Museum of Fine Arts, Boston, Gift of Miss Mildred Howells, 1957).

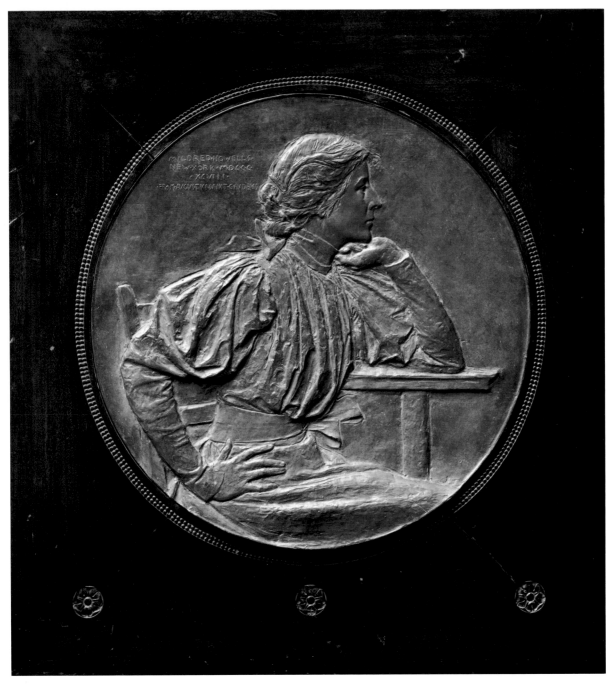

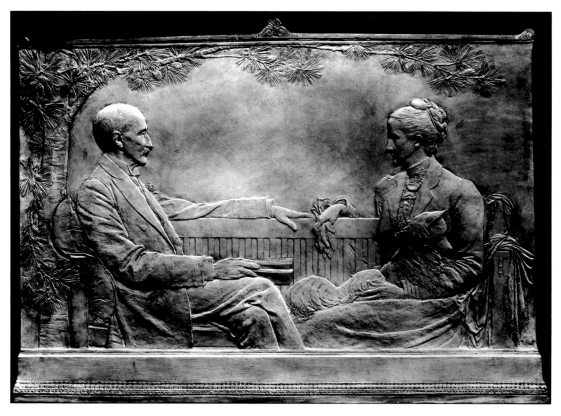

Fig. 106. AUGUSTUS SAINT-GAUDENS, *Wayne and Virginia MacVeagh*, 1902 ; photograph (Peter A. Juley and Son Collection, National Museum of American Art, Smithsonian Institution).

ual progression from the delicate, sketchlike carving of the dog, who stands behind the children and enhances the compositional interest, to the more fully rounded high carving that culminates with the boy in the foreground.

Much later in his career, in 1897, Saint-Gaudens did a portrait of William Dean Howells with his daughter Mildred (figs. 104, 105). They are shown in profile view in a candid moment: Mildred leans forward toward her father, who looks up at her over a newspaper he is holding. The two appear to be absorbed in each other, but the portrait of Mildred is oddly disconnected; her father is somehow out of focus. The sculptor himself was to recall: "To show how uncertain we are, or I am, about our judgment of the work that is in hand, I will explain that when I made this medallion I felt very happy about [Howell's] portrait and unhappy about that of Miss Mildred. Now, ten years later, I see the reverse would be the proper state of mind."[75]

One of the last group portraits of Saint-Gaudens's career was his relief of Wayne and Virginia C. MacVeagh (fig. 106), in which he showed the elderly couple looking tenderly at each other. Each rests a hand on the back of the bench on which they sit; their hands, though close, do not touch, nor need they; the lifelong devotion of the two exquisite figures is inherent in their pose.

Saint-Gaudens described as among his favorite single-portrait reliefs those of Sarah Redwood Lee (fig. 59) and Samuel Gray Ward (fig. 107). Ward was a financier who combined his keen business acumen with a knowledgeable attachment to art. He was one of the founders of the Metropolitan Museum, a member of its Board of Trustees, and its first Treasurer. In the 1881 portrait of Ward, Saint-Gaudens's virtuosity can be seen in the rich texture and loose handling of the jacket and in his treatment of Ward's bristlelike beard and mustache, both so skillfully rendered that their roughness is almost tangible (fig. 108). The Lee and Ward portraits were especially pleasing to Saint-Gaudens because they were the lowest reliefs he ever attempted. His fondness of them is understandable: in each, the portrayal of the sitter is comparable to a fine line drawing. The exquisite work in the *Ward* can be further likened to a print in bronze: the hatching that delineates the

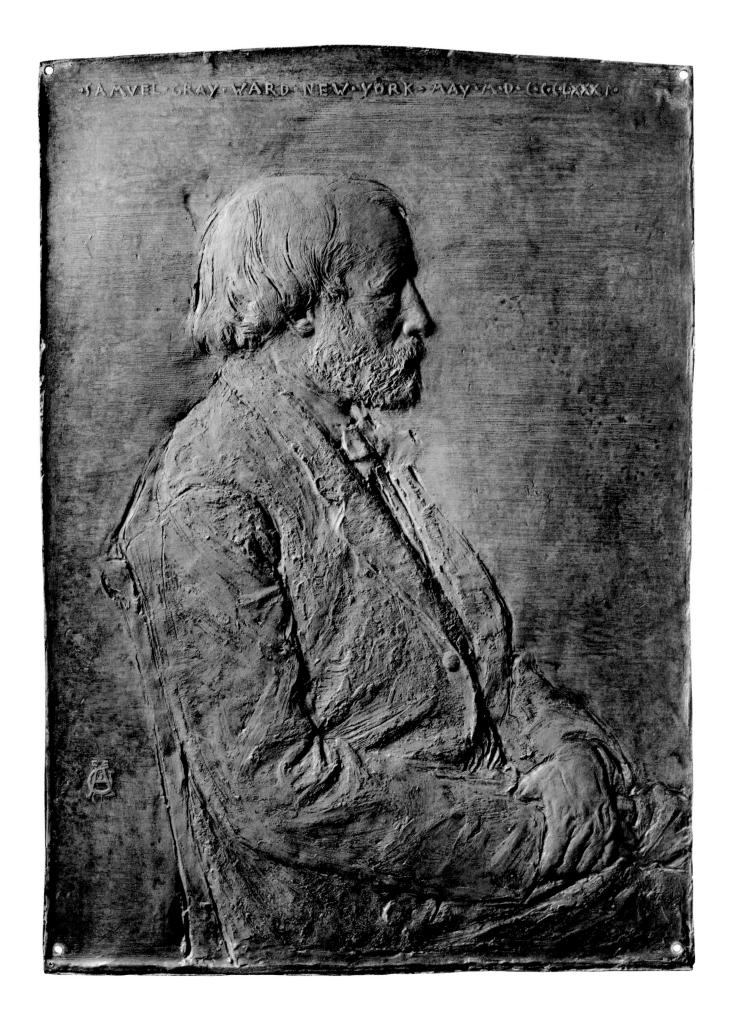

114

Fig. 107 (opposite). AUGUSTUS SAINT-GAUDENS, *Samuel Gray Ward*, 1881, bronze relief, 19¼ in. × 14 in. (New York City, Collection of Erving and Joyce Wolf).

Figs. 108–110. *Samuel Gray Ward*, details.

background recalls the technique of etching; the treatment of the clothing, the surface now soft and suffused, that of drypoint (figs. 109, 110).

Saint-Gaudens was especially successful in his reliefs of women. The 1884 portrait of Bessie Springs Smith (pl. III), Saint-Gaudens's wedding present to Bessie's husband, Stanford White, is a great achievement. Bessie's charming gesture of brushing aside her wedding veil with her hand serves as a compositional device to expose her face but at the same time can be read as a symbol of her revealing herself to the full promise of love. The flowers she holds are also in the process of unfolding, a delicate reflection of Bessie's measured progression along the pathway of life.

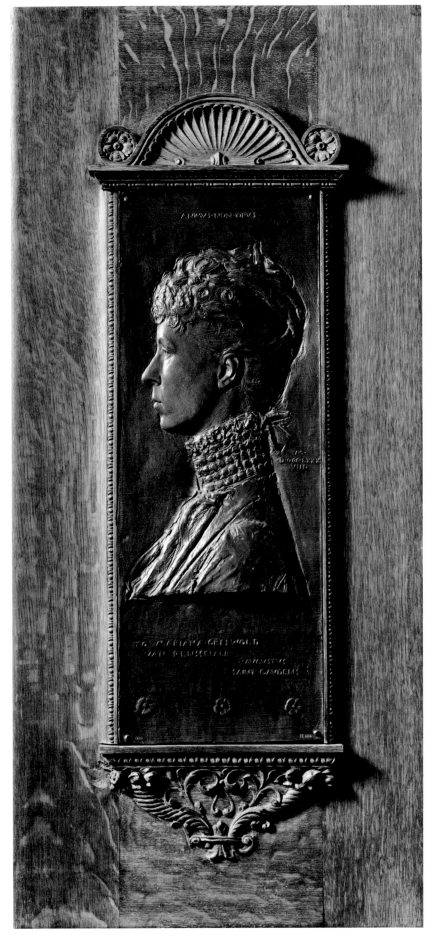

Fig. 111. Augustus Saint-Gaudens, *Portrait of Mrs. Schuyler Van Rensselaer,* 1888, this cast 1890, bronze relief, 20⁷⁄₁₆ in. × 7¾ in.; wood frame probably designed by Stanford White (New York City, The Metropolitan Museum of Art, Gift of Mrs. Schuyler Van Rensselaer, 1917).

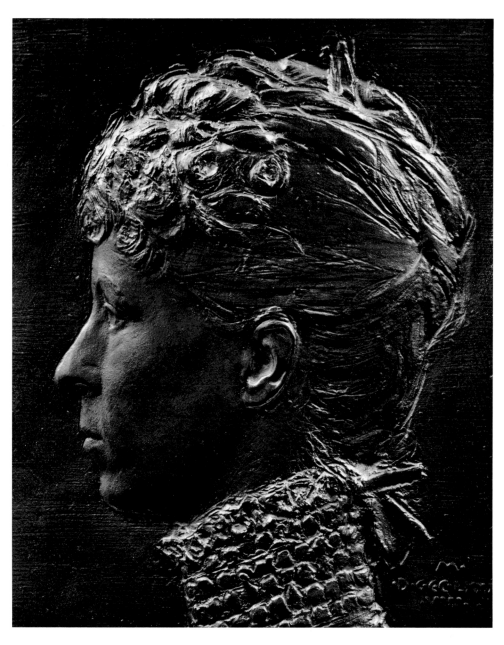

Fig. 112. *Portrait of Mrs. Schuyler Van Rensselaer*, detail.

One of the strongest of Saint-Gaudens's female portraits is that of Mrs. Schuyler Van Rensselaer (fig. 111; pl. VII). Mrs. Van Rensselaer was a noted author (she had written the first monograph on Henry Hobson Richardson); she was also a critic whose articles appeared in many prominent periodicals of the day. She reviewed a number of Saint-Gaudens's works, always sympathetically; she and Saint-Gaudens admired and greatly respected each other. The sculptor has inscribed the 1888 relief at the top with a legend that can be translated as "The spirit, not the work," and, at the bottom, simply "To Mariana Griswold/Van Rensselaer/Augustus/Saint-Gaudens." While the relief does not attempt to play down the subject's formidable character, it does contain some delicate features—the curls on her forehead and the wisps of hair that gently touch the base of her neck, for example—that soften her strong features (fig. 112).

In the bronze portrait of Louise Miller Howland (fig. 113), which is set off by a majestic frame presumably by Stanford White, Saint-Gaudens sought variety in a three-quarter-length composition in which he showed his subject leaning on a music-strewn piano. The concept is highly effective; its realization all the more laudable for its being a posthumous portrait, done exclusively from photographs. Saint-Gaudens experimented with the three-dimensionality of the relief, exploring it to a depth he did not employ again until he approached the final version of the Shaw memorial, which he completed nine years later.

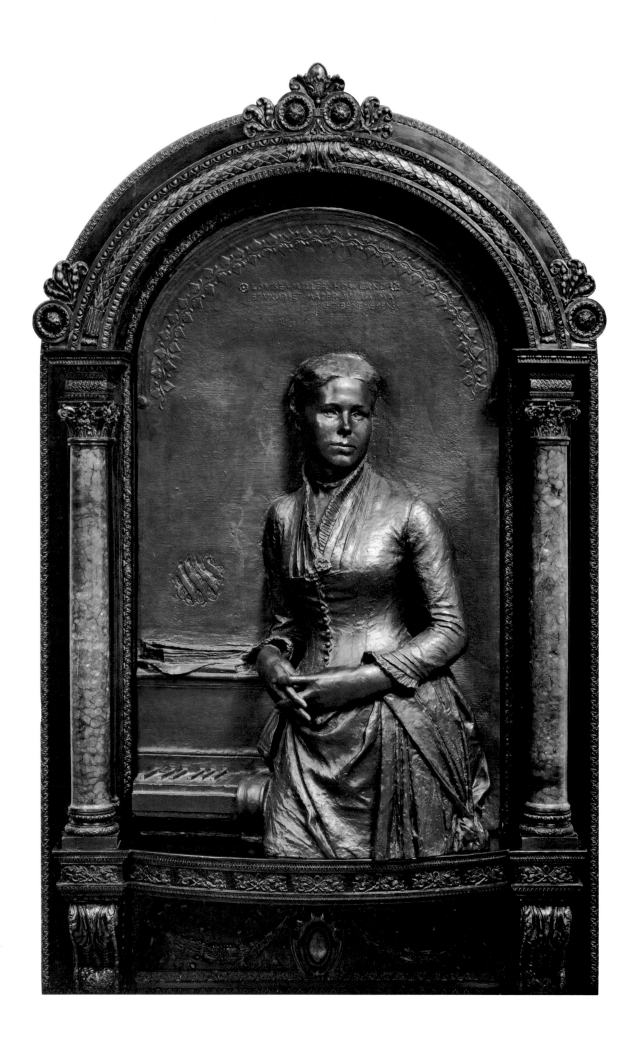

In these single-relief portraits of the 1880s Saint-Gaudens's success in executing them in all degrees of depth is a measure of his technical genius. From the shallowest, the portrait of Sarah Lee (fig. 59), to the deepest, that of Louise Howland (fig. 113), each is a perfect rendering. Seldom in the history of sculpture is a similar virtuosity found.

When Saint-Gaudens read Robert Louis Stevenson's *New Arabian Nights*, he was so enthusiastic about it that he told his friend Will Low, who was also a friend of the writer's, that if Stevenson ever came to the United States he would be pleased to model his portrait (fig. 114). Stevenson sat to Saint-Gaudens several times in 1887 and 1888 in his New York City hotel. He greatly influenced the sculptor's taste in literature, leading him through his own stories and essays and thence to the writings of other contemporary authors until Saint-Gaudens became a steady and appreciative reader. [76] The two men became fast friends, and carried on a steady correspondence until Stevenson's death, in 1894.

Stevenson was debilitated by tuberculosis and had to keep to his bed, where he wrote propped up with pillows. When Saint-Gaudens learned that his subject would be greatly uncomfortable in a conventional pose, he suggested that Stevenson write in his familiar position while his portrait was being modeled. The work, which shows Stevenson holding a budget of papers in one hand and one of his invariable cigarettes in the other (fig. 115), became one of the sculptor's best-known and most frequently reproduced portrait reliefs (fig. 116). To maintain the spontaneity of the portrayal through several subsequent commercial versions (fig. 117), the sculptor constantly varied some of its details as well as its size, shape, color, and inscription. [77]

A great honor was paid Saint-Gaudens when he was asked to do the memorial to Stevenson in the Church of St. Giles, in Edinburgh (fig. 118). The memorial committee had their choice of an international roster of sculptors; that they chose an American was tribute indeed. Saint-Gaudens remodeled his Stevenson relief for the memorial, increasing its size and changing several details: the bed to a lounge, for instance; the cigarette to a pen. Instead of stamping the letters of the inscription he modeled them—twelve consecutive times. He was worried over the actual inscription; he wanted to use Stevenson's poem, "Lines to Will H. Low," but was under pressure from the committee to choose instead a Stevenson prayer. In the end, he yielded to the committee's wishes and incorporated a prayer of Stevenson's ("Give us grace and strength to forbear and persevere") into the background. The relief is surrounded on top and sides with a garland of laurel, which ends at either side in Scottish heather and Samoan hibiscus (this last a reference to Stevenson's residence in Samoa, where he had lived from 1889 and where he is buried). The commission required Saint-Gaudens to make two trips to Great Britain. He was received with great cordiality by English artists and sculptors and was eventually made a member of the Royal Academy. [78]

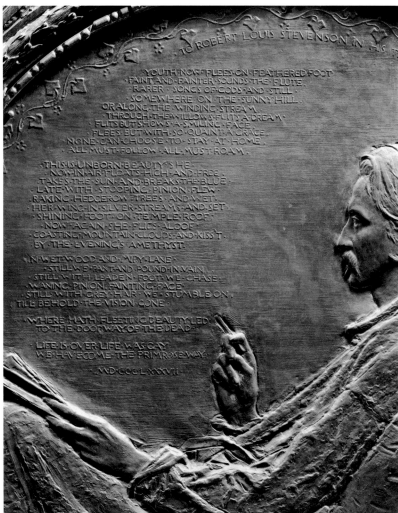

Fig. 114 (above). AUGUSTUS SAINT-GAUDENS, *Robert Louis Stevenson*, 1887, this cast 1890, bronze medallion, diam. 36 in.; wood frame probably designed by Stanford White (Princeton, New Jersey, Princeton University Library).

Fig. 115 (left). *Robert Louis Stevenson*, detail.

Fig. 116 (opposite, above left). AUGUSTUS SAINT-GAUDENS, *Robert Louis Stevenson*, 1887, this cast copyrighted 1892, bronze medallion, diam. 34½ in. (London, The Tate Gallery).

Fig. 117 (opposite, above right). AUGUSTUS SAINT-GAUDENS, *Robert Louis Stevenson*, 1887, this cast 1898, bronze medallion, diam. 17⅞ in.; wood frame probably designed by Stanford White (New York City, The Metropolitan Museum of Art, Gift of Anne Tonetti Gugler, in memory of her mother, Mary Lawrence Tonetti, 1981).

Fig. 118 (opposite, below). AUGUSTUS SAINT-GAUDENS, *Robert Louis Stevenson*, 1887, this cast 1902, bronze relief, 91 in. × 110 in. (Edinburgh, St. Giles' Cathedral).

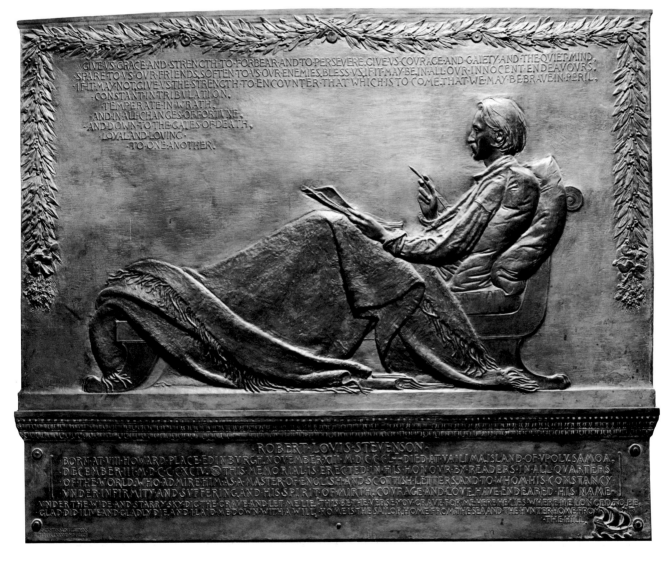

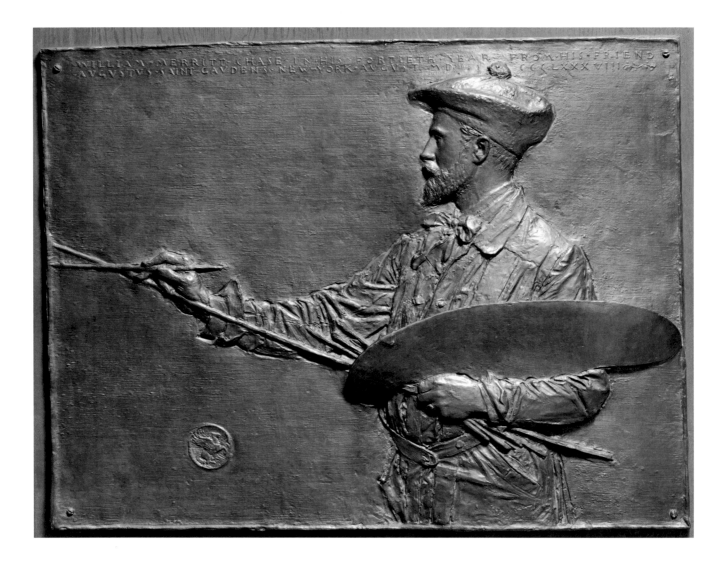

A superb relief of William M. Chase (fig. 119) fits into the category of Saint-Gaudens's depictions of his artist friends, this one honoring Chase in his fortieth year. The profile view of the painter shows him standing at an easel that lies beyond the perimeter of the portrait. The beauty of the modeling is matched by the compositional design. Saint-Gaudens has made full use of the width: Chase's brush touches the left side of the relief; the curved edge of his palette, the right. The pom-pom on the artist's beret, which obtrudes on the roman numeral date at the top, thus relieving its austerity, demonstrates Saint-Gaudens's fidelity to his design scheme, even in the smallest element.

The frames that surround Saint-Gaudens reliefs contribute in a large measure to their mystique. Highly personal in style, they are more than just a means of protecting the reliefs or of mounting them on a wall; they are an integral part of the work they surround and they were carefully conceived for the rooms they would occupy: a reflection of another great artistic force that was then sweeping the country.

An extraordinary confluence of influences in America in the eighteen-seventies and eighties created a mushroomlike growth in all branches of artistic endeavor. The mainstream was the French Beaux-Arts style, but another powerful tributary was English in origin: the expression of the Aesthetic Movement, which was a joining together of smaller currents made up of the work of the Pre-Raphaelites, an interest in Japanese design, Italian Renaissance precedents, and the Arts and Crafts Movement.

The Aesthetic Movement was a concept of totality. In interior design, for example, every element of a room was carefully chosen to blend with and enhance the overall effect. Architectural features, paneling,

Fig. 119 (opposite). Augustus Saint-Gaudens, *William Merritt Chase*, 1888, bronze relief, 22 in. × 29½ in. (New York City, Collection of the American Academy and Institute of Arts and Letters).

lighting fixtures, paintings, tapestries, accessories—everything was carefully chosen and executed to the same discreet aesthetic scheme. Frames were also a concern. They were influenced by the subtly gilded frames around works of the Pre-Raphaelite Dante Gabriel Rossetti and the Anglo-American James McNeill Whistler. These, done to the artist's design, tend to be wide and flat, with round or square ornament carved into the surface; in the case of Whistler, sometimes only a simple reeded surface. American painters, designers, and architects who picked up on this new trend include Elihu Vedder, Louis Comfort Tiffany, and Stanford White.

Because of the close collaboration between Stanford White and Augustus Saint-Gaudens, Saint-Gaudens's frames can be presumed to be largely the work of White; indeed, they reflect White's creativity. For the most part, the frames on Saint-Gaudens's bronze reliefs are made from quarter-sawed oak (a method of cutting the wood that reveals its grain in an especially decorative manner) and are colored with an aniline stain, but in the complexity of their design they are endlessly varied. The simplest, however—those produced commercially for the Robert Louis Stevenson medallions (fig. 117), for instance—are constructed of flat pieces of poplar or oak mitered at the corners and, often, decorated only with three small stylized rosettes below the relief or a decorative band of carved beading around its opening. A frame of far more complicated design, richly reeded and octagonal in shape, surrounds the Stevenson medallion at the Princeton University Library (fig. 114). Even more innovative—and certainly those with the closest Aesthetic-Movement associations—are the flat oak frames whose sole decoration is their chip-carved surfaces. These appear on the Gilder (fig. 73) and Lee family (fig. 103) reliefs, that of the latter additionally embellished with small shell-like motifs. Possibly the most beautiful of all the Aesthetic-Movement-inspired frames is the opulently reeded one on the portrait of Dr. Henry Shiff (fig. 72), which relates directly to a painting frame documented to White.[79]

In contrast to the delicately carved and reeded frames are more ornate ones that are of Renaissance deriva-
tion. Among the simplest of these is the frame for the portrait of Mrs. Schuyler Van Rensselaer (fig. 111;
pl. VII), which is executed in quarter-sawed oak. A delicate egg-and-dart molding surrounds the relief; a
fifteenth-century-inspired architectural motif of a shell flanked by rosettes crowns it; a foliated design
completes it at the bottom. A far more elaborate frame is the gilded and richly ornamented object that White
is known to have designed for the Saint-Gaudens wedding present to him—the portrait of his bride, Bessie
Springs Smith (pl. III).[80] The most ambitious of the Renaissance-inspired frames on Saint-Gaudens's reliefs
reveals White's unmistakable touch: one in gilded gesso and wood with freestanding marble columns that
embellishes the high-relief portrait of Louise Miller Howland (fig. 113).

These frames for Saint-Gaudens's reliefs are one of the crowning successes of the American Aesthetic
Movement. That Saint-Gaudens, Beaux-Arts-trained and strongly rooted in the French tradition, accepted
frames for his reliefs that reflected the influence of another school is further evidence of his keen interest in the
integration of the arts (again, French in origin) and, more specifically, of his unique eye for decorative effect.
In the end, perhaps, the greatest inference to be drawn from this blending of two complementary styles is the
sculptor's steadfast trust in White's artistic integrity. White's frames are to Saint-Gaudens's reliefs what the
architect's pedestals are to the sculptor's statues.

Because Saint-Gaudens's childhood had passed in poverty and hard work, he resolved from an early age to
better his standard of living. He had a keen business sense, possibly inherited from his shrewd Gallic father,
and he was determined to earn enough money to see that he and Augusta and their child could enjoy the good
things of life, free from financial worry. He was therefore well aware of the necessity of keeping his work before
the public, and through the eighteen-eighties he continued to show his reliefs and busts, mainly in exhibitions
held by the Society of American Artists. He also participated in 1888 and 1889 in exhibitions at the National
Academy of Design, which despite its rejection of his work in 1877 had elected him, now a prominent sculp-
tor, an associate in 1884.

In that same year, his monument to Robert R. Randall was erected at Sailors' Snug Harbor, in Staten
Island, on a base designed by Stanford White. Saint-Gaudens had completed the figure in New York, but, in-
evitably, become discontented with it and tore it down. He professed himself much better pleased with the
second version, but when it was in place he changed his mind again, this time irrevocably. To the end of his life

he never found himself "on good terms with the work," and even in his later years his most charitable remark concerning it was "the less said about the 'Randall' the better."[81]

Saint-Gaudens's remark about the *Randall* is typical of his ruthless honesty where his art was concerned. He was an overwhelmingly prolific worker, accepting as many commissions as he could possibly cope with (and, later, when he had to leave much of the work to his studio assistants, more than he could cope with). While he was establishing his career he could not afford to turn away any commissions, but his heart was not always in those he accepted. If a work engaged his imagination, he poured his enormous creative energy into it, sparing no effort to bring it to fulfillment; when he was not particularly interested, he was capable of turning out mediocrities. His son once said of him that money meant nothing to him but the power to produce work:[82] that, as well as his need to support his family, was undoubtedly why he took on more than he could handle. No one knew better than he when what he produced was not up to his standards. In the final analysis, his oeuvre—encompassing over two hundred pieces—is astounding not for its size but for the number of masterpieces it contains.

In 1885, Saint-Gaudens, a gregarious man who derived much enjoyment from the company of his colleagues, joined the Century Club in New York. Later in the year, in need of a respite from the heat and stress of the city, the Saint-Gaudenses rented a house in Cornish, New Hampshire. They spent the summer there, taking with them Frederick MacMonnies and Philip Martiny, the two young sculptors who had worked with Saint-Gaudens on such projects as the Vanderbilt house and who were now his studio assistants. Louis joined them, too, for Saint-Gaudens had several important new commissions, including a statue of Abraham Lincoln for Chicago (fig. 120; pls. v, vi). The contract for the statue had been drawn up by the trustees of a Lincoln Memorial Fund under the will of Eli Bates, a wealthy Chicago businessman. The sculptor's fee was to be $30,000, a sum that was to cover not only a figure to be at least eleven feet high but also its pedestal. The contract also stipulated that a further $10,000 would be allotted for building a semicircular pavement and seating area if they could be in place within thirty months of the completion of the statue and base.

Saint-Gaudens had at first been doubtful about the move to Cornish, but was persuaded by Augusta, who was eager to go. He became convinced of the wisdom of his decision only when he was told by the owner of the house he was renting that there were in New Hampshire "plenty of Lincoln-shaped men." During that first summer the sculptor used the house's hundred-year-old barn as a workshop, making sketches for a seated Lincoln—his original idea—and a standing one. Saint-Gaudens had had a strong affinity for Lincoln since his childhood. In his reminiscences he recalls hearing the news of Lincoln's assassination; he remembers his father and mother weeping over the newspaper accounts of the death of the Great Emancipator; he writes vividly of joining the interminable line that led to Lincoln's bier in City Hall in New York, where he looked at

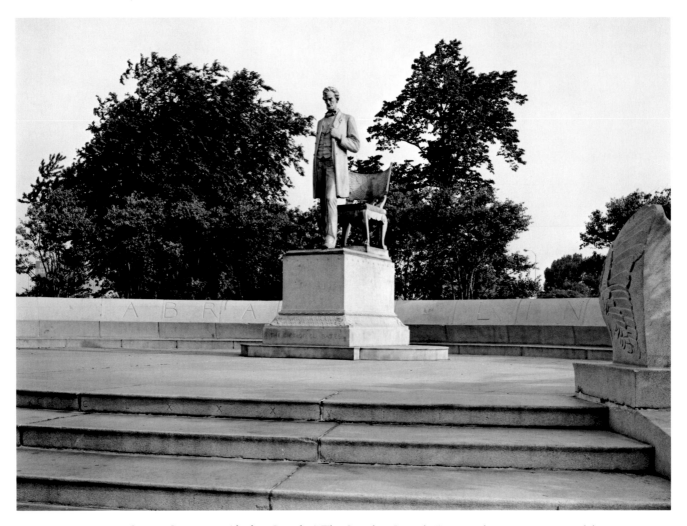

Fig. 120. Augustus Saint-Gaudens, *Abraham Lincoln* ("The Standing Lincoln"), 1887, bronze statue, over life-size; granite pedestal and exedra designed by Stanford White (Chicago, Lincoln Park).

the dead president and then went back to the end of the line to look at him again. He viewed the funeral from the roof of a theater on Broome Street; what remained in his mind was the sight of the men removing their hats as the funeral car went by, thus deepening the profound solemnity of his impression.[83]

For the head and hands of what came to be called "The Standing Lincoln," though the work's title is *Abraham Lincoln: The Man*, Saint-Gaudens relied on the 1860 life casts made by Leonard Volk, which had been discovered in the winter of 1885/86 in the possession of Saint-Gaudens's artist friend Wyatt Eaton; it turned out that Douglas Volk, Leonard's son, had given the casts to Eaton in Paris. As one of a thirty-three-member committee called together by Richard W. Gilder which had purchased the casts and given them to the Smithsonian Institution, Saint-Gaudens had received the bronze copies that were presented to each of the subscribers. For the figure, he used local models in working out the anatomical proportions, but he also drew on his memory of Lincoln, riding through a crowd of people and bowing to them, "a tall and very dark man seeming entirely out of proportion in his height with the carriage in which he was driven."[84] In his usual fashion, he made many sketches of the Lincoln figure, representing him as an orator or as a man fraught with worry (figs. 121, 122). In the end, he decided on a combination of both: a heroic and noble figure, deep in thought, who appears to have just risen from the chair behind him to begin an address. The expansive setting, complete with circular seat and pavement, was designed by Stanford White. Saint-Gaudens's addition of a chair (which must represent the Chair of State), from which the gaunt figure of Lincoln has obviously just risen, is without precedent in American sculpture.

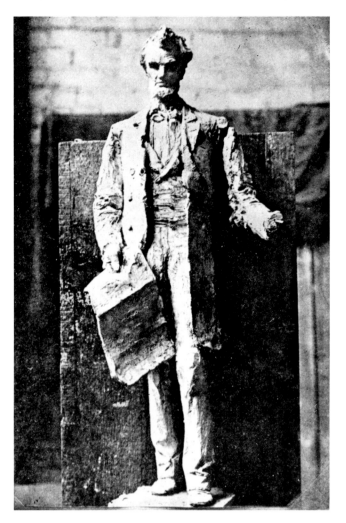

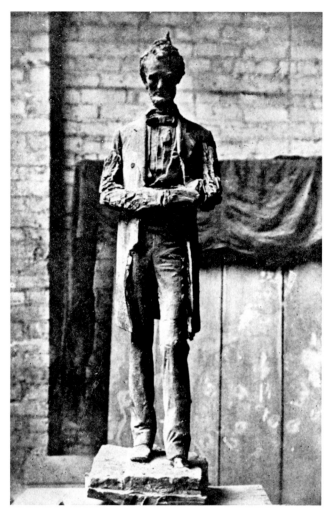

Fig. 121. AUGUSTUS SAINT-GAUDENS, "The Standing Lincoln," clay sketch, about 1885, destroyed; photograph (*The Reminiscences of Augustus Saint-Gaudens* 2, p. 27).

Fig. 122. AUGUSTUS SAINT-GAUDENS, "The Standing Lincoln," clay sketch, about 1885, destroyed; photograph (*The Reminiscences of Augustus Saint-Gaudens* 2, p. 27).

In an article titled "Saint Gaudens's Lincoln," published in *The Century*, Mariana Van Rensselaer wrote: "The Lincoln monument for Chicago is the most important commemorative work that Mr. St. Gaudens has yet produced and may well remain the most important of his life." She concluded her article by saying: "In the architectural portion of his work Mr. St. Gaudens was assisted by Mr. Stanford White, and together they have given us a monument which is the most precious the country yet possesses; which is not only our best likeness of Abraham Lincoln, but our finest work of monumental art."[85]

Another major work occupying Saint-Gaudens's attention at the same time was *The Puritan* (fig. 123; pl. IV), a representation of Deacon Samuel Chapin, one of the founders of the city of Springfield, Massachusetts. The statue had been commissioned by Chester Chapin, one of the deacon's descendants. In 1881, Saint-Gaudens had done a portrait bust of Chester, which he used as a model for the Puritan's head. What he sought in his presentation of *The Puritan* was to achieve not just a realistic portrayal of an idea but one endowed with a life and meaning that would transcend the limits of its physical entity. Here he succeeded: though he portrayed a figure in Puritan costume, the statue is not a portrait of an individual man but the embodiment of the Puritan spirit, purposeful and austere. The figure is splendidly realized: imbued with a sense of motion by the cloak that flows out behind him and with dedication and determination by the Bible and staff he carries, he exemplifies the principles and fortitude that the Massachusetts Bay Colony was founded on. Saint-Gaudens's achievement in *The Puritan* can be compared with that of Auguste Rodin (1840–1917) almost a decade later, when in his portrait of Honoré de Balzac (fig. 124) Rodin went beyond the writer's likeness and focused in-

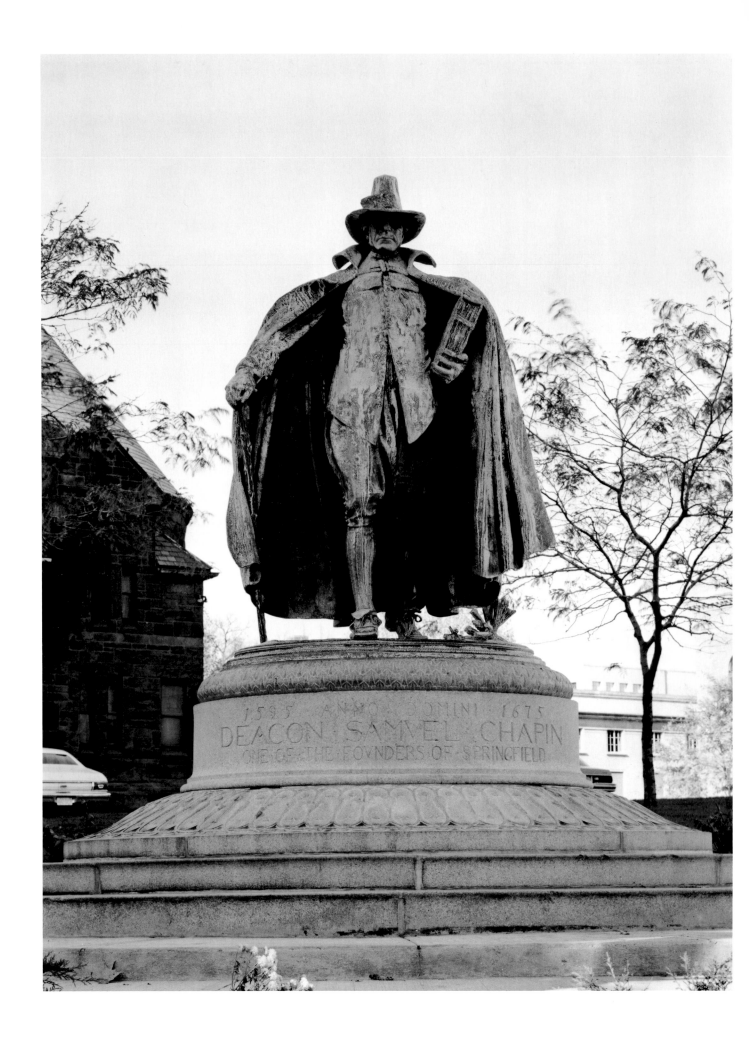

Fig. 123 (opposite). AUGUSTUS SAINT-GAUDENS, *The Puritan*, 1886, bronze statue, over life-size; granite pedestal designed by Stanford White (Springfield, Massachusetts, Merrick Park).

Fig. 124 (left). AUGUSTE RODIN, *Monument to Balzac*, 1897–98, this cast 1954, h. 106 in. (New York City, Collection, The Museum of Modern Art, presented in memory of Curt Valentin by his friends).

Fig. 125 (below). *The Puritan* in its original location in Stearns Square, Springfield, Massachusetts; photograph (Courtesy, Springfield Central Business District, Inc.).

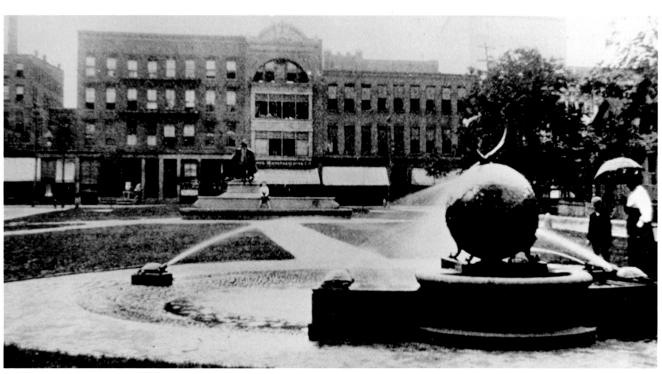

Fig. 126 (opposite). AUGUSTUS SAINT-GAUDENS, Figure for *The Adams Memorial*, 1890–91, bronze statue, over life-size, on stone base; granite pedestal and setting designed by Stanford White (Washington, D.C., Rock Creek Cemetery).

stead on his genius, evoking that quality so brilliantly that it can further be seen as a celebration not of the genius of just one man but of genius itself.

In White's design for *The Puritan*, the figure, set on a simple monolithic base, stood at one end of the site; at the other was a spherical pool with a central fountain and four bronze turtles set about it (fig. 125). Surrounding the pool was a stone seating area. The statue was unveiled on Thanksgiving Day, 1887, but twelve years later it was moved to Springfield's Merrick Park. White's carefully designed setting, unfortunately, was not reconstructed at the new site.

In comparing two of Saint-Gaudens's early public works Royal Cortissoz wrote: "Under the pressure of a greater inspiration . . . his art leaped forward, rising to a more imposing height."[86] That statement can be fittingly applied to a work the sculptor embarked on in 1886, the year *The Puritan* was completed. The Adams Memorial (fig. 126; pls. IX, X), commissioned by the writer Henry Adams, whose wife, the former Marian Hooper, had died by her own hand the previous year, has often been described as the sculptor's masterpiece; "one memorable effort in the sphere of loftiest abstraction."[87] With it he produced an expression of tragedy on such an elevated plane that not all the intervening years have seen it surpassed. It is unique in his oeuvre; no other piece of his contains even a reference to it.

After his wife's death Adams left for a trip to the Orient. In Japan, he became interested in the philosophy of Buddhism, no doubt while seeking to assuage his grief, or, perhaps, looking for an answer to the unanswerable. On his return he asked La Farge, a friend of his, to approach Saint-Gaudens to do the memorial for his wife's grave, which he would eventually share. He did not wish to consult the sculptor personally, nor was he able to express in any but the vaguest terms what concept he had in mind. He left La Farge to discuss the details with Saint-Gaudens; the task of discovering just what Adams wanted took the sculptor five years.

Fig. 127 (left). Augustus Saint-Gaudens, *The Adams Memorial*, clay sketch, about 1887, destroyed; photograph (Hanover, New Hampshire, Dartmouth College Library).

Fig. 128 (above). Augustus Saint-Gaudens, *The Adams Memorial*, clay sketch, about 1887, destroyed; photograph (New York City, Collection of the American Academy and Institute of Arts and Letters).

Fig. 129 (opposite). Entrance to *The Adams Memorial*.

Because Saint-Gaudens used both male and female models for his sketches (figs. 127, 128), he created a presence, cloaked in rough, heavy drapery, that is sexless, ageless, timeless, expressionless, and unfathomable. Opposite the gravestone is a stone exedra bench where a visitor can rest while all mortal associations drain away, gradually to be replaced with a profound sense of quietude, solace, and peace. What Saint-Gaudens achieved is not identifiable in any sense of the word: the figure is neither Eastern nor Western and only possibly an Occidental interpretation of some unknown and featureless Oriental quality. He never gave the work a title, and he did not live long enough to discuss it in his *Reminiscences*. His intention, like the figure, is shrouded in mystery.

The memorial, thoroughly secluded by shrubbery that has matured since its planting, is difficult to find within the cemetery (figs. 129–134). A narrow entrance leads to the site—a rectangle containing a hexagon formed by a slab behind the bronze figure and the four-sectioned bench that faces it. The small contained arena is filled with an extraordinary sense of solitude that seems to emanate from the figure, an atmosphere that may be a reflection of the intense privacy and silence Henry Adams maintained in the years following his wife's death.

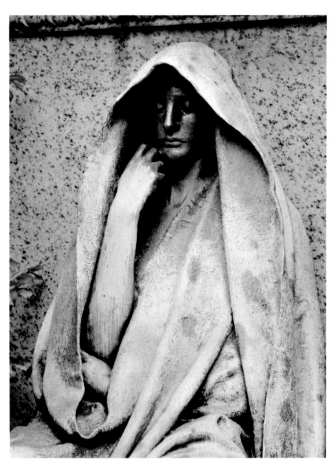

Figs. 130 (opposite, above), 131 (opposite, below). *The Adams Memorial.*

Figs. 132, 133 (above), 134 (right). *The Adams Memorial*, details.

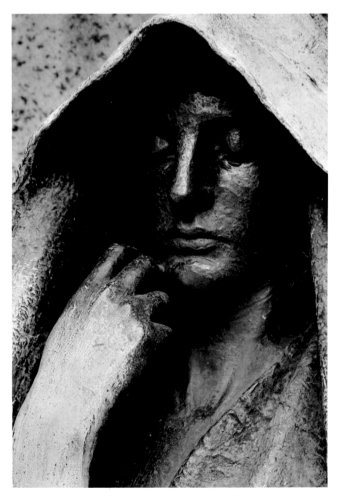

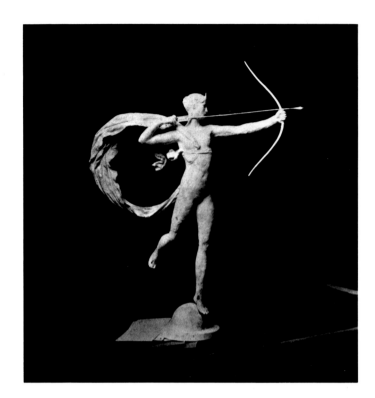

Fig. 135. Augustus Saint-Gaudens, Study for the first *Diana*, plaster sketch model; photograph (Hanover, New Hampshire, Dartmouth College Library).

Saint-Gaudens, forty years old and approaching the height of his career, began in 1888 what would be almost a decade of service on the faculty of the Art Students League. It was his first appointment as a teacher. Of the experience he was later to write: "It was of the greatest interest to me to watch the growth and development of talent among my pupils."[88] He gently urged on his pupils the influence of the Greeks before that of Michelangelo and his school. Specific names he mentioned to his followers were Phidias, Praxiteles, Michelangelo, Donatello, Luca della Robbia, Jean Goujon, Houdon, Rude, David d'Angers, Paul Dubois. Those came immediately to his mind, he said, but he added, "Of course, if we knew the names of the sculptors of the portal at Chartres or 'le beau Christ d'Amiens,' they would replace two of the more modern Frenchmen."[89] Which two he meant he did not say.

Homer Saint-Gaudens recorded some of his father's teaching methods. Saint-Gaudens believed that the most satisfactory way of beginning to sculpt lay in the ability to draw in charcoal. Another, though less important foundation he insisted on was an understanding of anatomy, since the knowledge of what was possible in the human figure would prove of immense aid in reproducing what was before a sculptor's eye. When a student thus prepared came to Saint-Gaudens, he was told to work as primitively as possible, to leave no tool marks showing, to make his surfaces seem as if they had grown there, to develop a technique and then to hide it. Saint-Gaudens began his pupils on studies from the nude, a training that he held to be of chief importance. He insisted that the figure should first have its center of gravity properly placed, and that from the beginning the pupils should make use of a plumb line. Saint-Gaudens next turned his attention to composition, asking his students to submit subjects and especially pleased when they came up with biblical or mythological themes. He regarded the construction of drapery and its treatment, the two closely allied, as of paramount importance. He concentrated his pupils' efforts on the figure, leaving the modeling of busts and reliefs to be treated in a place other than the League.[90]

Saint-Gaudens's studio assistants included his brother Louis, Frederick MacMonnies, and Philip Martiny. He found much to praise in them and in John Flanagan, who joined them later. He often recommended them for outside work, for when he recognized skill and promise in an assistant he was generous in his encouragement. Of all his assistants, MacMonnies was undoubtedly the most talented; the facility of his

Fig. 136 (above, left). Undated letter from Augustus Saint-Gaudens to Stanford White illustrating an idea for the *Diana* ("I will start the figure for the Tower today; something in this character"), brown ink on paper; sheet, 9^{15}⁄$_{16}$ in. × 5¾ in. (New York City, Columbia University, Avery Architectural and Fine Arts Library, Stanford White correspondence, Box 9).

Fig. 137 (above, right). LOUIS-ERNEST BARRIAS, *Fame*, 1878, this cast after 1889, bronze statuette, h. 28½ in. (Massachusetts, Wellesley College Museum, Gift of Dorothy Johnston Towne, Class of 1923).

Fig. 138 (left). AUGUSTUS SAINT-GAUDENS, Studies for *Diana*, pencil with ink notation on paper; sheet, 8⅜ in. × 5½ in. (New York City, Columbia University, Avery Architectural and Fine Arts Library, Stanford White correspondence, Box 9).

Fig. 139. MARIUS-JEAN-ANTONIN MERCIÉ, *Fame*, for *Gloria Victis*, 1874, bronze statue, h. 122½ in., detail (Paris, Musée du Petit Palais).

Fig. 140. AUGUSTUS SAINT-GAUDENS, *Diana of the Tower*, 1893–94, this cast dated 1899, bronze reduction, h. 38 in., detail (Washington, D.C., National Gallery of Art, Pepita Milmore Memorial Fund).

hand had been evident from the beginning. Saint-Gaudens gave him training in modeling and urged him to learn as much as he could when he went abroad, after 1884. MacMonnies went on to attend the École des Beaux-Arts in 1886 and 1887, and spent most of his life in France. Saint-Gaudens took an almost paternal interest in MacMonnies, which MacMonnies sometimes construed as meddling; Saint-Gaudens, in turn, often became thoroughly exasperated with the younger sculptor. Nevertheless, the two men admired each other and kept in close touch over the years.

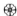

While Saint-Gaudens and White were beginning their discussions about the concept for the Adams Memorial, Saint-Gaudens made his first sculptural studies for the figure that was to be the weathervane on the top of White's 1891 Madison Square Garden: Diana, the goddess of the chase—an appropriate symbol for a building that housed sporting exhibitions (pl. VIII). The sculptor began with a bust of Davida Clark (1861–1910), a model who became his lover and the mother of his second son, and he later did a full-figure study of her for the *Diana* (fig. 135). Among Saint-Gaudens's earliest designs for Diana was a drawing (fig. 136) that shows his interpretation of "Fame," a motif then being used by European sculptors, including Louis-Ernest Barrias (1841–1905) in his *Fame* (fig. 137). Writing to Stanford White (see caption, fig. 136), he described his conception as being "on a ball with drapery blowing in the wind"; in another preliminary drawing he concentrated

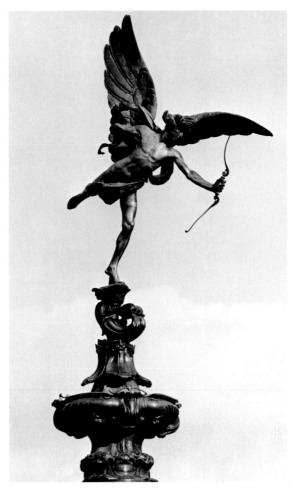

Fig. 141. AUGUSTUS SAINT-GAUDENS, the second *Diana* atop Madison Square Garden; photograph (Hanover, New Hampshire, Dartmouth College Library).

Fig. 142. ALFRED GILBERT, *Eros*, for the monument to Antony Ashley Cooper, seventh earl of Shaftesbury, 1893, aluminum, life-size (London, Piccadilly Circus).

on the swirling of the drapery (fig. 138). In their elegant facial features and in the twist of their hair a resemblance can be seen between the figure of Fame in Mercié's *Gloria Victis* (fig. 139) and that in a reduction of the second version of *Diana* (fig. 140). The second version of Diana (fig. 141) can be compared with Sir Alfred Gilbert's 1893 figure of Eros (fig. 142), in London, which surmounts his monument to Lord Shaftesbury: each of the two mythological images—one made of sheet copper, the other of aluminum—holds a bow and has a modest drapery that flutters about its naked body.

The first version of *Diana*, created in gilded sheet copper, was eighteen feet high and weighed two thousand pounds. The golden goddess (Saint-Gaudens's only nude female figure) stood on a globe, taking aim with the arched bow she held. A wonderful sweep of drapery behind her was designed to act as a rudder as she rotated on her base. When she was hoisted into place, in 1891, the entire city of New York was mesmerized by the sight. The Garden was higher than most of the surrounding buildings, and the lighted figure was a dazzling beacon against the night sky. White and Saint-Gaudens, however, were appalled. They had both agreed on the size of *Diana*, but she proved disproportionately large for the tower. Moreover, she was too heavy to move in the wind. She was therefore removed and sent to the World's Columbian Exposition in Chicago, where she was set on top of the Agricultural Building. When the exposition closed, she disappeared. Saint-Gaudens next did a version thirteen feet in height, which was also made of gilded copper sheeting. The modified figure, shorter and more slender, was installed on the Garden tower in 1894, but soon afterward lost her drapery-rudder to the wind and had to be bolted down. Though she could no longer serve as a weathervane, she was

Fig. 143 (opposite). Augustus Saint-Gaudens, *Diana*, 1893–94, gilded sheet copper, h. 156 in. (Philadelphia Museum of Art, Given by the New York Life Insurance Company).

Fig. 144 (right). Robert Gould Shaw, photograph (Boston, Courtesy of Parkman Shaw).

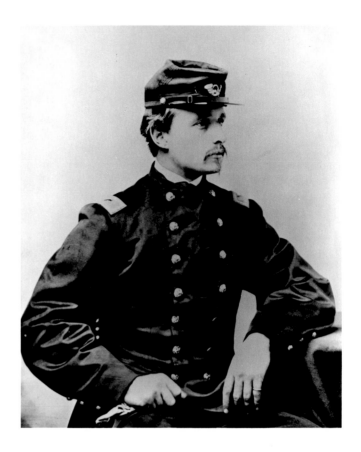

still a beautiful sight: by day, the sun was reflected from her golden surface; by night, she was illuminated against the surrounding darkness, a graceful landmark of the Gilded Age in New York. When Madison Square Garden was demolished in 1925, the figure was purchased along with the site, and finally ended up in the Philadelphia Museum of Art (fig. 143).

By 1887, almost every year was seeing either the commission for a major piece by Saint-Gaudens or the completion of one. In 1887, the Bates Fountain and the Standing Lincoln were unveiled in Chicago and *The Puritan* was installed in Springfield. The next decade would see a memorial monument to President James Garfield unveiled in Philadelphia's Fairmount Park, and the monument to Peter Cooper installed in New York. Saint-Gaudens could now concentrate his efforts on a commission he had been awarded in 1884 but had not been able to finish.

In February 1863 Robert Gould Shaw (fig. 144), a twenty-five-year-old Bostonian of patrician parentage, a Harvard student who had left school after his junior year to fight in the Civil War, and a veteran of the Battle of Antietam, was named by the governor of Massachusetts to lead the country's first black volunteer regiment, the Fifty-fourth Massachusetts Volunteer Infantry. The decision to enlist black soldiers was controversial in the North; in the South, the Confederate Congress passed a resolution condemning the command of white officers over black men and declaring that any such Union officer, if captured, would be put to death or otherwise punished. The newly trained members of the Fifty-fourth set off from Boston Common for South Carolina on May 28. As the regiment of poorly outfitted but proud black soldiers and their delicate-faced commander marched past certain clubs and residences, the proper Bostonians pulled down their window shades to protest this outrage to their sensibilities. The Fifty-fourth distinguished itself in its first battle, rescuing the Tenth Connecticut Regiment from defeat on an assault on James and Morris Islands, and, without rest, set immediately forth to lead an attack on Fort Wagner, the guardian of Charleston. Colonel Shaw, on foot, led his men in their charge up a hill, where they were greeted by a murderous volley from the Confederate forces. Shaw fell with a bullet in his heart in the first moment of combat. In the ensuing slaughter half the men of the regiment were killed, wounded, or unaccounted for. The colonel's body was stripped of its uniform and

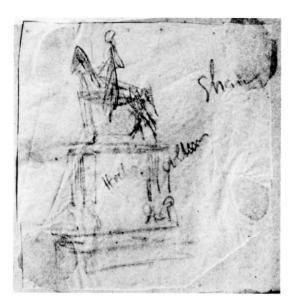

Fig. 145. AUGUSTUS SAINT-GAUDENS, Early drawing for *The Shaw Memorial*, about 1882; photograph (Hanover, New Hampshire, Dartmouth College Library).

Fig. 146. JEAN-LOUIS-ERNEST MEISSONIER, *Campagne de France, 1814*, 1864, oil on wood, 19^{11}/16 in. × 30^{5}/16 in. (Paris, Musée du Louvre).

Fig. 147. AUGUSTUS SAINT-GAUDENS, Study for *The Shaw Memorial*, plaster sketch, about 1883, 15 in. × 16 in. (Cornish, New Hampshire, Saint-Gaudens National Historic Site, National Park Service, U.S. Department of the Interior).

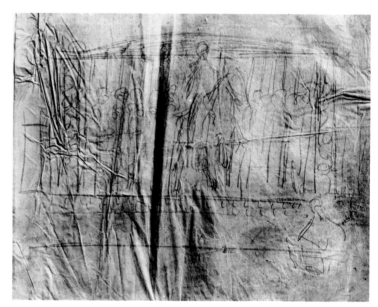

Fig. 148. AUGUSTUS SAINT-GAUDENS, Early drawing for *The Shaw Memorial*, about 1882; photograph (Hanover, New Hampshire, Dartmouth College Library).

thrown into a ditch, with the bodies of several of his men pitched in after him, but the regiment rose from its defeat, replenished its ranks, and went on to join in the eventual triumph of the Union Army.

In the North, plans for a fitting monument were immediately formulated, with Shaw's own regiment, though unpaid at the time, raising the first contribution. A substantial sum was realized, but the money went to provide the first free school for black children in Charleston, which was named after Shaw.[91] Next, in 1865, a group of twenty-one influential Boston citizens formed a committee to commission a monument to Shaw, and William Wetmore Story, then in Rome, was approached to sculpt an equestrian statue of him. Though he produced study sketches and a model of Shaw, nothing came of his efforts. Only in 1884, more than twenty years after Shaw's death, the commission was awarded to Saint-Gaudens through the good offices of his friend Henry Hobson Richardson. Saint-Gaudens, then a young sculptor, had just rented a studio in West Thirty-

Fig. 149. Augustus Saint-Gaudens, *Head of Soldier*, about 1890, this cast 1965, bronze model, h. 5¾ in. (Cornish, New Hampshire, Saint-Gaudens National Historic Site, National Park Service, U.S. Department of the Interior).

Fig. 150. Augustus Saint-Gaudens, *Head of Soldier*, about 1890, this cast 1965, bronze model, h. 7½ in. (Cornish, New Hampshire, Saint-Gaudens National Historic Site, National Park Service, U.S. Department of the Interior).

sixth Street for a period of five years (his tenure was to be fifteen), and though busy with other commissions, he immediately set to work. As he later wrote of the *Shaw*, "I, like most sculptors at the beginning of their careers, felt that by hook or crook I must do an equestrian statue, and that here I had found my opportunity (fig. 145)."[92] The Shaw family rejected his idea. Shaw had commanded a regiment of foot soldiers, not cavalry, and they felt that to portray him in the manner traditionally accorded only a national military hero was presumptuous. Saint-Gaudens then set about to find a way to reconcile his ideas with their wishes, and came up with a plan to associate Shaw directly with his men in a bas-relief. That met with the family's approval, and Saint-Gaudens began a project that would take more than twelve years to complete.

When Saint-Gaudens began his research for the *Shaw*, he asked his sister-in-law Eugenie Homer Emerson, then in Paris, to buy a photograph of Jean-Louis-Ernest Meissonier's 1864 painting *Compagne de France, 1814* (fig. 146) so he could examine it. In the painting, Napoleon is riding his horse toward the viewer; his generals are riding behind him. Saint-Gaudens made a drawing based on the painting, in which the equestrian Shaw, facing forward, is in the center of the composition (fig. 148). He rejected that view, however, in favor of a profile version (fig. 147).

Because of the intense interest he took in the work, he gradually expanded his conception from the low relief he had proposed—something that could reasonably be finished for the fee he had been offered, about $15,000—to a monument in high relief that saw the mounted Shaw increased in size almost to that of a statue and his men assuming more importance than the sculptor had originally intended. The troops gave him an immense amount of trouble. Because most of the men he was portraying were dead, Saint-Gaudens combed the highways and byways to find blacks who were willing to serve as models. The studies he made of some of their heads are among his finest portraits (figs. 149, 150). He was fascinated with the black physiognomy, and

Fig. 151. Augustus Saint-Gaudens, *Memorial to Robert Gould Shaw*, 1897, bronze relief, figures life-size; Knoxville marble frame and exedra on a granite base designed by Charles McKim (Boston, Boston Common).

sought faces that not only were of individual sculptural interest but would also contribute to the balance of the whole group.

In executing the work, Saint-Gaudens followed his usual pattern. No sooner would he arrive at the point of completion than he would tear his model apart and begin again, each time attaining a higher relief that in the end was almost freestanding. Because he was busy with other works such as the Adams Memorial and the *Diana* at the same time, the *Shaw* dragged on for so long that the committee became exasperated with him: when he requested more time, in 1892, they considered replacing him with Daniel Chester French, in order that "the statue might be ready in the probable lifetime of some members of the committee."[93] There was also disagreement over the inscriptions on the face and back of the monument; the committee wanted to use a somewhat lengthy motto, Saint-Gaudens wanted the inscription kept to a minimum. Finally, at the suggestion of Shaw's father, all agreed on the inclusion of four Latin words on the face of the relief that translate to "He forsook all to preserve the public weal," the motto of the Society of the Order of the Cincinnati, of which Shaw had been a hereditary member. On the back of the monument was inscribed a three-paragraph text composed by Charles W. Eliot, president of Harvard University.

The magnificent relief that resulted from Saint-Gaudens's thirteen-year endeavor is among his greatest

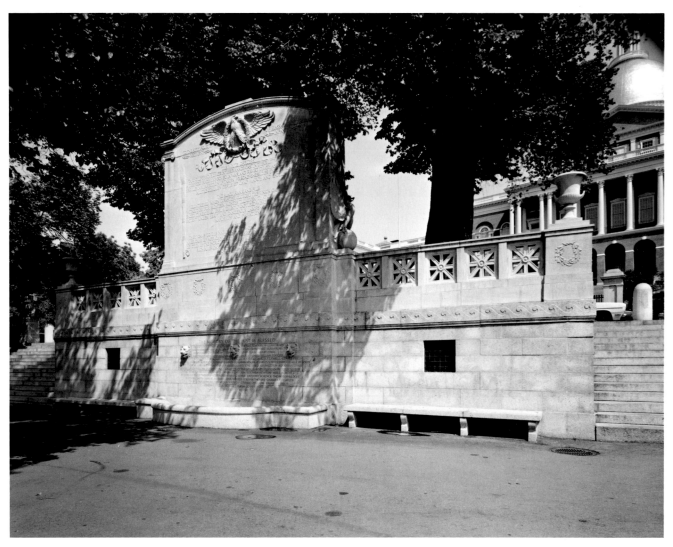

Fig. 152. *The Shaw Memorial*, rear view.

works. Set on an architectural frame of classical derivation designed by Charles McKim (figs. 151, 152; pls. XI, XII), it is best seen close up. From that vantage point, slightly beneath the relief, the viewer is thrust into close association with the soldiers who seem to be passing directly overhead (figs. 153–158). The line of march, led by the drummer boy and followed by the mounted figure of Shaw, is endless. Shaw's young face has an almost tragic expression; his young soldiers are stoic. They are accompanied by the trappings of war: their rifles and flags form one side of an obtuse angle; their outer legs and those of the horse form another; the drum, cut off at the front, is the apex. These stark backward lines serve only to accentuate the steady progress of the men: impelled forward by the angel of death who flies above them, they go inexorably on. The dominant force against the geometric background is the implacable Shaw on his spirited horse. The angel holds laurel and poppies, symbols of victory and final sleep; her flowing movement keeps pace with the prancing of the baroque steed, and the exquisite design of her drapery points up the harsh reality of the soldiers' uniforms. Though Saint-Gaudens's remarkable sense of design is nowhere more apparent, nowhere is it used to more painful effect. The inevitability implicit in the work is not limited to the movement of Shaw and his men but instead marks the passing of endless lines of young men marching off to endless wars. The work seems to throb with the sound of drumbeats, their cadence formed of such words as war, valor, patriotism; death, grief, waste.

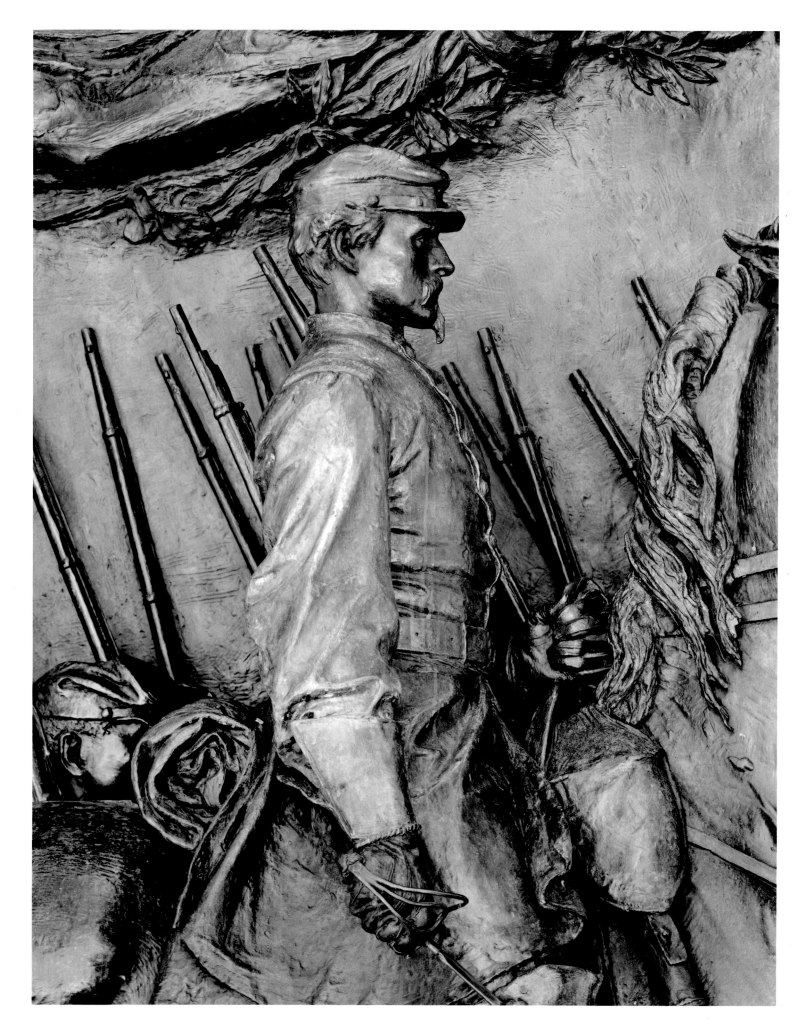

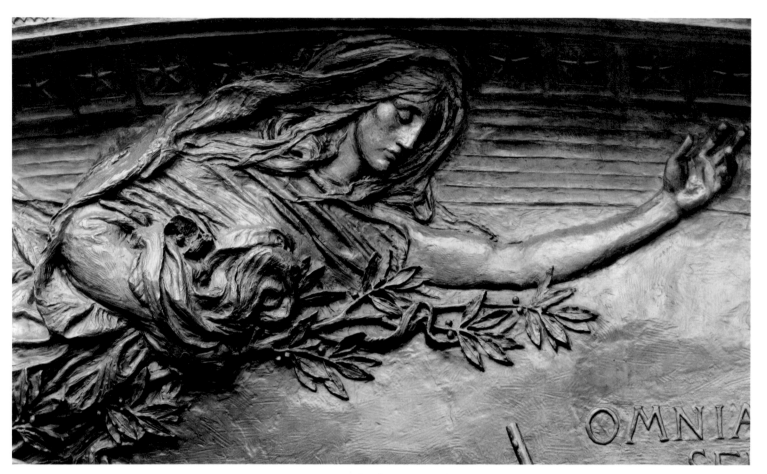

Figs. 153–158. *The Shaw Memorial*, details.

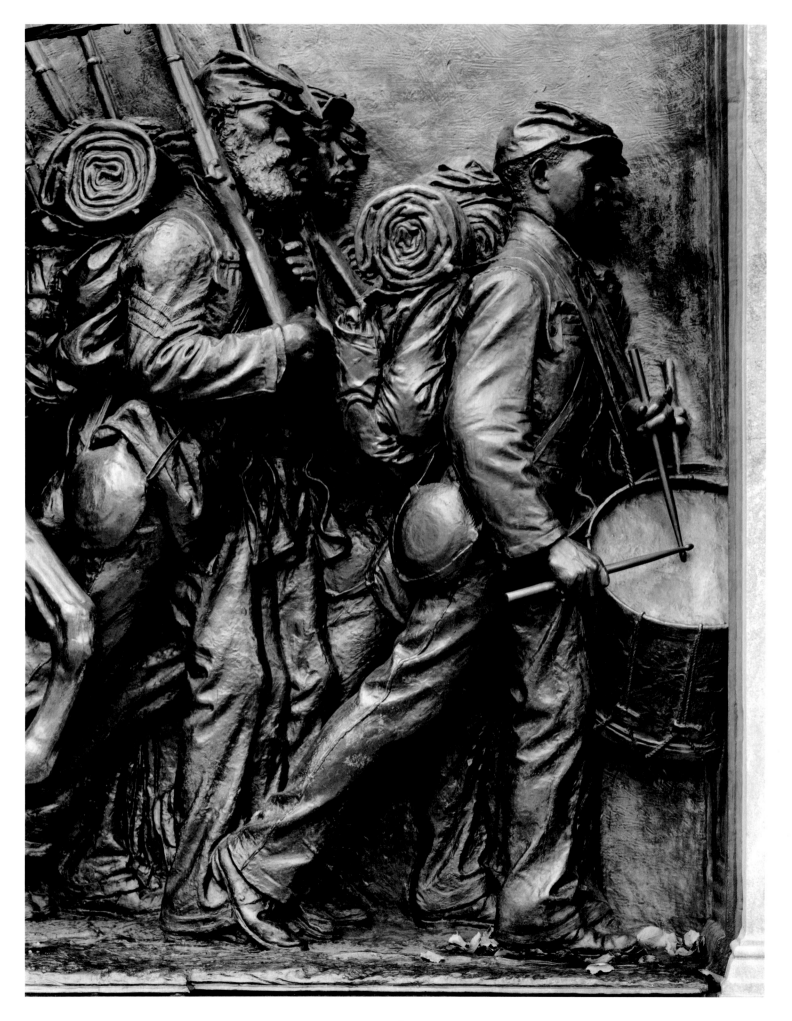

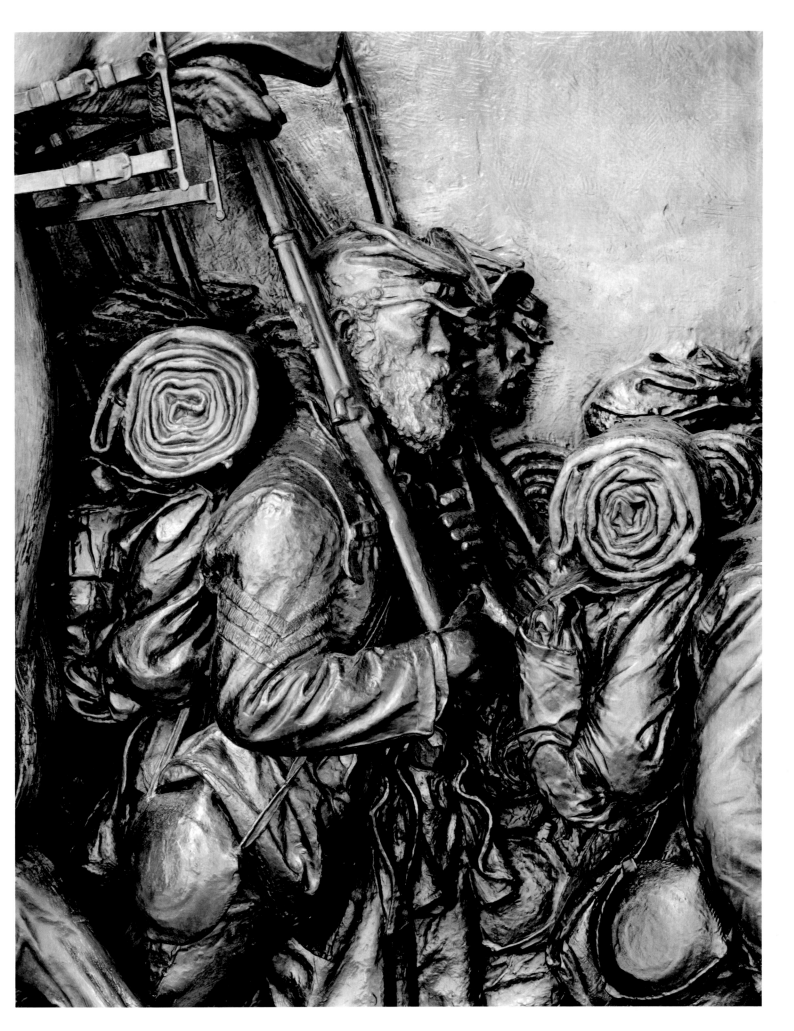

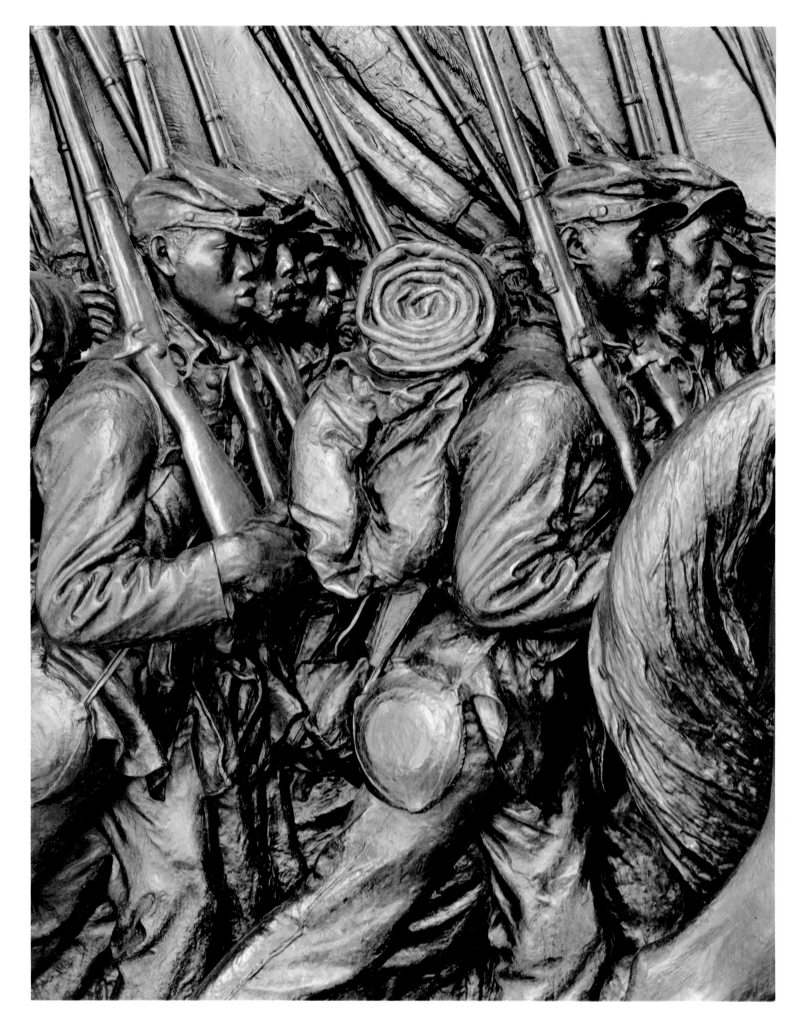

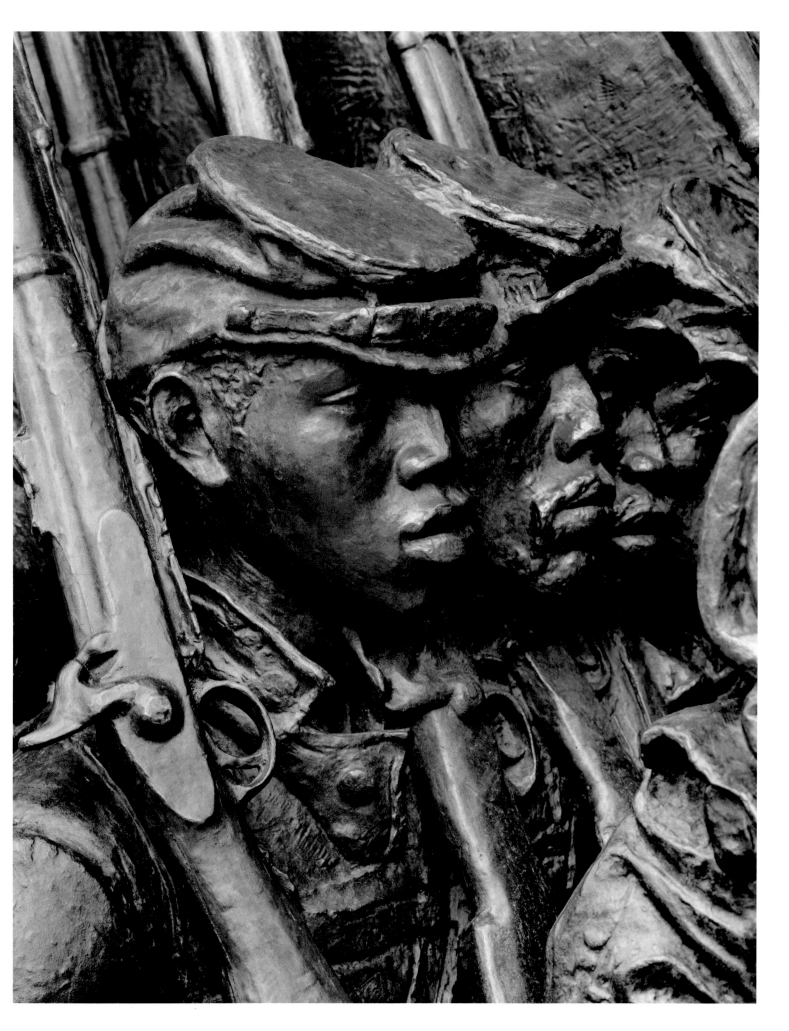

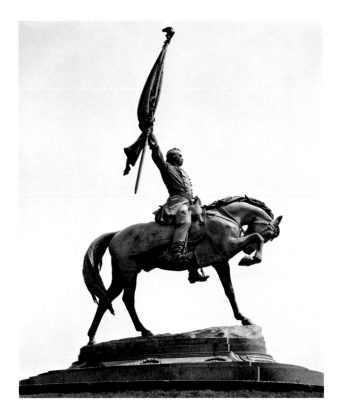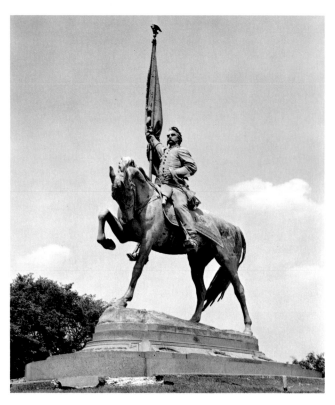

Figs. 159, 160. Augustus Saint-Gaudens, *The Logan Monument*, 1897, bronze equestrian statue of Major General John A. Logan, over life-size; granite pedestal designed by Stanford White (Chicago, Grant Park).

Toward the end of his thirteen-year labor on the *Shaw*, Saint-Gaudens began a monument to General John A. Logan (figs. 159, 160; pl. XIII), a Union officer and later a state senator from Illinois. The work was commissioned by the Illinois legislature in 1894; the design of the pedestal and the setting in Grant Park, at the intersection of Ninth Street and Michigan Avenue, were by McKim, Mead and White, with the assistance of Daniel Burnham, a Chicago architect. In the Logan monument Saint-Gaudens was able to achieve the heroic equestrian statue denied him by the Shaw family: the general, astride his great horse at the top of a hill, bearing his colors aloft, seems about to ride down the long flight of steps that lead straight out to Michigan Avenue. The *Logan* is a picturesque portrayal in the European tradition of Carlo Marochetti's *Richard the Lion-hearted* (fig. 161) or Emmanuel Frémiet's *Joan of Arc* (fig. 162). Each is a victorious figure erect on a spirited horse, one arm brandishing aloft a flag or a sword. The same dramatic image would recur in later American statues such as MacMonnies's *General Henry Warner Slocum* (dedicated in 1905, Brooklyn, New York, Grand Army Plaza), French's *George Washington* (installed 1902, Paris, Place d'Iéna), and Paul Wayland Bartlett's *Marquis de Lafayette* (unveiled 1908, Paris, Courtyard, Musée du Louvre).

Saint-Gaudens's role as a leader in the American art world had grown more illustrious with his elevation in 1890 to full academician at the National Academy of Design and his being named an honorary member of the Architectural League of New York. In 1891, he became one of the advisors on sculpture for the World's Columbian Exposition in Chicago, where his figure of *Diana*, from her place on the top of the Agricultural Building, would invoke his illustrious name. He was also to be represented at the Exposition by a colossal figure of *Christopher Columbus*, although the work had actually been modeled by Mary Lawrence, a pupil of Saint-Gaudens's at the Art Students League and one of his studio assistants. In August, Saint-Gaudens bought the house in Cornish where he had spent his New Hampshire summers. The view from the Cornish house of

Fig. 161. Baron Carlo Marochetti, *Richard the Lion-hearted*, 1860, bronze equestrian statue, over life-size (London, New Palace Yard).

Fig. 162. Emmanuel Frémiet, *Monument to Joan of Arc*, 1874, this cast 1899, gilded-bronze equestrian statue, over life-size (Paris, Place des Pyramides).

Mount Ascutney strikingly resembled the view he was familiar with from his father's stories of the Pyrenees, and he named the house Aspet, after his father's birthplace in southwestern France. (Bernard Saint-Gaudens died two years later.)

In 1894, in conjunction with his role as a member of the National Sculpture Society, an institution he had helped to establish the previous year, Saint-Gaudens, along with Olin Warner and John Quincy Adams Ward, served as advisor on the sculptural plan for the Reading Room of the Library of Congress. The plan called for a series of statues of allegorical subjects to decorate the ceiling-vault pendentives, and figures of related classical subjects to be placed on the balustrades below. Louis Saint-Gaudens was assigned the figure of *Homer*; Augustus, the figure of *Art*, which was modeled to his design by François Tonetti, Mary Lawrence's future husband. Also in the capacity of advisor on sculpture, Saint-Gaudens helped McKim to raise funds throughout the late 1890s for the founding of the American Academy in Rome, which was incorporated in 1905. It was a cause Saint-Gaudens felt stongly about. After his own experience as a foreign student in Rome he well recognized the need for an American equivalent of the French Academy in that city.

In 1897, two honorary degrees were bestowed on Saint-Gaudens; one by Princeton University, one by Harvard. (Yale was to honor him eight years later.) In the same year he received the commission for another statue of Abraham Lincoln; this one a bequest from a wealthy Chicago businessman named John Crerar. "The Seated Lincoln" (the formal title was *Abraham Lincoln: The Head of State*) was to be completed in 1906. The first model was destroyed in the fire that ravaged Saint-Gaudens's New Hampshire studio, and the unveiling did not take place until 1926, long after the sculptor and the designer of the base, Stanford White, were in their graves.

In November 1897, Saint-Gaudens left the United States for Europe. Homer speaks poignantly of his

father's departure: "He never returned [to New York] again as a resident. He had paid the city its price. From the 'Farragut' to the 'Shaw' he had given it his prime, his health. He left it a sick man, crippled for the remainder of his life by the ardor of his work. He had but ten years to live, ten years which he contrived through an extraordinary strength of will and body to spend wholly upon his art. When he returned to this land in 1900 he returned to the surgical ward of the Massachusetts General Hospital. . . . Let it not be thought . . . that Saint-Gaudens's sickness had taken him abroad. Quite on the contrary, it was his knowledge that his art had reached its strength that, for the last few years, had given him his desire to visit France. For in Paris alone he could measure himself with his contemporaries, place his work before the world's most critical audience, and learn, once for all, wherein it was good and wherein bad."[94]

On Saint-Gaudens's arrival in Europe he set off immediately on a trip to southern France, where he visited his father's birthplace—the original Aspet—and had photographs taken of the snow-capped Pic du Cahire, a prospect his father had often spoken of. (His modeling classes at the Art Students League were taken over by Mary Lawrence and another of his studio assistants.) He rented a studio in Paris that he would occupy for the next three years, a period during which he continued to work on commissions, both new and longstanding ones, and began to give serious attention to the casting of reductions and replicas of such works as *The Puritan*, the *Stevenson*, and the *Diana* for commercial distribution. He had seen how widely works by French sculptors —Mercié and Paul Dubois, for example—could be distributed, and had been interested when MacMonnies followed suit with a number of his works to great success and financial gain. Reductions of MacMonnies's *Diana* were cast by 1894; his *Bacchante and Infant Faun* and *Shakespeare* by 1897; his *Pan of Rohallion* and *Nathan Hale* were also being widely produced by the end of the century. Saint-Gaudens's interest in commercial distribution was not simply to increase his income but, rather, to see his work enjoying greater exposure. He nevertheless tried to vary his casts by changing perhaps an inscription, perhaps some minor detail, in an effort to endow each with individuality; to make each unique. Above all, he wished to avoid the taint of commercialism that would result from flooding the market with vast numbers of his pieces.

Saint-Gaudens visited London in January 1899 to attend a retrospective exhibition of the work of Sir Edward Burne-Jones (1833–1898), and then returned to Paris, where in April he called on Rodin and saw his *Gates of Hell*, which was then in progress. The work impressed him deeply. In 1900, with MacMonnies, A. Phimister Proctor, and Paul Wayland Bartlett, he served as a member of the committee to advise on the installation of sculpture for the United States commission in the Fine Arts Department at the Paris Exposition Universelle of 1900, where among the works he himself exhibited were several bronzes, including a cast of one of his best-known works, the *Amor Caritas* (fig. 99; pl. xiv). His work was awarded the Grand Prize, which led to the French Government's investing him as an Officer of the Legion of Honor and a corresponding member of the Société des Beaux-Arts, and offering to buy the bronzes for the Luxembourg Museum in Paris. Saint-Gaudens was flattered to have his work in that august institution, but asked that he be paid for it, for he wished it "clearly understood that it was *solicited* and *bought*, not offered by me to them."[95] The sum he named was a penny. The *Amor Caritas* had resulted from Saint-Gaudens's renewed preoccupation with the ideal figure lost in the fire that ended the Morgan tomb project and resurrected in 1887 for the Smith tomb in Newport. John Singer Sargent had become interested in the composition of the Smith tomb figure, and wished to make a painting of it. As Homer Saint-Gaudens related, ". . . Since my father had the greatest admiration for Sargent, he began to believe in a piece of his own work that could be paid so high a compliment."[96] According to Homer, in reworking the figure Saint-Gaudens had "modeled the wings in a more formal fashion and simplified the drapery with the greatest care. . . . It is pleasant to remember that the composition achieved such a success in the large that my father decided to reduce it to the small size now so frequently seen. He often announced his intention of producing this reduced figure in marble inlaid with gold and ivory and precious stones. Unfortunately he never found the time or the proper occasion."[97]

In 1900, Saint-Gaudens fell ill. By July his condition had not improved, and he returned to the United States to undergo surgery in Boston for the removal of an intestinal tumor. When it was discovered that the tumor was malignant, he removed himself to Cornish, organized his studio there, and engaged a staff of nearly

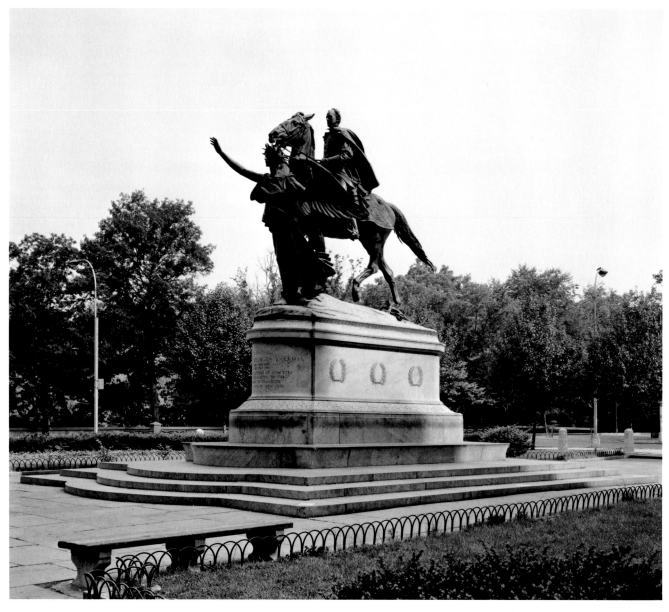

Fig. 163. Augustus Saint-Gaudens, *The Sherman Monument*, 1903, bronze equestrian statue of General William Tecumseh Sherman, over life-size; granite pedestal designed by Charles McKim (New York City, Grand Army Plaza).

a dozen assistants, including Louis, to work for him. It must have been clear to him that his illness was incurable, but he had many commissions left to complete and he continued to accept new ones: in 1901, he began work on the Parnell Monument for Dublin, which, like the *Stevenson* memorial in Edinburgh, was a great honor for an American artist to receive, and in 1902 he obtained the commission for the Daly Monument in Montana.

Saint-Gaudens's *Sherman Monument* (fig. 163; pl. xv) was the last great work of his career. He prepared for it over what was an unusually long time even for him. Through the influence of Whitelaw Reid, Saint-Gaudens had done a bronze bust of the general in 1888, when Sherman was living in New York (figs. 164, 165). Sherman had been a great hero to Saint-Gaudens, and he looked on the commission as a labor of love.[98] He completed the bust after eighteen two-hour periods. He later said that it had been a memorable experience, and that he regretted nothing more than he had not kept a daily record of the general's conversation, for he had "talked freely and most delightfully of the war, men and things." Saint-Gaudens had found the elderly general "an excellent sitter, except when I passed to his side to study the profile. Then he seemed uneasy. His

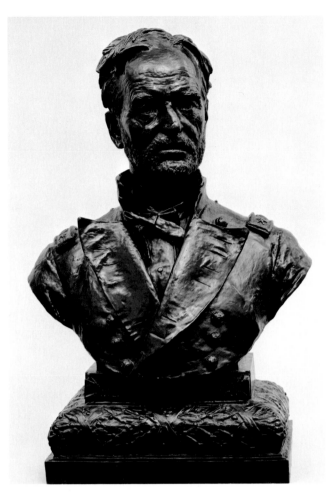

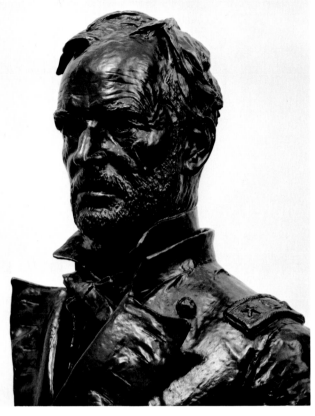

Fig. 164. Augustus Saint-Gaudens, *William Tecumseh Sherman*, 1888, this cast 1910, bronze bust, h. 31¼ in. (New York City, The Metropolitan Museum of Art, Gift by subscription through the Saint-Gaudens Memorial Committee, 1912).

Fig. 165. *William Tecumseh Sherman*, detail.

eyes followed me alertly. And if I went too far around, his head turned too, very much, some one observed, as if he was watching out for his 'communications from the rear.'"[99]

The bust, and particularly the intimate knowledge he had gained of Sherman during their conversations, were major influences on the great equestrian statue he began after he had completed the Shaw Memorial four years later. He took the work with him on his final trip to France. In his Paris studio he worked and reworked the model, worrying over the proportions of the horse's legs and seeking endlessly to determine the general's measurements. He also arranged and rearranged the drapery for the figure of Victory that according to the terms of his contract with the Chamber of Commerce of the State of New York he incorporated into the monument. At the Salon of 1899 he exhibited a plaster of the full-size equestrian statue as well as a model of the entire monument, complete with the Victory figure. In England, Sir Alfred Gilbert was working at the same time on a figure of Victory (fig. 166) that had appeared first as a gilded figure on the orb in Queen Victoria's hand in his Jubilee monument to her (1887, England, Winchester Castle). He later used the figure in a 1904 proposal for a memorial to the men who had fallen in the Boer War. In that version it led St. George as he rode over the

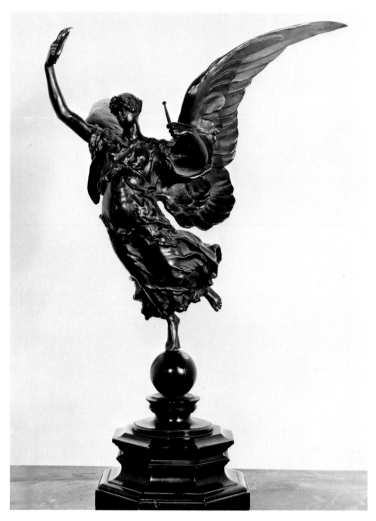

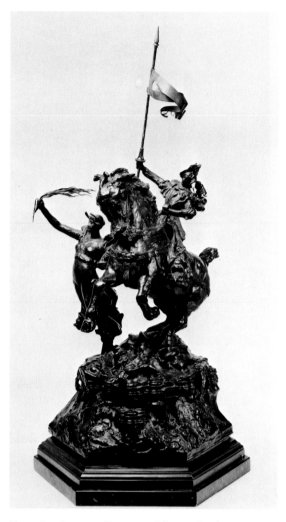

Fig. 166. ALFRED GILBERT, *Victory*, 1890, bronze statuette, h. 11 in. (London, Sir Brinsley Ford, CBE, FSA).

Fig. 167. ALFRED GILBERT, *Victory Leading St. George*, 1904, bronze sketch model, 17¼ in. (Cambridge, England, Permission of the Syndics of the Fitzwilliam Museum).

vanquished dragon (fig. 167). The monument was never realized. Gilbert's *Victory* figures are similar to that of Saint-Gaudens (fig. 168) in that each holds a palm frond and in each a sense of motion is created by the treatment of the drapery.

Saint-Gaudens struggled over his Victory's drapery (fig. 169; pl. XVI), giving vivid descriptions of his travails in several letters he wrote to his friends: "I have been arranging drapery on four copies I have made of the nude of the 'Victory,' and one of the four has come out remarkably well, so all I have to do is to copy it, and I am consequently much elated. . . . The reason I have felt so elated over this drapery business, is that it makes the drapery on the [Boston Public] Library figures . . . child's play, as far as the always complicated and terrible question of how to arrange flowing draperies goes. It's a question that each fellow has to dig out for himself." He wrote later, ". . . It's the grandest 'Victory' anybody ever made. Hooraah! and I shall have the model done in a month or so."[100] He moved from the problem of just the right fall of the drapery to his usual vacillation over the right way to present the general's cloak. He wrote to Louis about the work after the plaster of the monument had made its appearance at the opening of the Exposition Universelle in 1900: "I'm very cocky about the 'Sherman,' which has turned out well, particularly the 'Victory.' It has cost me about two thousand dollars, though, getting all these things together and in the Salon, and many, many gray hairs."[101] He left the principal bronze casting to be done in Paris when he returned to the United States, but even then he continued to alter certain features and send them back to the founders: the wings, which did not please him; parts of the general's cloak; the horse's mane; and the pine branch on the base, which referred to Sherman's march through Georgia to the sea.[102]

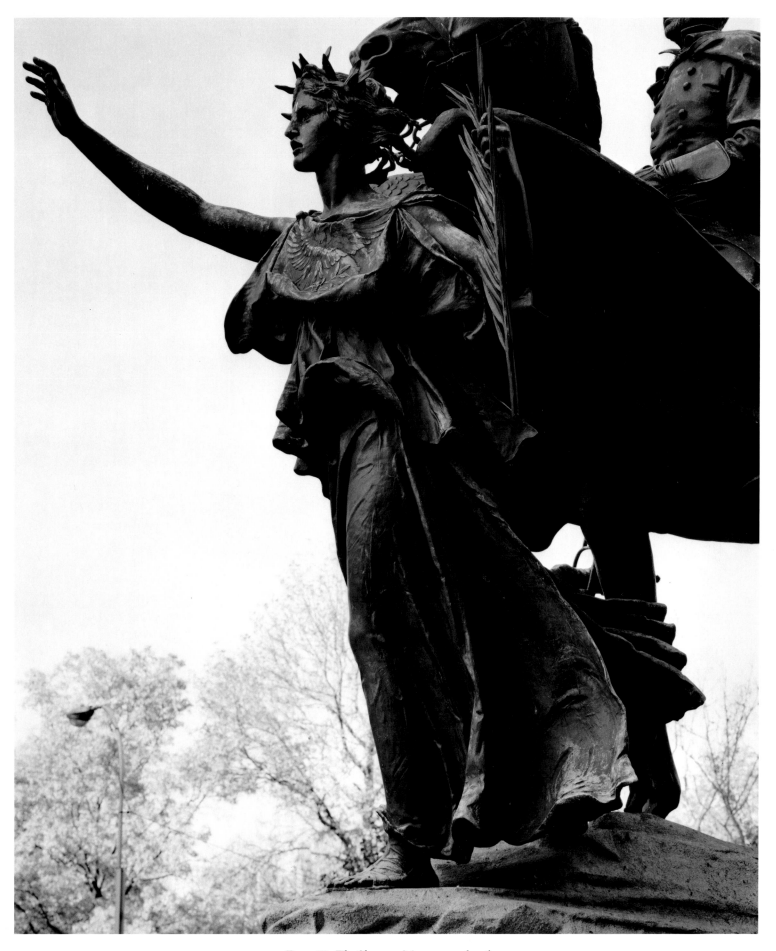

Fig. 168. *The Sherman Monument*, detail.

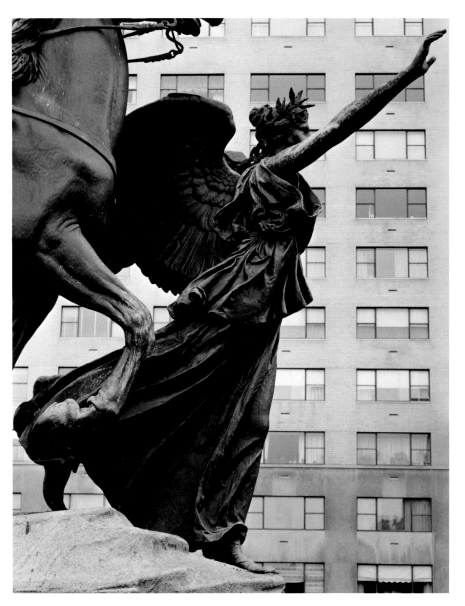

Fig. 169. *The Sherman Monument*, detail.

In 1900, after Saint-Gaudens was discharged from the hospital in Boston, one cast of the *Sherman* was in Paris, at the Exposition Universelle; a plaster duplicate was at the French foundry; a third was set up in Cornish so that he could rework certain elements. Homer Saint-Gaudens adds this note on his father's working methods: "This tendency almost endlessly to alter and re-alter details lasted to the close of his life, he himself being the first to recognize his crotchet and to laugh at it."[103] When the model was set up at Cornish, Saint-Gaudens concentrated his attention on the pedestal and considerations of color. Though he first proposed to have a combination of a gilded-bronze statue on a cream-colored base, he failed to obtain the stone he desired for the pedestal, and finally had the *Sherman* covered with two layers of gold leaf. The pedestal, designed by Charles F. McKim, was of pink granite.

The next struggle was over the location of the monument. Saint-Gaudens wanted it placed on Riverside Drive in New York City, in front of Grant's tomb, but his wishes were overridden by those of the Sherman family. The eventual site chosen was the southeast corner of Central Park. Even then Saint-Gaudens pressed to have the work placed to his satisfaction; he wanted it easily visible from all sides, and he requested that there be a "redisposition" of the trees around it. That called down on his head a controversy with Park Commissioner W. R. Wilcox, who sent him a firm letter, saying in part: ". . . I am unwilling for a moment to admit that the whole park system must revolve around a single statue, or that trees and grass, or other park features, must give way to any hobby, no matter by whom it is ridden."[104]

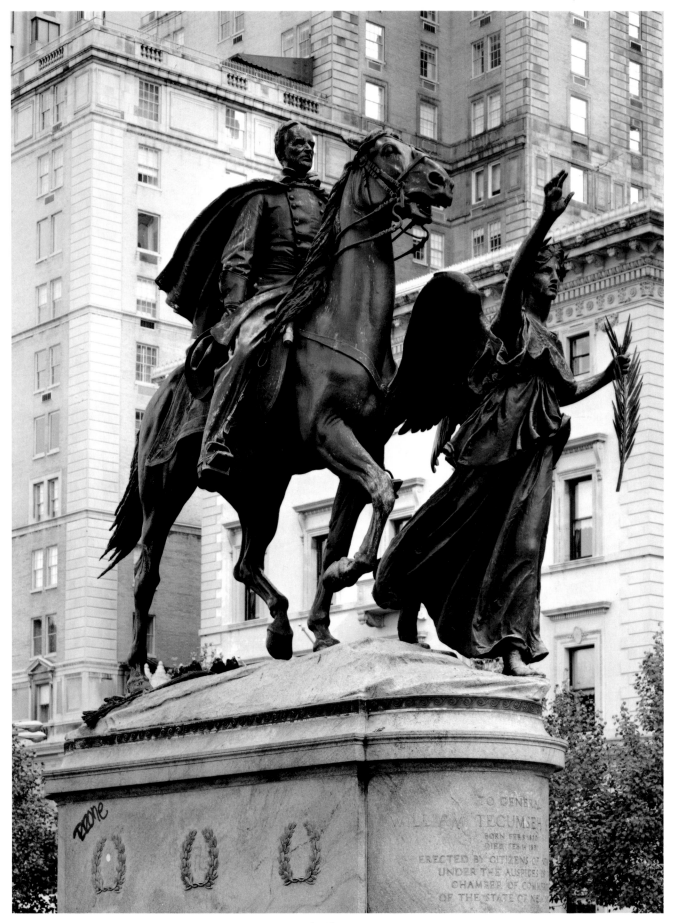

Fig. 170. *The Sherman Monument.*

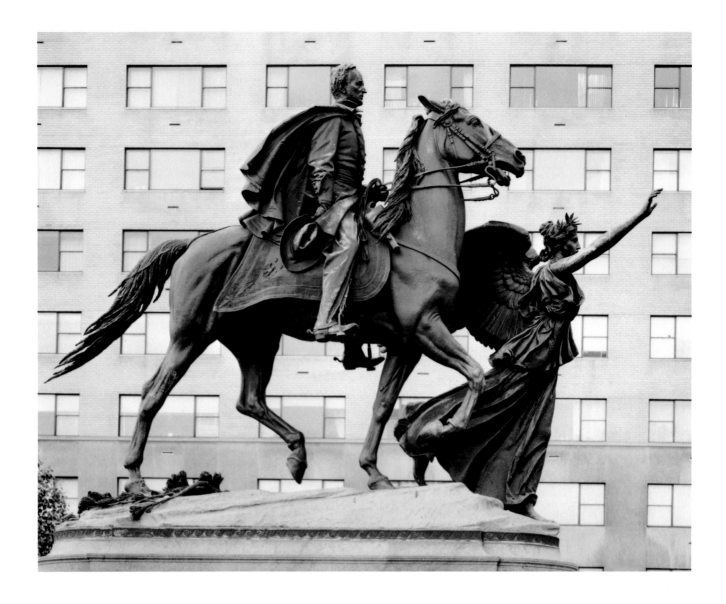

The work is still visible to advantage at its place on Grand Army Plaza, at Fifty-ninth Street just off Fifth Avenue (figs. 170, 171). If the figure of the equestrian *Logan* could be compared to the principal figure in a dramatic action, Saint-Gaudens's *Sherman* is a member of an ensemble. The drama is over. The guns are silent. Sherman's expression can be interpreted as one of regret, as though he had looked on too much death. He sits on his horse passively, his right arm hangs at his side (fig. 172); he seems to be carried forward without conscious volition. Though the exquisite figure of Victory seems to be leading him, it is his destiny that he follows, now near the end. The superb sense of forward movement in the monument is created by the purposeful trot of the horse and by the general's cloak, which blows in the wind behind him. Every element in the Victory figure reflects one in the statue: her outstretched right arm, the arch of the horse's head; her skirt, his tail; her wings, the general's cloak. The horse follows her obediently, keeping pace with her as he bears the general onward.

When the monument was unveiled in New York, it was hailed as being a noble descendant of traditional equestrian masterpieces, among them Verrocchio's equestrian *Bartolomeo Colleoni* in Venice. The crowd present at the unveiling cheered their approval; they were the last public cheers Saint-Gaudens was to hear. He still continued to accede to requests for busts and reliefs, though more often than not they were being executed by his studio assistants. In 1904, he was subjected to another shock, this one not physical but emotional. His New Hampshire studio caught fire, destroying many of his lifelong treasures and several of his works in progress. Homer Saint-Gaudens, who was attending the theater in New York that night with his father, wrote

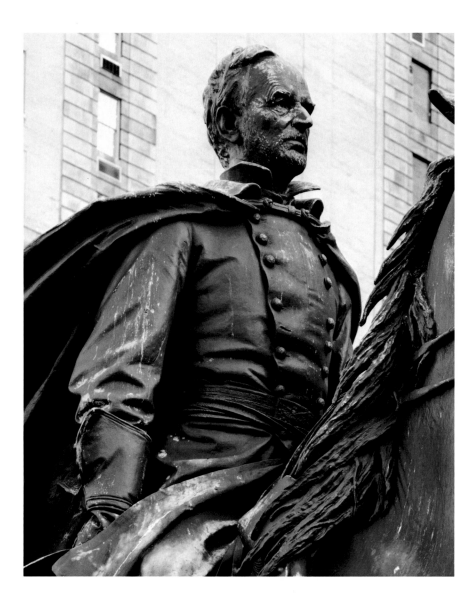

of the disaster: "Though my father took the news with a self-possession that showed that, despite his ill-health, the years had brought him a share of mental peace, nevertheless I am sure it caused him great distress."[105] As a result of the fire, which had started in a stable adjoining the studio about nine o'clock in the evening, when there was not a man on the place, almost all the work of four years perished: "A number of bas-reliefs, the Parnell, the nearly finished seated Lincoln, and a statue of Marcus Daly which sank into the embers with flakes of plastoline bursting from it as if from some tortured body."[106] There were even more severe losses: ". . . most of his treasured papers and letters, such as those from Robert Louis Stevenson, all of his portfolios containing records of twenty years, many photographs of commissions then on hand which he was unable to reproduce, his own drawing of his mother, the portrait of him by Kenyon Cox, the sketch of him by Bastien-Lepage, the Sargent sketch of him and a water color of a Capri girl, paintings by Winslow Homer, William M. Chase, and William Gedney Bunce, and many other pictures and objects reminiscent of his life."[107]

Saint-Gaudens's invincible spirit carried him through. He owned a second studio, and this, "with other buildings and adaptable barns in the vicinity, allowed the work to progress again immediately while he comforted himself with the thought that the monuments would improve because of the imposed recreation."[108] Two short years later, he endured a second blow, the tragic murder of his old friend Stanford White. Though the two men had not seen much of each other in recent years, their bond stretched back over a long period. They had been young together; their collaboration had been an extraordinarily productive and bril-

liant one. Saint-Gaudens "still counted White not only a master in his art, but one of the few men of his younger days on whom he could depend for intimate sympathy and advice."[109]

Though the shadows around Saint-Gaudens were deepening, he continued to function. In the few years left to him after the fire, he received appointments to committees and juries and was the recipient of several honors. He was elected to the American Academy of Arts and Letters; he was named by President Theodore Roosevelt to serve as a consulting member on Roosevelt's Board of Public Buildings; he served as an advisor on sculpture to the Vicksburg National Military Park; and he was elected an honorary member of the Royal Academy of Arts, in London. He was a celebrated figure in America.

In 1905, when his activity as a sculptor was inevitably coming to a close, one last remarkable commission was awarded him that brought his career to a glorious finish. At a dinner at the White House, President Theodore Roosevelt asked him to design gold coinage for the nation. Saint-Gaudens provided designs in high relief for ten- and twenty-dollar gold coins. Homer Saint-Gaudens tells of the consultation between the president and the sculptor: "They both grew enthusiastic over the old high-relief Greek coins, until the President declared that he would have the mint stamp a modern version of such coins in spite of itself if my father would design them."[110] In a letter to the president, Saint-Gaudens confirmed their decision: "You have hit the nail on the head with regard to the coinage. Of course the great coins (and you might almost say the only coins) are the Greek ones you speak of, just as the great medals are those of the fifteenth century by Pisanello and Sperandio."[111]

The first model Saint-Gaudens submitted was one of the double eagle, or twenty-dollar piece. After dies were made at the United States mint, in Philadelphia, the relief of the figures proved so high that the coins could not be produced on a regular press. About twenty pieces were then struck on a medal press; these, in what is called "ultra high relief" (fig. 173), were unsuitable for distribution. Though Saint-Gaudens modified the relief, the coins still could not be stamped to satisfactory effect. The sculptor made a third attempt, but that too failed. President Roosevelt began to suspect that the mint officials, perhaps offended that an outsider was usurping what they considered their prerogative, were not doing all that they could to produce the coins. He intervened, and the officials found that they could turn out the coins after all. In 1907 both the double eagle (fig. 174) and the eagle (fig. 175) were issued. They were greatly acclaimed as the most majestic achievement in the medium; they are still considered the most beautiful coins ever to be produced in America. Saint-Gaudens, in invoking the influence of Pisanello, again tapped the wellspring of inspiration that had started

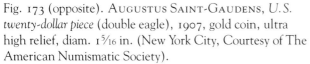

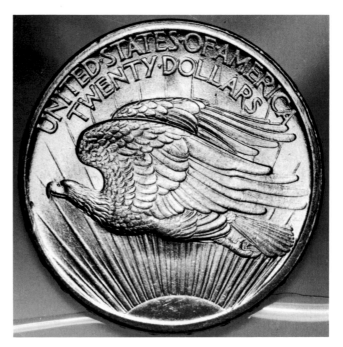

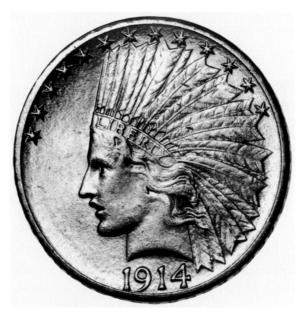

Fig. 173 (opposite). AUGUSTUS SAINT-GAUDENS, *U.S. twenty-dollar piece* (double eagle), 1907, gold coin, ultra high relief, diam. 1⁵⁄₁₆ in. (New York City, Courtesy of The American Numismatic Society).

Fig. 174 (above, left and right). AUGUSTUS SAINT-GAUDENS, *U.S. twenty-dollar piece* (double eagle), 1907, gold coin, business strike, diam. 1⁵⁄₁₆ in. (New York City, Courtesy of The American Numismatic Society).

Fig. 175 (right and below). AUGUSTUS SAINT-GAUDENS, *U.S. ten-dollar piece* (eagle), 1914, gold coin, business strike, diam. 1¹⁄₁₆ in. (New York City, Courtesy of The American Numismatic Society).

him on his glorious reliefs three decades before. With the coins, the only real creative achievement of his final years, an even older parallel can be drawn. In their small size, in the exquisitely wrought details of their design, the sculptor completed a full circle that carried him back to his days as a cameo-cutter's apprentice. In the coins, as in his cameos, his craftsmanship and innate genius met and conquered their first and last challenges.

Saint-Gaudens died in Cornish in August 1907. Fittingly, the last portrait of his life was a relief of Augusta (fig. 176), a woman who had been of steadfast support throughout a long and sometimes difficult marriage. Saint-Gaudens was a ship that sometimes voyaged into uncharted waters, but Augusta was his harbor and he always returned to her. In the relief, Saint-Gaudens shows her in profile, holding a vase of flowers and standing on the porch of the Cornish studio. The work has an uncompleted appearance; except for the detailing of the head the lines are merely sketched in. There is, however, one matchless touch: Saint-Gaudens has put himself into the portrait at the bottom, in the form of a dog, the symbol of fidelity, that stands loyally at Augusta's side, gazing off into the distance. Saint-Gaudens, then dying of cancer, was looking into an immense distance. He may have intended this work as a final tribute to her; it was his final farewell.

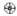

Notes

Abbreviations Used in Notes

DCL Saint-Gaudens Papers, Dartmouth College Library, Hanover, New Hampshire.

ENSAD/AN Archives de l'École Nationale Supérieure des Arts Décoratifs, Archives Nationale, Paris.

ENSBA/AN Archives de l'École Nationale Supérieure des Beaux-Arts, Archives Nationale, Paris.

NAD National Academy of Design, New York City.

S-G Augustus Saint-Gaudens.

The most frequently cited sources in the notes will be referred to by the following short forms:

CRAVEN
Wayne Craven. *Sculpture in America*. New York: Thomas Y. Crowell Company, 1968.

CORTISSOZ
Royal Cortissoz. *Augustus Saint-Gaudens*. Boston and New York: Houghton Mifflin and Company, 1907.

JANSON
H. W. Janson. "The Trouble with American Nineteenth Century Sculpture." In *American Art Review* 3 (November–December 1976), pp. 50–57.

S-G
The Reminiscences of Augustus Saint-Gaudens. Edited by Homer Saint-Gaudens. 2 vols. New York: The Century Co., 1913.

THARP
Louise Hall Tharp. *Saint-Gaudens and the Gilded Era*. Boston: Little, Brown and Company, 1969.

1. S-G, in a letter of 5/8/1888, presumably to the editor of *Appleton's Cyclopedia of American Biography*, wrote that his name should be spelled without a hyphen (Richard Watson Gilder Papers, Manuscript Division, New York Public Library), but since he signed his name in a variety of ways during his lifetime and, after 1888, frequently used the hyphen in inscribing his sculpture, that form is employed throughout the book.

2. *Boston Globe*, August 4, 1907, pp. 1, 6.

3. *Time Magazine* 51 (March 15, 1948), p. 76.

4. Ibid.

5. *Time Magazine* 94 (November 21, 1969), p. 61.

6. Janson, p. 50.

7. Craven, p. 381.

8. Janson, p. 56.

9. Frank T. Robinson, "Henry Hudson Kitson," in *Living New England Artists* (Boston, Samuel E. Cassino, 1888), p. 115.

10. Anne Wagner, "Learning to Sculpt in the Nineteenth Century: An Introduction," in *The Romantics to Rodin*, ed. Peter Fusco and H. W. Janson (Los Angeles: Los Angeles County Museum of Art in association with George Braziller, Inc., 1980), pp. 17–18.

11. Craven, p. 382.

12. Cortissoz, p. 78.

13. S-G 1, p. 367.

14. Ibid. 2, p. 109.

15. The drapery for the figure, while done after S-G's fashion, may actually have been arranged by an assistant.

16. S-G 1, p. 230.

17. Letter, S-G to Gibbs, September 1879 (DCL).

18. Wagner (see n. 10), p. 9.

19. S-G is listed as having been admitted to the antique class for the school year of 1863/64, but with no specific date of entry. Since his name is near the end of the list of students, he presumably was admitted after the beginning of 1864 (Register of Students of the Antique School, Session of 1863–64, Archives, NAD). I am grateful to Barbara Krulik, Assistant Director of the NAD, for providing this information and that below at n. 23.

20. I am grateful to Morgan Lewis, coordinator of alumni exhibitions at the Cooper Union, who kindly provided this information from the school's annual report.

21. Lois Marie Fink, "American Renaissance: 1870–1917," in *Academy: The Academic Tradition in American Art* (Washington, D.C.: Smithsonian Institution Press for the National Collection of Fine Arts, 1975), p. 52.

22. S-G 1, p. 45.

23. NAD, Register of Students of the Antique School, Session of 1865/1866 and 1866/1867; Register of Members of the Life School, Session of 1866/1867.

24. S-G 2, pp. 183–84.

25. Ibid. 1, p. 69.

26. ENSAD/AN.

27. Cortissoz, pp. 8–11.

28. S-G 1, p. 74.

29. S-G was admitted to the École on March 30, 1868. Écoles spéciales de peinture et sculpture (ENSBA/AN).

30. S-G 1, p. 77.

31. Ibid., p. 79.

32. The duration of the stay in Rome varied. During S-G's period at the École, the sculpture students spent four years at the French Academy in Rome; the stay was later reduced to three years.

33. S-G 1, p. 113.

34. William Gerdts, *American Neo-Classic Sculpture* (New York: The Viking Press, 1973), p. 128.

35. "The Lounger," *Harper's Weekly Magazine* 5 (April 20, 1861), p. 243. I am grateful to Lauretta Dimmick, an Andrew W. Mellon Fellow at The Metropolitan Museum of Art, 1984–85, for providing this information.

36. S-G 1, p. 109. Elsewhere the statue's inspiration is cited as verses by the nineteenth-century Portuguese writer and historian Alexandre Herculano (Diogo de Macedo, *A Obra de Soares dos Reis*, Portô, Museu Nacional de Soares dos Reis, 1940, p. 9).

37. S-G 1, p. 109.

38. Letter from Florence Gibbs to S-G, April 1872 (DCL).

39. Letter from S-G to Mongomery Gibbs, 7/8/1872 (DCL).

40. S-G 1, pp. 134, 144–47, 164.

41. Ibid., p. 144.

42. Ibid., p. 142–43.

43. Craven, pp. 376–77.

44. S-G 1, p. 130.

45. Ibid., p. 174.

46. Ibid.

47. Ibid., pp. 174–75.

48. Ibid., p. 169.

49. Ibid., p. 159.

50. Tharp, p. 95.

51. S-G 1, p. 186.

52. Ibid., p. 162.

53. Ibid.

54. Ibid., p. 216. The work is inscribed "A. Gibert/paysagiste/Rome 1869." The sitter was probably Jean-Baptiste-Adolphe Gibert (1803–1889), who he is known to have spent long years in Rome.

55. Tharp, p. 109.

56. S-G 1, pp. 192-93.

57. Ibid., pp. 200–201.

58. Ibid., pp. 201–202.

59. Ibid., p. 209.

60. In a letter from S-G to David Maitland, quoted in Maitland's reminiscences, *Day Before Yesterday* (New York, Charles Scribner's Sons, 1920), pp. 263–64, the sculptor mentions sending the relief of Armstrong, together with a bust of Admiral Farragut, to the Society of American Artists' 1878 exhibition, but the catalogue does not list him as an exhibitor.

61. The reliefs were those of David Maitland Armstrong, Helen Maitland Armstrong, Francis Davis Millet, the family of Richard Watson Gilder, and Jules Bastien-Lepage.

62. S-G's "Sketchbook," Summer 1879 (Collection of the American Academy and Institute of Arts and Letters), includes drawings for the *Farragut*.

63. Cortissoz, pp. 46, 51.

64. S-G 1, pp. 349–50.

65. Tharp, p. 177.

66. S-G 1, p. 220-21.

67. Tharp, p. 180.

68. S-G 1, p. 224.

69. Ibid., p. 272.

70. Ibid., p. 273.

71. Tharp, p. 180.

72. S-G 1, p. 274.

73. Ibid., pp. 354–55.

74. Mark Jones, *The Art of the Medal* (London: British Museum Publications Ltd., 1979) p. 121.

75. S-G 2, p. 78.

76. Ibid. 1, p. 389.

77. For a complete exploration of the Stevenson relief variations, see John Dryfhout, "Robert Louis Stevenson" in *Metamorphoses in Nineteenth-Century Sculpture*, ed. Jeanne L. Wasserman (Cambridge and London: Harvard University Press for the Fogg Art Museum, 1975), pp. 187–200.

78. S-G 2, p. 125.

79. Paul Wenzel and Maurice Krakow, *Sketches and Designs by Stanford White* (New York: The Architectural Book Publishing Co., 1920), pl. 37.

80. Ibid., pl. 34.

81. S-G 1, pp. 272–73.

82. Ibid., p. 274.

83. Ibid., p. 51.

84. Ibid., p. 42.

85. *The Century* 45 (November 1887), pp. 37–39.

86. Cortissoz, p. 51.

87. Ibid., p. 34.

88. S-G 2, p. 4.

89. Ibid., p. 18.

90. Ibid., pp. 18–23.

91. Lincoln Kirstein, *Lay This Laurel* (New York: Eakins Press, 1973), unpaged.

92. S-G 1, p. 332.

93. Kirstein (see. n. 89).

94. S-G 2, p. 122.

95. Ibid., p. 132.

96. Ibid., p. 131.

97. Ibid.

98. Ibid. 1, p. 378.

99. Ibid., p. 379.

100. Ibid. 2, p. 135.

101. Ibid.

102. Ibid., p. 227.

103. Ibid., p. 289.

104. Ibid., p. 295 (letter quoted).

105. Ibid., p. 247.

106. Ibid., p. 248.

107. Ibid.

108. Ibid.

109. Ibid., p. 251.

110. Ibid., p. 329.

111. Ibid., pp. 329–30.

BIBLIOGRAPHY

ADAMS, ADELINE. *The Spirit of American Sculpture.* New York: The National Sculpture Society, 1923.

ARMSTRONG, MAITLAND. *Day Before Yesterday.* New York: Charles Scribner's Sons, 1920.

BEATTIE, SUSAN. *The New Sculpture.* New Haven and London: Yale University Press, published for the Paul Mellon Centre for Studies in British Art, 1983.

BOND, JOHN W. "Augustus Saint-Gaudens: The Man and His Art." Manuscript, Office of Archeology and Historic Preservation, National Park Service, Washington, D.C., 1968.

BOUTON, MARGARET. "The Early Works of Augustus Saint-Gaudens." Ph.D. dissertation, Radcliffe College, 1946.

CAFFIN, CHARLES H. *American Masters of Sculpture.* New York: Doubleday, Page & Company, 1903.

CORTISSOZ, ROYAL. *Augustus Saint-Gaudens.* Boston and New York: Houghton Mifflin and Company, 1907.

CRAVEN, WAYNE. *Sculpture in America.* New York: Thomas Y. Crowell, 1968.

DELAHAYE, J. M. "Paul Dubois Statuaire, 1829–1905." Thesis, École du Louvre, 1973.

DRYFHOUT, JOHN H. *The Work of Augustus Saint-Gaudens.* Hanover, New Hampshire: University Press of New England, 1982.

DRYFHOUT, JOHN, and COX, BEVERLY. *Augustus Saint-Gaudens: The Portrait Reliefs.* Exhibition catalogue. Washington, D.C.: National Portrait Gallery, Smithsonian Institution, 1969.

DU CASTEL, FRANÇOISE P.-D. *Paul Dubois.* Paris: Les Editions du Scorpion, Jean D'Halluin, Éditeur, 1964.

ELSEN, ALBERT E., ed. *Rodin Rediscovered.* Exhibition catalogue. Washington, D.C.: National Gallery of Art, 1981.

FIDIÈRE, O[ctave]. *Chapu: sa vie et son oeuvre.* Paris: Librairie Plon, 1894.

FUSCO, PETER, and JANSON, H. W., eds. *The Romantics to Rodin.* Exhibition catalogue. Los Angeles and New York: Los Angeles County Museum of Art in association with George Braziller, Inc., 1980.

HEDBERG, GREGORY; STALEY, ALLEN; ORMOND, LEONÉE; ORMOND, RICHARD; DORMENT, RICHARD. *Victorian High Renaissance.* Exhibition catalogue. Minneapolis, Minnesota: The Minneapolis Institute of Arts, 1978.

HIND, C. LEWIS. *Augustus Saint-Gaudens.* New York: The International Studio, John Lane Company, 1908.

JANSON, H.W. *19-Century Sculpture.* New York: Harry N. Abrams, Inc., 1985.

KASHEY, ROBERT, and REYMERT, MARTIN L. H. *Western European Bronzes of the Nineteenth Century: A Survey.* Exhibition catalogue. New York: Shepherd Gallery, 1973.

KIRSTEIN, LINCOLN. *Lay This Laurel.* New York: Eakins Press, 1973.

Low, WILL H. *A Chronicle of Friendships.* New York: Charles Scribner's Sons, 1908.

MARCUS, LOIS GOLDREICH. "Studies in Nineteenth-Century American Sculpture: Augustus Saint-Gaudens (1848–1907)." Ph.D. dissertation, City University of New York, 1979.

McSPADDEN, J. WALKER. *Famous Sculptors of America.* New York: Dodd, Mead & Co., 1924.

MIROLLI, RUTH BUTLER, and VAN NIMMEN, JANE. *Nineteenth Century French Sculpture: Monuments for the Middle Class.* Exhibition catalogue. Louisville, Kentucky: J. B. Speed Art Museum, 1971.

READ, BENEDICT. *Victorian Sculpture.* New Haven and London: Yale University Press, published for the Paul Mellon Centre for Studies in British Art, 1982.

RHEIMS, MAURICE. *La Sculpture au XIX Siècle.* Paris: Arts et Metiers Graphiques, 1972.

SAINT-GAUDENS, HOMER, ed. *The Reminiscences of Augustus Saint-Gaudens.* 2 vols. New York: The Century Co., 1913.

SHAPIRO, MICHAEL EDWARD. "The Development of American Bronze Foundries, 1850–1900." Ph.D. dissertation, Harvard University, 1980.

TAFT, LORADO. *The History of American Sculpture.* New York: Macmillan Co., 1903.

THARP, LOUISE HALL. *Saint-Gaudens and the Gilded Era.* Boston and Toronto: Little, Brown and Company, 1969.

WASSERMAN, JEANNE L., ed. *Metamorphoses in Nineteenth-Century Sculpture.* Exhibition catalogue. Cambridge: Harvard University, Fogg Art Museum, 1975.

Exhibition Checklist

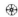

The Metropolitan Museum of Art, New York

November 19, 1985–January 26, 1986

Museum of Fine Arts, Boston

February 26, 1986–May 11, 1986

John Tuffs, about 1861
Shell cameo, 1¾ in. × 1⁷⁄₁₆ in.
Unsigned
Private collection (fig. 38)

Hercules, before 1867
Onyx cameo, diam. 1¼ in.
Signed (initials) at left
Cornish, New Hampshire, Saint-Gaudens National Historic
 Site, National Park Service, U.S. Department of the In-
 terior (fig. 41)

Hiawatha, 1872
Marble statue, life-size
Signed (cursive) on rock
Private collection (fig. 45)

Hannah Rohr Tuffs, 1872
Shell cameo, 1⁷⁄₈ in. × 1½ in.
Unsigned
Private collection

Mary, Queen of Scots Cameo, Gibbs version, 1872
Onyx cameo, ¾ in. × ½ in.
Unsigned
Private collection (fig. 51)

Youthful Mars, about 1873
Onyx cameo, 1½ in. × 1 in.
Signed (initials) at right
Cornish, New Hampshire, Saint-Gaudens National Historic
 Site, National Park Service, U.S. Department of the In-
 terior (fig. 54)

William Maxwell Evarts, 1874
Marble bust, h. 23 in.
Signed (cursive) on edge of right shoulder
Private collection (fig. 53)

David Maitland Armstrong, 1877
Bronze relief, 7⁷⁄₈ in. × 4⁹⁄₁₆ in.; wood frame painted by Helen
 Maitland Armstrong
Signed at inscription
New York City, Collection of Mr. Maitland A. Edey (fig. 61)

George Willoughby Maynard, 1877
Bronze relief, 8¼ in. × 5⁷⁄₈ in.
Signed around upper left corner
New York City, The Century Association (fig. 63)

*Augustus Saint-Gaudens, Stanford White, and Charles F.
 McKim* (caricature), 1878
Bronze medallion, diam. 6½ in.
Unsigned
New York City, The New York Public Library, Art, Prints, and
 Photographs Division, Astor, Lenox and Tilden Founda-
 tions (fig. 68)

Charles F. McKim, 1878
Bronze relief, 7½ in. × 5 in.
Signed at lower inscription
New York City, The New York Public Library, Art, Prints, and
 Photographs Division, Astor, Lenox, and Tilden Founda-
 tions (fig. 69)

Dr. Walter Cary, 1878
Bronze relief, 9³⁄₁₆ in. × 6⁹⁄₁₆ in.
Signed at top
Private collection (fig. 5)

Dr. Walter Cary, 1879
Bronze relief, 9³⁄₈ in. × 6¾ in.
Signed at top
Private collection (fig. 70)

* to be shown only at The Metropolitan Museum of Art

** to be shown only at the Museum of Fine Arts, Boston

Maria Love, 1879
Bronze relief, 9⅝ in. × 6⅝ in.
Signed (monogram) at lower right
Private collection (fig. 71)

Richard Watson Gilder, Helena de Kay Gilder, and Rodman Gilder, 1879
Bronze relief, 8⅝ in. × 16⅞ in.; wood frame probably designed by Stanford White
Signed at inscription
Private collection (fig. 73)

Rodman de Kay Gilder, 1879
Bronze relief, 13½ in. × 16⁵⁄₁₆ in.
Signed (monogram) at upper right
Private collection (fig. 74)

Admiral David Glasgow Farragut, 1879–80
Bronze statue, over life-size
Signed on base, left side
New York City, Madison Square Park (figs. 1, 77; pl. 1)

Head of Farragut, 1879–80
This bronze cast 1910, h. 11¼ in.
Signed (monogram) below collar, right side
New York City, The Metropolitan Museum of Art, Gift by subscription through the Saint-Gaudens Memorial Committee, 1912 (pl. 11)

Jules Bastien-Lepage, 1880
Bronze relief, 14⁹⁄₁₆ in. × 10⅜ in.
Signed at inscription
Museum of Fine Arts, Boston, The Everett Fund, 1881 (fig. 75)

Dr. Henry Shiff, 1880
Bronze relief, 10¹¹⁄₁₆ in. × 11¼ in.; wood frame designed by Stanford White
Signed at inscription
Cornish, New Hampshire, Saint-Gaudens National Historic Site, National Park Service, U.S. Department of the Interior (fig. 72)

The Children of Prescott Hall Butler, 1880–81
Bronze relief, 23¾ in. × 35¼ in.
Signed at inscription, lower right; monogrammed at upper right
Property of Prescott Butler Huntington (fig. 100)

Sarah Redwood Lee and Helen Parrish Lee, 1881
Bronze relief, 14⅝ in. × 24⅛ in.; wood frame probably designed by Stanford White
Signed at lower inscription
Emmitsburg, Maryland, Mount Saint Mary's College, Special Collections House, Lee-LaFarge Collection (fig. 103)

Sarah Redwood Lee, 1881
Bronze relief, 25⅞ in. × 11⅛ in.
Signed (monogram) at upper right
Emmitsburg, Maryland, Mount Saint Mary's College, Special Collections House, Lee-LaFarge Collection (fig. 59)

Samuel Gray Ward, 1881
Bronze relief, 19¼ in. × 14 in.
Signed (monogram) at lower left
New York City, Collection of Erving and Joyce Wolf (figs. 107–110)

The Vanderbilt Mantelpiece, 1882 *
Marble, h. 184⅜ in.
Unsigned
New York City, The Metropolitan Museum of Art, Gift of Mrs. Cornelius Vanderbilt II, 1925 (fig. 86)

Bessie Springs Smith (Mrs. Stanford White), 1884
Marble relief, 24¹⁵⁄₁₆ in. × 11¹⁵⁄₁₆ in.
Frame, gilded wood with gesso, designed by Stanford White
Signed at lower left
New York City, The Metropolitan Museum of Art, Gift of Erving Wolf Foundation (pl. 111)

The Children of Jacob H. Schiff, 1885 **
Bronze relief, 67⁵⁄₁₆ in. × 50⅜ in.
Unsigned
Cornish, New Hampshire, Saint-Gaudens National Historic Site, National Park Service, U.S. Department of the Interior (fig. 15)

The Children of Jacob H. Schiff, 1885 *
Marble relief version, inscribed 1888, carved in 1907, 68⅞
 in. × 51 in.
Signed at bottom
New York City, The Metropolitan Museum of Art, Gift of
 Jacob H. Schiff, 1905

The Puritan, 1886
This bronze copyrighted 1899, h. 30½ in.
Signed on top of base, right side
New York City, The Metropolitan Museum of Art, Bequest of
 Jacob Ruppert, 1939

Abraham Lincoln ("The Standing Lincoln"), 1887
This bronze reduction cast after 1910, h. 39½ in.
Signed on base, right side
Cornish, New Hampshire, Saint-Gaudens National Historic
 Site, National Park Service, U.S. Department of the In-
 terior

Robert Louis Stevenson, 1887
This bronze medallion cast 1890, diam. 36 in.; wood frame
 probably designed by Stanford White
Signed at upper inscription
Princeton, New Jersey, Princeton University Library (figs.
 114, 115)

Robert Louis Stevenson, 1887
This bronze relief cast 1902, 91 in. × 110 in.
Signed at lower left
Edinburgh, St. Giles' Cathedral (fig. 118)

William Tecumseh Sherman, 1888
This bronze bust cast 1910, h. 31¼ in.
Signed on base, left side
New York City, The Metropolitan Museum of Art, Gift by sub-
 scription through the Saint-Gaudens Memorial Commit-
 tee, 1912 (figs. 164, 165)

Portrait of Mrs. Schuyler Van Rensselaer, 1888
This bronze relief cast 1890, 20⁷⁄₁₆ in. × 7¾ in.; wood frame
 probably designed by Stanford White
Signed at lower inscription
New York City, The Metropolitan Museum of Art, Gift of
 Mrs. Schuyler Van Rensselaer, 1917 (figs. 111, 112;
 pl. VII)

Louise Miller Howland, 1888
Bronze relief, 39⅛ in. × 23½ in.; wood and gilded gesso frame
 with marble columns probably designed by Stanford
 White
Signed at lower left
Private collection (fig. 113)

William Merritt Chase, 1888
Bronze relief, 22 in. × 29½ in.
Signed at inscription
New York City, Collection of the American Academy and In-
 stitute of Arts and Letters (fig. 119)

Violet Sargent, 1890 *
Bronze relief, 50 in. × 34 in.; wood frame probably designed by
 Stanford White
Signed (initials) in cartouche on bench
Washington, D.C., National Museum of American Art,
 Smithsonian Institution, Gift of Mrs. John L. Hughes

The Adams Memorial, 1890–91
Bronze figure cast 1969, over life-size
Unsigned
Washington, D.C., National Museum of American Art,
 Smithsonian Institution

Diana, 1893–94
This bronze reduction cast about 1895, h. 38⅞ in.
Unsigned
New York City, Collection of Erving and Joyce Wolf

Diana of the Tower, 1893–94
This bronze reduction dated 1899, h. 38 in.
Signed on base at back
Washington, D.C., National Gallery of Art, Pepita Milmore
 Memorial Fund (fig. 140)

Diana, 1893–94
Gilded-bronze reduction, h. 28¼ in.
Signed on base at back
Private collection

Diana, 1893–94
Gilded-bronze reduction cast 1928, h. 102 in.
Unsigned
New York City, The Metropolitan Museum of Art, Rogers
 Fund, 1928 (pl. VIII)

Head of Robert Gould Shaw for the Shaw Memorial, 1897
Bronze model, about 1890, this cast 1908, h. 10 in.
Signed (monogram) on neck, right side
Cornish, New Hampshire, Saint-Gaudens National Historic
 Site, National Park Service, U.S. Department of the In-
 terior

Head of Soldier for the Shaw Memorial, 1897
Bronze model, about 1890, this cast about 1955, h. 6 in.
Unsigned
Cornish, New Hampshire, Saint-Gaudens National Historic
 Site, National Park Service, U.S. Department of the In-
 terior

Head of Soldier for the Shaw Memorial, 1897
Bronze model, about 1890, this cast 1965, h. 5¾ in.
Unsigned
Cornish, New Hampshire, Saint-Gaudens National Historic
 Site, National Park Service, U.S. Department of the In-
 terior (fig. 149)

Head of Soldier for the Shaw Memorial, 1897
Bronze model, about 1890, this cast 1965, h. 6 in.
Unsigned
Cornish, New Hampshire, Saint-Gaudens National Historic
 Site, National Park Service, U.S. Department of the In-
 terior

Head of Soldier for the Shaw Memorial, 1897
Bronze model, about 1890, this cast 1965, h. 7½ in.
Unsigned
Cornish, New Hampshire, Saint-Gaudens National Historic
 Site, National Park Service, U.S. Department of the In-
 terior (fig. 150)

Head of Soldier for the Shaw Memorial, 1897
Bronze model, about 1890, this cast 1965, h. 5¾ in.
Unsigned
Cornish, New Hampshire, Saint-Gaudens National Historic
 Site, National Park Service, U.S. Department of the In-
 terior

Mildred Howells, 1898
Bronze medallion, diam. 21 in.; wood frame probably de-
 signed by Stanford White
Signed at inscription
Museum of Fine Arts, Boston, Gift of Miss Mildred Howells,
 1957 (fig. 105)

Amor Caritas, 1880–98
This gilded-bronze relief cast 1918, 113⁵⁄₁₆ in. × 50 in.
Signed at lower right
New York City, The Metropolitan Museum of Art, Rogers
 Fund, 1918 (fig. 99; pl. XIV)

Head of Victory, 1902
Gilded bronze, h. 8¼ in.
Signed on base at right
Boston, Nichols House Museum (pl. XVII)

Figure of Victory, 1902
This gilded-bronze reduction copyrighted 1912, h. 38 in.
Signed on base at right
New York City, The Metropolitan Museum of Art, Rogers
 Fund, 1917

U.S. twenty-dollar piece (double eagle), 1907
Gold coin, ultra high relief, diam. 1⁵⁄₁₆ in.
Signed (monogram) at lower right
New York City, The American Numismatic Society (fig. 173)

U.S. twenty-dollar piece (double eagle), 1907
Gold coin, high relief, diam. 1⁵⁄₁₆ in.
Signed (monogram) at lower right
New York City, The American Numismatic Society

U.S. twenty-dollar piece (double eagle), 1907
Gold coin, business strike, diam. 1⁵⁄₁₆ in.
Signed (monogram) at lower right
New York City, The American Numismatic Society (fig. 174)

U.S. ten-dollar piece (eagle), 1914
Gold coin, matte finish proof, diam. 1¹⁄₁₆ in.
Unsigned
New York City, The American Numismatic Society

U.S. ten-dollar piece (eagle), 1914
Gold coin, business strike, diam. 1¹⁄₁₆ in.
Unsigned
New York City, The American Numismatic Society (fig. 175)

Augusta Homer Saint-Gaudens, 1907
Bronze relief, 35¹³⁄₁₆ in. × 23¼ in.
Signed (monogram) at lower right
Cornish, New Hampshire, Saint-Gaudens National Historic
 Site, National Park Service, U.S. Department of the In-
 terior (fig. 176)

Photo Credits

American Academy and Institute of Arts and Letters, New York City: figs. 1, 35, 40, 128

The American Numismatic Society, New York City: figs. 173, 174, 175

Wayne Andrews, Chicago: fig. 92

Art Resource, New York City: figs. 13 (Alinari 24187), 82 (Alinari 2313), 95 (Alinari 24177), 97 (Giraudon 737), 146 (Alinari 27802), 162 (Alinari 25141)

Avery Architectural and Fine Arts Library, Columbia University, New York City: figs. 66, 136, 138

David Batchelder; courtesy of National Portrait Gallery, Smithsonian Institution, Washington, D.C.: figs. 15, 63, 70, 104

The William Benton Museum of Art, The University of Connecticut, Storrs, Connecticut: frontispiece

Bernie Cleff, Philadelphia: fig. 8

Conway Library, Courtauld Institute of Art, London: figs. 47 (A80/4551), 118 (B77/4177), 142 (852/40 [2]), 161 (822/38 [16])

Photographic Survey of Private Collections, Courtauld Institute of Art, London: fig. 166

Dartmouth College Library, Hanover, New Hampshire: p. 34; figs. 14, 16, 17, 18, 19, 20, 21, 23, 24, 25, 26, 28, 29, 30, 32, 33, 36, 37, 42, 44, 45, 55, 56, 57, 81, 87, 88, 93, 127, 135, 141, 145, 148

Deane's Studio, Jacksonville, Florida: figs. 5, 71

Fitzwilliam Museum, Cambridge, England: fig. 167

Kathryn Greenthal, Boston: fig. 139

The Houghton Library, Harvard University, Cambridge, Massachusetts: fig. 80

Aubrey P. Janion; courtesy of Saint-Gaudens National Historic Site, National Park Service, U.S. Department of the Interior, Cornish, New Hampshire: fig. 94

Peter A. Juley & Son Collection, National Museum of American Art, Smithsonian Institution, Washington, D.C.: figs. 4 (J0021730), 43 (J0021701), 78 (J0021727), 79 (J0021726), 96 (J0021685), 106 (J0021698)

The Metropolitan Museum of Art, New York City: figs. 2, 3, 39, 58, 86, 99

Musée de la Monnaie, Paris: fig. 76

Musée d'Orsay, Paris: fig. 64

Musées Nationaux, Paris: figs. 6, 98

Museum of the City of New York, New York City: figs. 90, 91

Museum of Fine Arts, Boston: fig. 10

Museum of Fine Arts, Houston: fig. 48

Museum of Modern Art, New York City: fig. 124

National Gallery of Art, Washington, D.C.: figs. 11, 60, 140

National Museum of American Art, Smithsonian Institution, Washington, D.C.: fig. 52

The New-York Historical Society, New York City: figs. 46, 89

Jeffrey Nintzel; courtesy of Saint-Gaudens National Historic Site, National Park Service, U.S. Department of the Interior, Cornish, New Hampshire: fig. 147

Michael Richman, Washington, D.C.: fig. 9

Saint-Gaudens National Historic Site, National Park Service, U.S. Department of the Interior, Cornish, New Hampshire: fig. 102

Parkman Shaw, Boston: fig. 144

Springfield Central, Springfield, Massachusetts: fig. 125

Cecil Stoughton; courtesy of Saint-Gaudens National Historic Site, National Park Service, U.S. Department of the Interior, Cornish, New Hampshire: fig. 50

Gordon Sweet; courtesy of Mrs. Gordon Sweet, Mt. Carmel, Connecticut: figs. 22, 51, 65, 83, 85

The Tate Gallery, London: fig. 116

Jerry L. Thompson, Amenia, New York: figs. 27, 38, 53, 61, 73, 74, 77, 100, 107, 108, 109, 110, 113, 120, 123, 126, 129, 130, 131, 132, 133, 134, 151, 152, 153, 154, 155, 156, 157, 158, 159, 160, 163, 168, 169, 170, 171, 172; pls. I, IV, V, VI, IX, X, XI, XII, XIII, XV, XVI; courtesy of American Academy and Institute of Arts and Letters, New York City: fig. 119; courtesy of Los Angeles Museum of Art: fig. 49; courtesy of The Metropolitan Museum of Art, New York City: figs. 7, 12, 101, 111, 112, 117, 164, 165, pls. II, III, VII, VIII, XIV; courtesy of Mount Saint Mary's College, Emmitsburg, Maryland: figs. 59, 103; courtesy of Museum of Fine Arts, Boston: figs. 67, 75, 105; courtesy of New York Public Library: figs. 68, 69; courtesy of Nichols House Museum, Boston: pl. XVII; courtesy of Philadelphia Museum of Art: fig. 143; courtesy of Princeton University Library, Princeton, New Jersey: figs. 114, 115; courtesy of Saint-Gaudens National Historic Site, National Park Service, U.S. Department of the Interior, Cornish, New Hampshire: figs. 41, 54, 72, 149, 150, 176

Union Pacific Railroad Museum, Omaha, Nebraska: fig. 84

Wadsworth Atheneum, Hartford, Connecticut: fig. 62

Wellesley College, Wellesley, Massachusetts: fig. 137

Williams College, Williamstown, Massachusetts: fig. 31